THE PRIVATE EYE IN PUBLIC ART

First published in 2023 by ORO Editions
Publishers of Architecture, Art, and Design
Gordon Goff, publisher

www.oroeditions.com

Foreword by Eleanor Heartney
Book design by John Isaacs
Jacqueline Pearse, Editorial Associate
Jake Andersen, Managing Editor

Typeset in New Transport

10 9 8 7 6 5 4 3 2 1 First edition

ISBN 978-1-957183-15-2

Printed in China

THE PRIVATE EYE IN PUBLIC ART
JOYCE POMEROY SCHWARTZ

Foreword by Eleanor Heartney

*Dedicated to my father Alfred Pomeroy, my brother Lee Pomeroy,
and my husband Harold Schwartz, who encouraged and supported me
throughout my family and working lives.*

If I have one conviction, it is that the public deserves enduring art by our greatest artists. I believe public art should be museum quality, and the artist selection process should have excellence as its primary goal. Saying that, issues of time, space, community, and content are issues to be explored and considered only in the hands of the right artist for the right project.

— Joyce Pomeroy Schwartz

THE PRIVATE EYE IN PUBLIC ART

Acknowledgments

Over the years many people have inspired me, personally and professionally. I would like to acknowledge them here.

First and foremost, I am appreciative of all the incredible artists I have worked with, and of those with whom I wanted to work, but never had the chance.

This book could never have happened without the consistent and innovative vision of my longtime devoted book designer, John Isaacs.

I am also deeply grateful for the dedicated assistance of my imaginative and conscientious associate, Jacqueline "Jack" Pearse, a meticulous editor and great art photographer, who does everything well with intense caring.

And sincere appreciation is also due to: Jake Andersen, the managing editor of state-of-the-art publishers ORO Editions/Goff Associates; Alix Lane Schwartz, for her effective perception and discerning insights; Delaney Schwartz for her thoughtful design review; Andrea Monfried, committed editor of art and architecture books; and Susan Strauss, my first editor.

My life has been enhanced by working and playing in the world of incomparable artists and dedicated art professionals. I will always be grateful to The Pace Gallery in New York City, founded by the enlightened and committed gallerists, Arne and Milly Glimcher and Richard Solomon of Pace Prints. I became their first Director of Commissions.

Throughout my career I've been assisted by the expertise and friendship of influential mentors. One of the most important was the late Donald Thalacker, dedicated architect and art patron of the GSA (General Services Administration). His good advice and revitalization of the WPA Federal Art and Architecture program put me on a path to help create meaningful public art in America and the world.

From the beginning I was guided by the incomparable late Doris C. Freedman, founder of the Public Art Fund and New York City's Percent for Art program. Later I became associated with Ralph DiBart, an outstanding urban planner and arts advocate, and David Hanks, a curator of design arts, whose legendary books on design and architecture continue to inspire me.

Great experiences in the international art world were made possible by my professional collaboration with visionary colleagues from Japan: Shigeyuki Fukasawa (Chairman Kotobuki Chair/Town Art Corporation) and his wife Yasuyo Kudo (Founder of Art Place).

I also thank Sokichi Sugimura (Public Art Research Center PARI, Tokyo) and Peter Shyong (Dimension Endowment of Art, Taiwan).

Crucial to my continuing education in the public arts were keepers of outstanding contemporary sculpture gardens and organizations: Giuliano Gori (Collezione Gori, Villa di Celle, Pistoia, Italy), Mary Beebe (Stuart Collection, USC San Diego), David Collens and H. Peter Stern (Storm King Art Center), Don McNeil (General Mills Sculpture Collection), Mary Kilroy (RDA Philadelphia Redevelopment Authority Fine Arts), Penny Bach (Philadelphia's Association for Public Art), Lynn Gumpert, (Grey Gallery at NYU Langone), Kim Maier and Michelle Isenberg (Association of Professional Art Advisors APAA), Michele Cohen (NYC Public Art for Public Schools), and Sandra Bloodworth (Metropolitan Transit Authority Arts & Design).

My life and career would not have been the same without my great friendship, over many years, with incomparable professional colleagues: Ellen Cantrowitz, Alix Holloway, Maura Kehoe Collins, Vivian Ebersman, Martina Yamin, Sarah Murkett, Lila Harnett, Melissa Feldman, Holly Carter, Barbara London, Jack Becker, Marcia Tanner, Tsipi Ben Haim, Ada Ciniglio, Joy Glidden, Natalie Angles, Janet Rossbach, Paola Ochoa, Sheila Hicks, Maria Nevelson, Kathy Brew, Peter McCourt, Stephanie Gelb, Alexandra Altman and my niece, Jordana Pomeroy and nephew, Jeremy Pomeroy.

And finally, I would like to thank my family: My supportive and loving sons, David, Evan, and Bill, and their wives, Harriet, Kristine, and Terry, my cousin Doris Selwyn Match Engel, and my dear oldest friend Eleanor Shaw. And last but not least, my wonderfully creative grandchildren, who have enriched my later years: the aforementioned Alix and Delaney, Liam, Jon, and Rebecca, their partners Oliver and Kat, and my two great-granddaughters, Iris and Josephine.

I have been extremely fortunate to have lived the life I have, and to have met so many outstanding artists and remarkable people along the way. It is impossible to note them all here, but I am grateful for their friendship, knowledge, and inspiration.

— **Joyce Pomeroy Schwartz**

FOREWORD
BY ELEANOR HEARTNEY

In this wide-ranging survey cum memoir, Joyce Pomeroy Schwartz takes us through the evolution of public art from a slightly suspect activity in the 1970s to its unquestioned role as an indispensable feature of our contemporary environment. Along the way, as she documents here, art and life have continually bumped up against each other, raising questions about private responsibility, social meaning, shared and contested values, and local and national identities. One can chart the changing course of public art through a succession of triumphant works that have come to be embraced and loved by a grateful public. One can also chart its course through a series of controversies that reveal hidden fault lines in the stories we tell about ourselves. Both stories are equally valuable. As Pomeroy Schwartz maintains, conflicts can be enormously productive because they spur democratic debate, self-reflection, and a consciousness of the importance of free expression.

What shines through this inspiring story is Pomeroy Schwartz's belief in art's potential to bind us together and create a place for shared experiences. This is not as simple as it sounds. *The Private Eye in Public Art* documents the struggle involved in bringing art of the highest quality into the public sphere. When an artwork is placed in a public space, it can't rely on didactic labels, art-educated viewers, clean white galleries, or any of the apparatus that help create meaning in a gallery or museum setting. Difficulties can emerge from all directions – from sponsors who doubt the public's ability to accept challenging work, from architects and planners who seek innocuous additions to their preconceived designs, from artists who fail to adapt their ideas to the public sphere, and from viewers who misread the intent of a public work. Over the course of her long career, Pomeroy Schwartz has learned how to mediate between these different groups. As she shows here, each commission must be approached on its own terms. And even with the most delicate of negotiations, projects can lose their way.

A public artwork succeeds or fails based on its ability to engage people who encounter it as they go about their tasks. More than any other form of art, public art is woven into the fabric of daily life. In many ways this book serves as a primer on how to engage the public without simply pandering to its preconceived notions about what an artwork should look like. As Pomeroy Schwartz reveals, success in the field of public art is not about giving people what they want. It is about providing them with the opportunity to experience something they didn't know they wanted until they encountered it. To that end, she reveals here how she has learned over many years in the field to support artists while mediating between their visions and those of sponsors, architects, planners, and a sometimes-resistant public. She has been able to help artists navigate the red tape, funding struggles, local politics, and unexpected

roadblocks that hinder their projects. Perhaps most remarkably, she has proved that the public can be educated to understand and love works that engage with the most complex and sophisticated of conceptual ideas. From her perspective of fifty years in the field, Pomeroy Schwartz can look back with satisfaction at a constellation of works that have enhanced our living spaces and increased our sense of community.

But she ends this book on a disquieting note. As Pomeroy Schwartz meditates on recent battles over the disposition of Confederate monuments and the erasure of discredited historical names and disgraceful events from public (and private) space, she asks, "Does the removal of these works from the public realm – whether they are destroyed or relocated to a museum – constitute revisionist history? Is it not critical to confront the burdens of the past, however ugly?" Hanging over this narrative, then, is an uncertainty: Are the kinds of shared experiences that this book documents possible anymore? In an era of siloed social media, alternative histories, irreconcilable facts, and communal retreat into the isolation of digital life it might rightfully be asked: Do we still share a common reality? It often seems we can't even agree on even the most basic facts – about election outcomes, public health, and basic biology. Is there any way to repair our fractured sense of communal life?

This is where public art comes in. Over the last fifty years Pomeroy Schwartz has watched public art evolve to fulfill many functions: it enhances, educates, challenges, and confronts its audiences. Looking to the future, it is clear that public art will continue to serve a vital role in helping a democratic society maintain a sense of common purpose. But as society changes, so must public art. I am no seer, but I would like to suggest a couple of areas where I think public art will be increasingly important in the future.

The first has to do with environmental issues. As climate change stares us down, it is clear that rising temperatures, disappearing shorelines, droughts, hurricanes, floods, and extreme weather events will be among the biggest threats to our communal life. There is already a rich tradition of artists who have gone beyond merely decrying our environmental irresponsibility and instead have begun to formulate possible solutions to concrete ecological problems. Some of these artists work with scientists and other specialists to re-imagine how we can arrange our cities and rural areas to create a more sustainable environment. Others work with community groups to realize their goals in ways that promote flourishing social and natural ecosystems. Artists make parks of landfills, create gardens in cities, and remediate toxic wastelands. They challenge laws and boundaries that stand in the way of environmental repair. They redefine our relationships with other species. In all such activities they explore ways that we can continue to survive and thrive on our damaged planet.

In doing so, they reaffirm their confidence that there are certain values and beliefs that are shared by all human – and nonhuman – life. This, of course, is the very essence of a public undertaking.

A second area where art will play an increasingly vital role in public life involves the internet. After an initial honeymoon period in which pundits predicted that the world wide web would bring us all together in a border-free globalized community, it now is clear just how divisive cyberspace can be. Commentators continually bemoan the isolation and tribalism fomented by social media. They point out how authoritarian governments go online to manipulate their populations. They warn about the creation of a form of surveillance capitalism in which every keystroke is recorded and exploited for private gain. And they invoke the rise of new and ever-more pernicious forms of cyber-crime. Yet, while all this is true, it seems too soon to jettison all the utopian dreams that accompanied the creation of our new cyber reality. Here again, art may play an important role. If it can be wrested away from the profiteers, cyberspace can and should provide a new kind of public space. Artists are already helping define a different approach to the digital world. They use augmented reality to inject images of an alternative world into common urban spaces. They create forums for public meetings in cyberspace that provide a twenty-first-century equivalent of the traditional town hall meeting. They make data about environmental pollution, crime, or social injustice accessible at the stroke of a key. They orchestrate demonstrations and protests, undermine the private colonization of public space, and make sure that alternative voices are heard. In other words, they play a vital role in restoring the lost promise of a democratic and democratizing digital world. Again, this is the essence of a public undertaking.

Going forward, the world will continue to become ever more complex and the threats to our common reality will grow ever more insidious. Can we imagine a world without a public realm? Sadly, that is not so difficult, and in fact there has long been a thriving sci-fi industry that delivers endless versions of such scenarios. Do we have to acquiesce in these dystopian visions? Here the answer depends on the depth of our commitment to an expansive and inclusive view of the public realm. And so, we circle back to questions about art and life that have energized Pomeroy Schwartz since the beginning of her career. In its narrowest definition, public art is art that appears in a public setting. But as Pomeroy Schwartz reveals, it has the potential to be so much more than that. At its best, public art distills our dreams, desires, contradictions, and fears and refashions them into something we all can share. When such art becomes part of our public life it does much more than simply enhance our surroundings. It actually helps create the conditions that make a public realm possible. This is the promise and the continuing challenge of public art.

PROLOGUE

Visibility is never a matter of mere bulk … Nonetheless, the monument is huge, grand, vast, immense, of immeasurable moment, its aims as ambitious as god's, its effects like a laser's – intense, consuming – its scope comprehensive, its fame universal, its value supreme.[1]
— William Gass

This is a book about public art. It is about my life in public art, the fundamental convictions that fueled my passion, and the realization of major works of public art. My focus is a moment in time: when American creativity was fueled by tremendous energy, mirroring radical but optimistic shifts in our social structures, values, politics, and technology. Artists' desire to communicate with a broader audience, the decimation of our urban cores, the loosening of social mores, civil rights struggles, a new wave of feminism, the Cold War, the Space Race, and the activism they spawned converged to create a fertile field for artists' experimentation, a heightened consciousness of public space, and the power of art to inform it. It was a time of palpable and momentous change, as many artists deliberately turned from museums and galleries to explore artmaking in the public realm, their adventurous spirits challenging traditional notions of content, scale, audience, and context and propelling art in exciting and uncharted directions.

This was the world I entered in the 1970s in New York City. A relative latecomer to the professional world, I lacked experience. But my activities organizing arts events for my local Rockaway, Queens community while raising a family testified to my commitment and nurtured my convictions about the absolute value of the arts to civil society and our collective responsibility to support, encourage, and appreciate the artists who make it.

These foundational principles – that art heightens consciousness of who we are as human beings; that art is an enduring cultural statement that springs from its time and place but also bridges past and future, here and there; that art educates, challenging us to abandon preconceptions and to view the world through an unfamiliar lens; that artmaking is a constructive act; and that public art affirms democratic values – have shaped my long career.

Actively supported by the patronage of corporations, institutions, and government agencies, public art flourishes. In public spaces, we have an opportunity to live with the visionary ideas of leading contemporary artists. The forces of urban revitalization and heightened consciousness of the social effects of art in reinforcing communities have played no small part. Large-scale, purposely commissioned art has become an essential component of expansive

architectural plans for public places.

Public art is everywhere: helping to shape the identities of public spaces (whether new or revitalized places), artworks distinguish transportation facilities, urban centers, shopping malls, corporate complexes, government office buildings, and university campuses. Its ubiquity has not been without philosophical, political, and practical hurdles, but to me there is no question that the controversy and debate it spawns are healthy indicators of individuals' and communities' investment in the public realm. As Rosalyn Deutsche has eloquently written: "Conflict, far from the ruin of democratic public space, is the condition of its existence."[2] After all, public art cannot but be seen in the context of daily life.

My conviction that the public artist is a problem solver – responding to a specific question at a specific place and time – is the springboard for my thinking about the ideas and intentions expressed in individual works of art. While these works owe their existence in part to legislation – which brings with it politics, procedures, and regulatory environment – the most meaningful works of public art are made by those artists who understand scale (as opposed to size), who intelligently and sensitively parse the architectural, cultural, and historical circumstances of a site while bringing their unique conceptual approach and aesthetic to problem solving.

But if each artist brings their personal vision, is credibility then entirely relative? What are the standards for evaluating public art? Whose standards are they? Judgments are made and tested over time. Some say that the standards by which art in museums is judged do not apply to art in public places. I most emphatically disagree: art that appropriates public space must be enduring, its quality as high or even higher than art in museums or galleries. Museums can set aside weaker works; not so public art, which remains in our shared spaces, affecting us, whether worthy or not.

Contemporary artists with whom I have worked bring a committed personal sensibility to their public works. Public art is as diverse as the sensibilities and experiences of the artists who make it. Some conceptualize the grandeur and monumentality of the American landscape and at the same time honor a personal ecological awareness. Others recognize the poetry in urban industry. All have an awareness of time, place, and memory – a sensitivity to the built and natural environments. Some pay homage to Marcel Duchamp; some transform ordinary "found objects" into a personal monumentality. Still others find their inspiration in uncommon content, and create art that can be profound or playful, while expressing a witty intellectual subversiveness. Their art is truly accessible and, at the same time meaningful on several levels.

I have been extremely fortunate: I have worked with some of the great

public artists of our time and have formed enduring friendships with many. Beyond enriching my understanding of art and artmaking, each experience tested the power of advocacy and validated the role of the independent art adviser. Early on, I understood that I had to be open-minded, have an intuitive understanding and visual appreciation of art, and not be afraid of conflict and confrontation. I had to be a positive realist.

For close to fifty years, I have been interpreter – of artists to clients and clients to artists – straddling both worlds. Ultimately, I am a passionate advocate for art, for public space, for freedom of expression, and for the uncompromised realization of an artist's vision.

I am encouraged by what I have observed in recent years, and truly believe that our public art is defining a distinctly American cultural heritage. Everyone involved in the public art process, from the mayors of cities and CEO's of corporations, to community leaders, citizens, architects, art committees, and the artists themselves is acting in the interest of the public good and the greater goal of defining and perpetuating the cultural history of a city, country, or place. Ultimately, arts and culture represent the aspirations and identity of a people … And that raises questions over time.

Notwithstanding their spontaneity and creativity, artists are the most disciplined of workers, perfectionists who create for themselves without compromise. Lawrence Weschler's observation of artist Robert Irwin resonates in this regard: "In short, he is an artist who one day got hooked on his own curiosity and decided to live it."[3] The artist may reject restrictions imposed from without, yet in order to function, imposes constraints on themself that are far more rigorous. The artist's ability to question (both inner and outer) restraints to find a higher order of well-being may yet have an invaluable lesson for society.

A roadmap

This volume is part history, part memoir, part practicum. My perspective, approach, and experience are reflexive, each informing the other. The structure of this book reflects this, moving from a brief history that establishes the profusion, diversity, and importance of public art since ancient times, to my story, which begins with the rebirth of public art and revitalization of the philosophy that had driven the WPA with the establishment of the NEA, GSA, and Percent-for-Art legislation in the 1960s and 1970s.

— **Joyce Pomeroy Schwartz**, New York

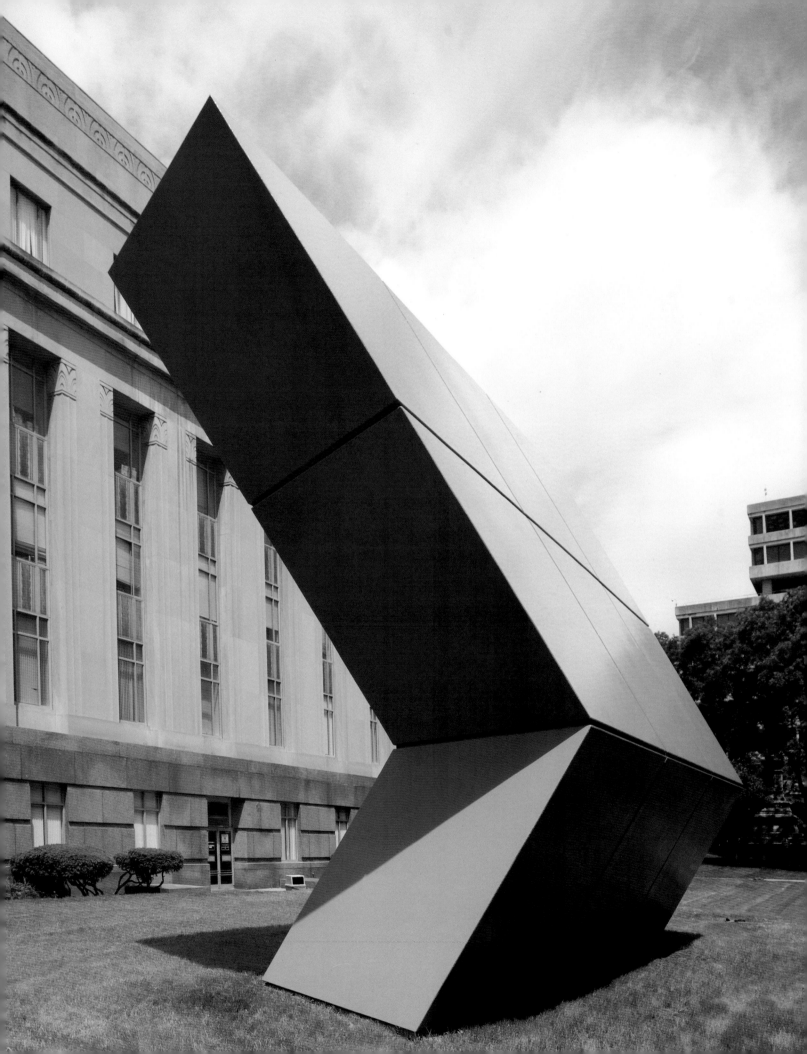

I
PROFILE

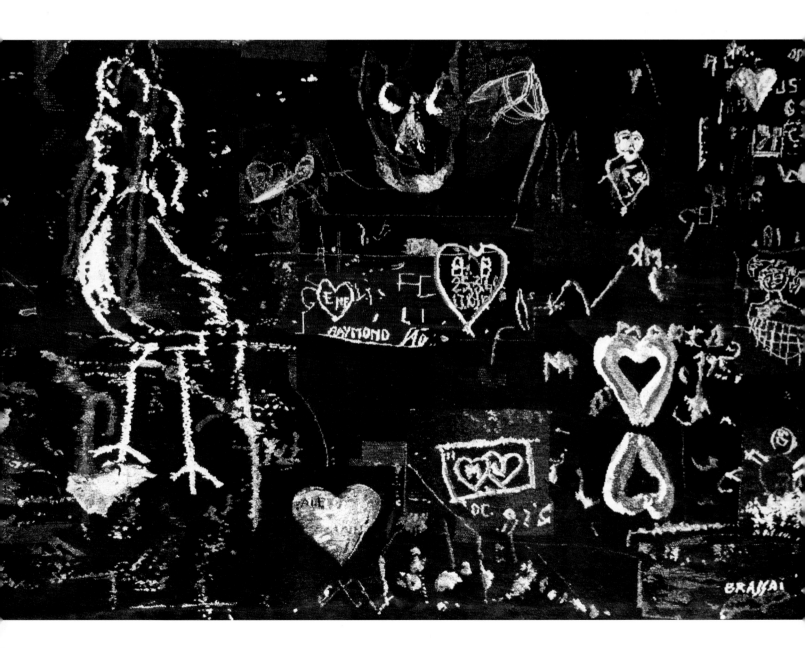

These creators, makers of the new, can never become obsolete, for in the arts there is no correct answer. [4]
— Daniel Boorstin

MY LIFE IN ART

I was born and raised in Brooklyn, New York. My father was an interior designer. My mother was a housewife, raising her children and caring for her home – a strong woman with energy, which could have been better directed if she had worked. In her eighties, she talked about the few years before she married. As a young woman, she managed a store selling handbags; as she told us often, within two weeks of work, she was made store manager. She never recovered from that early experience of being independent. I saw my mother's energy, but determined to use mine more broadly.

I wanted to live in a world of art.

Museums were my earliest art education. From the time I was eight or nine years old, my mother dropped me off at the Brooklyn Museum every Saturday. It was in that encyclopedic museum – a repository of culture and art – that I became passionate about African and Native American art. Those collections were forever imprinted on my consciousness. By the time I was ten, I was traveling by myself on the subway to the Metropolitan Museum and the Museum of Modern Art (MoMA), where I became a member in 1946 at age 18.

My interest in public art was encouraged while I was an undergraduate at Hunter College. I had painted, and I wanted to be an art major. I studied anthropology, and my visits to the American Museum of Natural History enhanced my understanding of diverse cultures. But my parents' fears (which mirrored the times) about the bohemianism of artists' lives affected me, and I received a degree in English Literature and American History instead of Art.

My younger brother, Lee Harris Pomeroy, encouraged continually by my mother, became an architect. From him I learned the importance of context in formulating an architectural solution and, in turn, about the context of public art. I was drawn to artists for their intuitive questioning, and to public art rather than easel or studio art, convinced that placing art in a public context affirms democratic values and enriches the lives of all people, whether conversant with or uninitiated in the arts.

My activities in the arts had their first public expression in the 1950s, when I was a young mother and one of several women (including Eleanor Tunick and Evelyn Mauss) who founded the Rockaway Music and Arts Council, the second such organization in New York State. Our objective was simple: to bring the arts

Page 20

Tony Smith
She who Must Be Obeyed
1975
Frances Perkins Building, Washington, D.C.

Page 22

Brassaï
Graffiti 1
1959
Collection of Joyce Pomeroy Schwartz

to people of all ages who lived in our rather remote community in New York City. I became its first Executive Director.

In the 1960s, my husband and I moved our young family to Manhattan. He opened a dental office directly across from MoMA, in Rockefeller Apartments. We later moved to the same building, and I have lived here ever since. At the time, I thought about becoming an art teacher, and received a Master of Arts degree in art education from New York University. But the social climate was changing, and public awareness of the arts was becoming more expansive. Film, video, and photography experienced a rejuvenation; many young artists began to work in those media, and students began to study them.

In 1967, a friend of my brother suggested that we open an art gallery in a brownstone he rented on the Upper East Side. I thought immediately of photography, having gone to graduate school with people who were experimenting with the medium as fine art. I was intrigued by its possibilities.

A gallery for fine art photography would be current and exciting. There was only one in New York at the time; Helen Gee hung works for sale by young photographers in a coffee shop she operated in downtown Manhattan.

I planned to emulate fine art galleries on the Upper East Side, and to specialize in the photography of major American and international photographers. This meant one-person and group shows, professionally framing all works, and having champagne openings, as serious galleries did in New York at the time.

Artists I showed were André Kertész, Brassaï, Robert Doineau, Robert Heinecken, Jacques Henri Lartigue, Ray Metzker, Man Ray, Naomi Savage, W. Eugene Smith, Edward Weston, Marc Riboud, Cornell Capa, and others known as the "concerned photographers." Capa subsequently founded the International Center for Photography, the first and still vital major museum of photography in America. I suspected the medium was going to take off, and it did. I was interested in artists who explored photography technically and those who used it as a tool to interpret reality – as an authentic art medium. The curator of photography at MoMA, Peter Bunnell, guided me on the more avant-garde photographers of the time.

We funded the gallery ourselves; my partner, Sheldon Frankel, furnished the space, I did the work, and we shared the profits. We launched with a group show, but in our second exhibition, I juxtaposed the work of just two artists, each informing the other. We paired Ray Metzker and Paul Caponigro. They loved the idea. They were of equal stature and age, having different directions. An urban artist, Metzker, was photographing the trains and streets of Chicago. Caponigro was a follower of Minor White and a photographer of nature. It was a superior show.

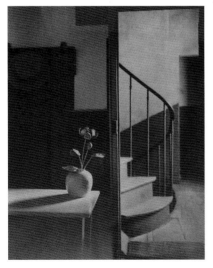

André Kertész
Chez Mondrian
1926, printed ca. 1968
Collection of Joyce Pomeroy Schwartz

Fortuitously, *New York Times* columnist Jacob Deshin reviewed the first group show. In his how-to column for amateur photographers, he often lamented the non-existence of a gallery that showed photography as fine art. His positive review led to inquiries from all over the world. There clearly was a market and appreciation for photography.

The gallery was both a critical and commercial success. Nevertheless, for personal reasons, it was short-lived. We closed in 1970. I spent a year focused on my family and thinking about next steps. I missed the independence of working, I missed being in the art world, and most of all, I missed artists, whose creative agitation and fearlessness were magnetic. I felt lost without the focus of work.

My sympathetic husband urged me to get a job – any job, even if I had to work at Bloomingdales! His encouragement was what I needed. I knew I could work well with artists and help them with their careers. For six months prior I did work at Bloomingdales, where I found out I had the unknown talent of being a good salesperson. One doesn't know their ability until tested.

It took six months of interviews with The Pace Gallery's founders Arne Glimcher and Milly Glimcher, along with Richard Solomon of Pace Prints, before they would hire me in 1972. How I arrived there was equal parts serendipity and strategy. Working at Pace was the beginning of a long and satisfying life working in the larger art world: I distinctly remember a feeling that was where I belonged. I was confident that I could make a significant contribution. The Pace founders hired me to represent The Pace Gallery and Pace Prints clients and develop new collectors in the corporate and architectural worlds.

My conviction that aesthetic worth, coupled with humanistic affect, defined art's essential value aligned perfectly with the art world phenomena that were defining a new era in public art. That and my commitment to make art accessible to a larger, more diverse public was motivation for me to define a new service at Pace, and consequently create a unique place for myself at the gallery.

In Arne Glimcher, I found an open mind. I told him that new public art initiatives by the GSA, NEA, and percent-for-art programs had potential for Pace artists, several of whom already were engaging with art in the public realm. Among them were David von Schlegell and Louise Nevelson, who became my enlightening mentors. I worked closely with them. They actively sought major public art projects. Pace also represented artists Robert Irwin, Jean Dubuffet, Lucas Samaras, Tony Smith, Isamu Noguchi, and Jack Youngerman, all of whom had a deep interest in making art for architecture and the environment. Unusual among galleries Pace cast itself as a full-service gallery, one that supported artists' studio art and encouraged them to seek major public projects. Smaller galleries found public art less feasible and more time consuming. I suggested that we find a public art site for our artists.

Ray Metzker
Nude Composite
1966, 1984
Collection of Joyce Pomeroy Schwartz

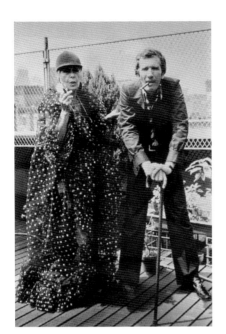

Louise Nevelson and Arnie Glimcher
1974

Always ready to embark on a new adventure and expand his gallery's reach, Glimcher pointed his finger at me and said: "Do it!" I said to Arne, if I, as a woman, were to sign my name on letters to cities and states, the recipient would assume I was an assistant or secretary. I needed a title. Glimcher agreed, and named me the Director of Commissions at The Pace Gallery. That title foretold my future.

I was off and running. As Director, I sought major public art commissions for government and corporate buildings across the country. In assisting artists with complex approvals, regulatory requirements, and community involvement, I confirmed Pace's support, something many galleries were unable to offer. I identified diverse projects for all of our artists and managed the projects to completion. I became comfortable in a complex environment of lawyers, government agencies, fabricators, materials suppliers, and of course, the committees selecting the artists.

My Pace experience was pivotal, establishing the experience and foundational precepts for my career as public art adviser. Learning the administrative side of the business was important, but most significant was being with some of the most progressive and creative artists' minds of the time. I learned more from them than from critics or other art professionals. They are the ultimate art professionals. But most importantly to me, they were my mentors, exemplars, and friends.

One was Louise Nevelson. I will always remember her defining herself as "an intuitive architect." Her gallery exhibitions were conceived as entire architectural installations, which she realized with the help of Glimcher's superior exhibition design skills. Nevelson loved to build works of monumental scale and complexity, which, for the most part, were the province of her male contemporaries.

Always a hands-on maker, she realized monumental artworks with the help of craftspeople, specifically welders at Lippincott foundry and woodworkers. In the course of fabricating her early large-scale works, she asked Don Lippincott to save the discarded metals of other artists working at the foundry. In her early work, she had assembled the detritus of construction sites and the streets to create wood sculptures; here she recycled metal scraps and conceived new works as giant trees, notably her Seventh Decade Garden.

Admirers of her work began to send discarded materials from construction sites to her studio in New York's Little Italy. Carefully categorizing and storing these fragments according to size and shape, she always had a well-organized supply of used wood for new art. She transformed her art by color; black, white, and gold. White sculptures, large or small, were often named Wedding or Dawn, black works entitled *Night* or *Shadow* or *End of Day*, and gold works designated

as *Royal*. Her words say it all: "My total conscious search in life has been for a new seeing, a new image, a new insight. This search not only includes the object, but the in-between places, the dawns and the dusks, the objective world, the heavenly spheres, the places between the land and the sea … Whatever creation man invents, the image can be found in nature."[5]

Nevelson had extraordinary energy and unparalleled openness to new ideas. She thought deeply and very personally about her art, finding her own distinctive voice early on. Her fearlessness, commitment, and attitudes about art and public space profoundly affected my later work as an independent public art adviser: it became a way of identifying visionary artists with whom I wanted to work. In addition, her extraordinary physical and emotional strength, despite her age, inspired me as a woman. An inherently shy person, Nevelson needed and demanded full attention for her art. As she matured, she developed an inimitable persona – an artist of stature and flamboyance, she became a colorful public character. She shattered preconceptions of what was considered women's art.

She understood nuances of scale and context as the keys to making great art for architecture. She always looked toward the future, forever exploring new ways to redefine and make highly individualistic artworks. Once, when I complimented her on her newest gallery installation, she immediately countered, "Darling, wait until you see what I am doing for my next show."

Her confidence in the value of her distinctive vision and the intensity of her interest in the ever-new directions her art concepts developed were contagious. I began to understand accomplished artists' conviction that their art was worthy of the full attention of the world – a positive and meaningful form of narcissism. While this self-absorption may have had negative repercussions in families or among artist friends, I considered it forgivable because these artists gave so much to the world of art.

Another significant mentor for me was David von Schlegell. He made monumental sculptures primarily in stone and steel. He was among first of the sculptors to be recognized for site-specific art. Von Schlegell taught me about the relationship between form and technique, about the fabrication of large-scale sculptures in diverse and appropriate materials. He doggedly pursued his personal aesthetic vision for specific architectural or landscape sites, employing diverse imagery that reflected his personal affinity with the vocabularies of engineering and industry. He carefully selected stone quarries and fabricators of specialty metals. The owner of one specialty metal factory in Queens, New York invited him to spend six months making his art in the factory "to inspire workers to take their craft to a more poetic level."[6] Here was an obvious lesson that was proven to me time and again: industrial craftspeople and sculptors were mutually appreciative of each other's skills.

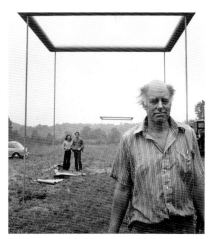

David von Schlegell
Untitled
1972
(Installation view with von Schlegell, 1972)
Storm King Art Center, NY

Similarly, he collaborated with architect Harry Cobb (I.M. Pei & Partners) on monumental sitework for Harbor Towers Apartments on Boston's waterfront, completed in 1972. Von Schlegell told me: "The buildings came first, and I adapted to what was given, but Cobb involved himself in my choices, and I responded to his thoughts. He rejected my first proposal. It was a mistake, and I will always be grateful for his insight."[7]

As Director of the Master Class in Sculpture at Yale University, von Schlegell announced to each new class: "I am here to do my own work. You do yours, and at times we will come together to critique each other's art constructively."[8] His goal was to encourage student artists to cultivate their own personal vocabulary and perspective. Significantly, he selected his students, identifying those whose intellect and drive would make them important mature sculptors. He was a legend to his students. One of them, artist Kristin Jones, reminisced with me: "David spoke to me as a colleague. He was deeply invested in his thinking about his work. There was the sense of a shared adventure into the experiment of making of making form, of daring to be an artist, of not knowing, and working to see."[9]

Pace artists Tony Smith, Robert Irwin, and Jack Youngerman defined an individual approach to art for architecture and landscape. They mentored me along with von Schlegell and helped me to establish the demanding criteria by which to assess whether an artist was capable of making a meaningful contribution to a public place.

A great minimalist sculptor and influential art teacher, Tony Smith made sculptures whose forms shaped the spaces they filled. For him, the true measure of a work was its ability to transform its place. Lauded by art critics, the scale and complexity of his forms, which appear minimal, are transformational to architecture and landscape sites. His oft-cited statements about his sculpture *Die* speak to intentionality and precision: When challenged about the apparent arbitrariness of its size, he famously declared that if it were larger, it would be a monument, and if it were smaller, it would be an object, neither of which he set out to make. He accomplished few permanent public works, although his teaching and museum exhibitions influenced the entire field.

Smith's proposal for a public high school in Staten Island confirmed a radically new direction in his art. But the architect chose another artist's predictable polished-steel abstract sculpture rather than destabilize client expectations. Although Smith died shortly thereafter, having never developed his new aesthetic vision, the unrealized work is a valuable window into his intentions and likely trajectory.

Isamu Noguchi considered himself a revolutionary public artist; his first public commission, a powerful bas-relief sculpture, was the result of an open

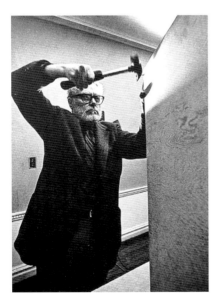

Tony Smith in studio
1970

competition in 1938 for the facade of what was then the Associated Press building at Rockefeller Center. Early on, he also created maquettes for projects ranging from children's playgrounds to stage set designs. Noguchi has been emulated often but never surpassed in his understanding of scale, siting, and materials. The conceptual edge in his work, which was inspired by modern industry, was tempered in his strong sensitivity to natural materials.

He often spoke of his disappointment in not having realized many public projects he had conceived – particularly playgrounds for New York City. I remember many conversations with him about those playgrounds he and architect Louis Kahn designed in the 1960s. Their efforts to build a landscape for children in Riverside Park in Manhattan were frustrated by political realities just as Noguchi's earlier proposals had been. But in Atlanta in the mid-1970s, Noguchi found a welcoming environment and created Playscapes in Olmsted-designed Piedmont Park. (In the same city, Vito Acconci was not so lucky: in 1985, the city rejected his *Pink Playground*, which was not only satiric but seems to have foreshadowed gender equity issues of our current era.)

The Noguchi Museum he established on the site of his former studio in an industrial section of Long Island City, enables us to appreciate his enormous contribution. His museum may have inspired the sculptor Mark di Suvero to create an open-air museum for emerging artists, Socrates Sculpture Park, on property adjacent his studio. Where in Europe, museums established by or for individual artists are common, few American artists have their own museums.

After ten years working with mentor-artists at Pace and with the encouragement of Arne and Milly Glimcher, I left to found my own company as an independent public art consultant and curator of art in public places: Works of Art for Public Spaces Ltd. My rationale was simple: I was anxious to recommend artists, in addition to those represented by Pace, for public commissions. I also wanted to travel the world seeing great public art and meeting international artists. In a way, I had come full circle: orchestrating access to artists and the arts for a larger public as I had as Director of the Rockaway Music and Arts Council.

I had clearly found my niche. I was passionate about public art, and I wanted to immerse myself in its future. I was excited to be able to consider any artist. Being independent meant I would not be limited to working only with the artists connected with a gallery. I was a free agent, the definition of a consultant. I am very proud of having been uncompromising in the selection of artists and having made a successful business.

In 1979, while still at Pace, I arranged an interview between Louise Nevelson and Lila Harnett, an art critic for *Cue* magazine. Lila and I had become friendly. She mentioned that her husband, a magazine publisher, regularly met

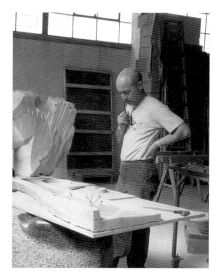

Isamu Noguchi working on a model for Riverside Park Playground
1963

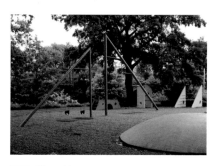

Isamu Noguchi
Playscapes
1976
Piedmont Park, Atlanta, GA

Vito Acconci
Pink Playground
1983

informally with a group of businessmen in diverse fields, who discussed their singular professional issues. She was convinced that such a forum would be good for women in the art world. She suggested that women in different arts-related endeavors should talk and share experiences. Together, and beginning with only eight professional women, we established ArtTable. I was on the first board and continue as an active participant. I helped celebrate ArtTable's 40th anniversary as a major national organization.

The idea was to nurture ArtTable as a small network of art professionals, but predictably, each of us knew someone who wanted to join. The group quickly expanded to more than thirty women. We met in our own homes. Although America was experiencing a second-wave of feminism, ArtTable was created as an organization with a professional, rather than a feminist mission. Its goal now, as it was then, is to give women in diverse art fields the opportunity to share their unique work experiences and encourage them to move into other art professions.

ArtTable has evolved over time and expanded its reach. The organization currently has over twelve hundred women members across the country, with several regional branches. It has to an extent traded intimacy for professional impact. Although apolitical in intent, the organization boldly condemned Jesse Helms's assault on the National Endowment for the Arts. Its annual awards program has honored art historians, philanthropists, museum and gallery directors, beginning with Kitty Carlisle Hart, and including Iris Cantor, Marion Goodman, Agnes Gund, Lucy Lippard, Linda Nochlin, Emily Rauh Pulitzer, Lowery Stokes Sims, and others.

Over the years, and particularly in light of the distance traveled by women in the workplace, I have thought a lot about the place of women in the art world – artists, gallerists, consultants. Female artists have suffered the fate of most talented women through history: overlooked and marginalized out of the collective consciousness by historians, critics, journalists, or their male counterparts. The exceptions are relatively few. During the period of my greatest activity, women who today are most celebrated among conceptual and land artists were considered secondary to their male contemporaries, even when those contemporaries were their husbands – notably Nancy Holt and Robert Smithson.

Admittedly I was not operating from a feminist platform: my selection of artists had everything to do with advancing artists, no matter their gender, capable of making meaningful and enduring art at a scale appropriate to the public space. I was convinced of the community-building and healing power of art, but selecting specific works of art to critique or remedy social or political dissonances was not my intention. I was delighted to see "Women Land Artists

Randy Rosen, Clementine Brown, Lila Harnett – Founder of ArtTable, Joyce Pomeroy Schwartz, and Carol Morgan

Lowery Stokes Sims, Leslie King-Hammond, Dorothee Peiper-Riegraf, and Joyce Pomeroy Schwartz
2011

Get Their Day in the Museum" by Megan O'Grady in *The New York Times Style Magazine* of November 21, 2018.[10] Recognition of many is long overdue.

While major museums, by and large, continue to select men as directors, gallery owners often are women. Notable among the pathfinders are Grace Borgenicht, Terry Dintenfass, Virginia Dwan, Peggy Guggenheim, Martha Jackson, Betty Parsons, Virginia Zabriskie, Edith Halpert, who years ago established Grand Central Galleries, and Bertha Weill in France, the first woman gallerist to show Picasso and Matisse. They constituted a force for contemporary art and have had an outstanding role in developing the art system in America. This has not been emphasized enough. (Positively, women are beginning to become directors of museums: Marcia Tucker (the founder) and later Lisa Phillips at the New Museum of Contemporary Art, Wilhelmina Holladay (the founder) and Susan Fisher Sterling at the National Museum of Women in the Arts, Claudia Gould at the Jewish Museum, Jordana Pomeroy and formerly Dahlia Morgan at the Frost Museum at FIU, Melissa Chu at the Hirschhorn Museum and Sculpture Garden, Anne Pasternak at the Brooklyn Museum, Lynn Gumpert at Grey Gallery in New York, Ann Philbin at the Hammer Museum in Los Angeles, Thelma Golden and formerly Kinshasha Holman Conwill and Lowery Stokes Sims at the Studio Museum in Harlem, Kathy Halbreich and then Mary Ceruti at the Walker Art Center in Minneapolis, Anne d'Harnoncourt at the Philadelphia Museum of Art, and others.)

The major big business galleries – Gagosian, Hauser & Wirth, Marlborough, Pace, David Zwirner – are still male-dominated. For the most part, galleries owned by women have not attained the highest levels of business. The great exception is Marion Goodman: her publication, *Multiples*, showcased the work of leading artists, and when she later established her legendary gallery, it became one among the six most prestigious in the world. I do not pretend to have the answers, but I hope that we soon arrive at a point where systemic obstacles are eliminated.

Life is about continual growth, and I leave myself open. There is no question that I'm still evolving, even entering my tenth decade. A wonderful thing about being in the art field is that like life, it is continually changing. If you are open, you can move into new or different areas. I enjoy change. It's part of my personality. In addition to selecting artists for public projects, I began to curate shows of large-scale works of art in public places and galleries. Public art continues to be my focus, but my reach has expanded and diversified. Changing focus and expanding and creating new professional opportunities are essential in the arts and have characterized my endeavors.

It has been, and still is, a great life.

View of Rockefeller Apartments from MoMA Garden
2022

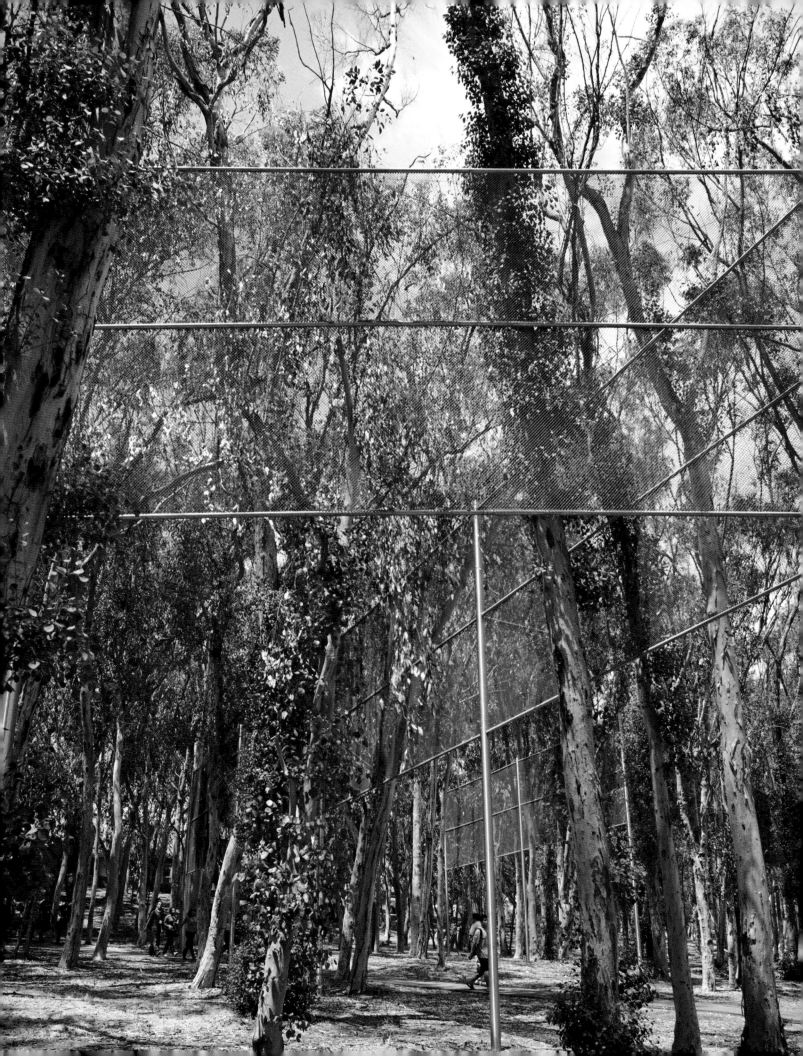

II
PERSPECTIVE

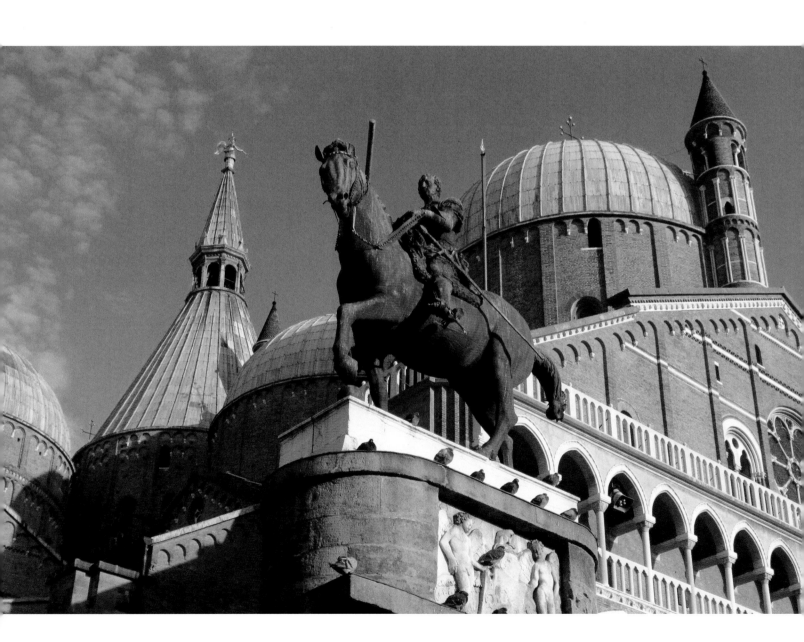

The term "public" signifies the world itself, in so far as it is common to all of us …
It is related to the human artifact, the fabrication of human hands, as well as the
affairs which go on among those who inhabit the man-made world together …
If the world is to contain a public space, it cannot be erected for one generation
and planned for the living only; it must transcend the life-span of mortal men.[11]
— Hannah Arendt, *The Human Condition*

HISTORY

This volume does not pretend to be a comprehensive history or academic
critique of public art: many admirable histories have been written – by art
historians, leaders of government agencies charged with the promotion and
stewardship of public art, and independent consultants. This is my story.

I have had meaningful relationships with the contemporary artists I cite
and whose works illustrate my convictions about public art. They have been
mentors, associates, and friends. I wish I could say that I have completed
projects with all of them, but realistically, one has only so much time.

At the approximate midpoint of my career, editor Joseph Wilkes invited me
to write a chapter on public art for a multi-volume *Encyclopedia of Architecture.*[12]
The profusion and diversity of art in public places from ancient times provided
the historical backdrop for my focus on the evolution of public art in the United
States. I suggested that public art offered the unique cultural legacy for a
complex and diversified nation.

Beginning tentatively in the late 1960s, just as I was launching my career,
the United States General Services Administration (GSA) and the National
Endowment for the Arts (NEA) resuscitated imperatives of the Depression-era
Works Projects Administration (WPA). The program had lost its vitality and
all but disappeared in the years immediately following WWII. The GSA was
both building owner and art patron; the NEA provided incentives by officially
promoting art as a positive contributor to the health of communities, the
renewed urbanization of cities, and the general well-being of America. Percent-
for-art legislation, initially the province of the federal government (already
widespread in Europe), was adopted by states, counties, and cities throughout
America. This excitement about the promise of art in public places coincided
with the burgeoning conceptual art and environmental art movements and
contemporary artists' growing desire to move beyond the gallery and museum
spheres.

I described public art's powerful role in illuminating the majesty of
America's spectacular landscapes, threats to our natural environment, and the

Page 32

Robert Irwin
Two Running Violet V Forms
1983
Stuart Collection, UC San Diego, CA

Page 34

Donatello
Equestrian Statue of Gattamelata
1445–53
Padua, Italy

contribution of the arts to placemaking and the revitalization of the nation's cities, many decimated by urban flight and the rise of suburbia.

Corollary to governments' embrace of public art as enhancing the experience of our shared public places, individuals, museums, corporations, and developers underwrote art in public places. While their motivations differed widely – from commercialism to enlightened stewardship, from self-aggrandizement to altruism – and the audiences ranged from universal to specific, their efforts have contributed to the creation of a distinctly American cultural identity with emphasis on public inclusion and the social dimension of art.

Since the *Encyclopedia*'s publication (1989), public art has further evolved, with environmental responsibility and social relevance its dominant themes. Public art programs have proliferated at the federal, state, and local levels. Further, the wisdom of engaging a professional public art adviser to manage the artist selection process, integrate the needs of the artist and all participants, and preserve the integrity of the art and artist has been proven time and time again.

Needless to say, these developments have meant a great deal to me personally: I was part of this wave. Most importantly, the sheer numbers and variety of projects evidence a profound awareness and acceptance of the value of art to our communities and to our identity as a nation. I am delighted that public art consulting is a recognized profession and that its ranks have swelled. I am a proud member of the Association of Professional Art Advisers (APAA), founded in 1980 with a mission to establish standards of excellence and professionalism in the field.

Many art museums large and small have opened across the country, bringing artists and diverse art to local communities. Contributing to the transformation of towns built on and formerly dependent on industry, abandoned factories have been repurposed as arts centers of all kinds. A most recent example is The Legacy Museum: From Enslavement to Mass Incarceration, which occupies a former warehouse in Montgomery, Alabama and is the companion to the open-air National Memorial for Peace and Justice. Small signature museums have become central to cities' identities; a case in point is the positive impact Crystal Bridges has had on Bentonville, Arkansas. Kansas City's Nelson-Atkins Museum of Art has developed into a major encyclopedic museum for the Midwest. In New York, the Studio Museum in Harlem has long had a vibrant world-class program, bringing great works to both the museum and neighborhood public spaces, notably Marcus Garvey Park. Cities with permanent works of public art by renowned artists have become de facto arts destinations.

Whether public art remains relevant in America despite current shifts in

Judith Shea
Storage
1999
Nelson-Atkins Museum of Art, Kansas City, MO

Hank Willis Thomas
Raise Up
2016
National Memorial for Peace and Justice,
Montgomery, AL

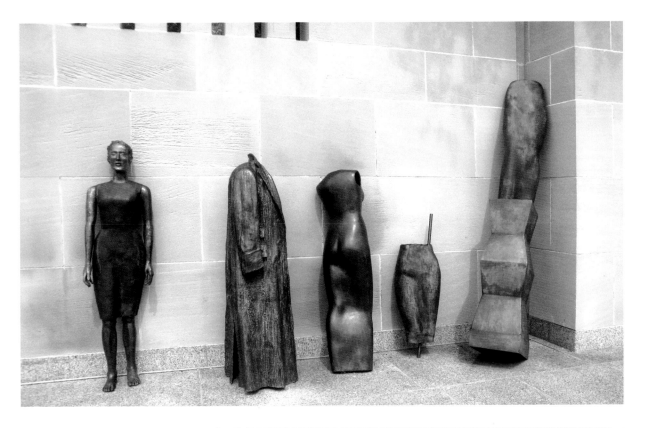

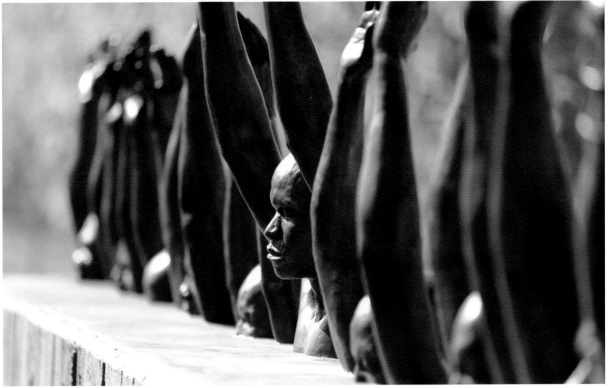

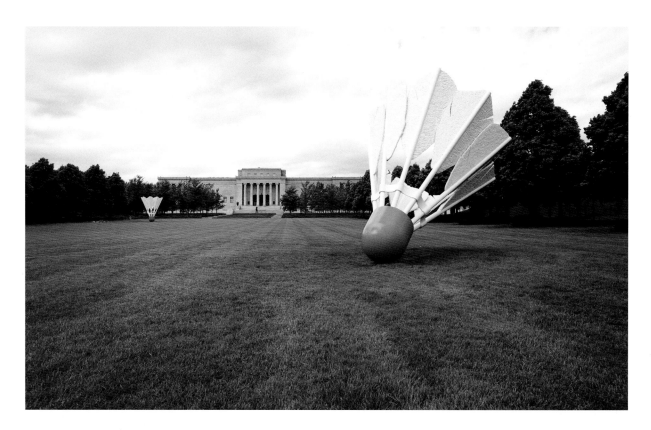

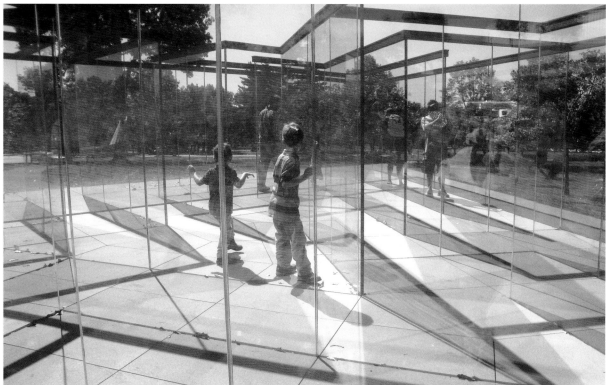

urban and suburban development is a question. The arts have demonstrably and positively impacted small towns and cities as they have become unique destinations for residents, visitors, and tourists. However, as big businesses choose thriving cities for their expansion rather than spur the renaissance of suffering urban centers – e.g. Amazon and Google in New York City – can we turn to the arts, including specialty and private collectors' museums, to revive languishing cities and towns across America?

The arts are vulnerable. Federal support for arts programs, including the NEA, has ebbed and flowed predictably through administrations. As the twenty-first century matures, I am well-aware of challenges facing the arts today, including what is most certainly a cultural vacuum in Washington. The arts have been seriously undermined by administrations that would cut funding dramatically, effectively denying their power and value to civil society. Notwithstanding, I am hopeful that the ignorance, shortsightedness, and lack of generosity underpinning efforts to limit or eliminate federal funding for the arts represent temporary aberrations.

Over the course of the last few years, as I contemplated telling my story, I have asked myself why I was attracted to the field, who inspired me, what I accomplished, how I did what I did, why the period was so momentous. I reread the *Encyclopedia* entry and was gratified to find that though my convictions about the value of public art, its power to shine a light on who we are as human beings, and its role in building or reinforcing community and rejuvenating public space have matured, they have not essentially changed.

Claes Oldenburg and Coosje van Bruggen
Shuttlecocks
1994
Nelson-Atkins Museum of Art, Kansas City, MO

Robert Morris
Glass Labyrinth
2013
Nelson-Atkins Museum of Art, Kansas City, MO

What Makes Art Public?
A Short History of Public Art

Freed from the "inhibiting authority" of a museum, art works viewed in larger context are open to greater public scrutiny and debate.[40]
— John Beardsley

Rooted in a specific place and time, art nevertheless speaks across time, space, and cultures. It is at once the personal vision of a creative imagination, which is grounded in time and place, and an expression of our shared humanity. That some art is representational, some conceptual, some decorative, some abstract underscores its affective power. To acknowledge that at least as early as the ancient Greeks, art's importance has been debated but at the same time, to assert that it communicates is not inconsistent. Art stirs our emotions and spurs our imagination: it inspires, evokes joy and humor and outrage and despair. It is the artist's commentary on the world they encounter; it tells a story, causes us to see things differently, to question, and to confront another perspective, whether the intentions underlying its creation are education, enlightenment, protest, propaganda, or decoration.

What makes art public? Its placement in our common space is an important, if obvious, characteristic. But defining public art as art in a public place is simplistic, failing to recognize the deeper meaning of public and the attendant obligations. Public art implies accessibility both literal and metaphysical; it transcends temporality; it suggests community and shared narratives, experiences, and responses. It is for everyone. It is not elitist. It is environmental, architectural, functional, monumental, commemorative, and communicative. Public art has demonstrable and enduring value to society. Its affective power is realized most intensely when it is made by artists who understand scale, proportion, and durability of materials and whose personal vision drives them to shape space rather than simply to fill it.

Public art has existed in different forms from antiquity to the present day according to the needs and aspirations of the culture producing it. We have only to look to cities whose identities are bound to their art – among them Florence, Rome, Barcelona – to understand the historical significance of public art. Public art intends to communicate with a diverse audience. Works in public places are experienced by those who are educated in the arts and those who are not, those who seek it out and those who stumble upon it. Criteria for its publicness are continuous accessibility and siting in an architectural or landscape environment such that it creates a powerful sense of place for all.

Notwithstanding the preponderance of sculpture in public places,

terra-cotta and stone reliefs, frescoes, murals, and architectural ornament have equally rich histories. The enduring universal languages of sculpture and painting reference the forms of nature, geometry and, more recently, technology. Hills, valleys, plants, air, and water have inspired artists to create personal statements and express a point of view. The power of art and design to communicate ideals and beliefs can be seen in the pyramids in Egypt and Mexico, and the architecture and ornamentation of Carolingian and Gothic cathedrals.

Gardens that contain art and are used as public and private places of pleasure may have had their origins in sacred groves consecrated to a spirit or divinity; there trees, rocks, and water typically surrounded a shrine or an altar in a temple, grotto, or cave. Perched on a cliff over the falls of the Arno River near Tivoli, the Temple of the Sibyl (first century BC) was frequently imitated in European gardens.[14] In Roman times, statues of deities were valued both for their aesthetic qualities and their mythical powers: a statue of Priapus was placed in a garden to frighten elves, birds, or mischievous youths; Plautus wrote of gardens watched over by Venus; sculptures of Terminus marked boundaries of states and rural properties. Pliny described the carefully arranged arbor, colonnade, or walkway that offered a sunny promenade in winter, shade in the heat of summer, and a variety of views as one moved along the walk. Such an idea references the peripaton, the walk or promenade of the Greek garden. To this day, public art marks intersections, terminates vistas, identifies focal points, animates promenades, and directs movement.[15]

In classical Greece, the best art was public. Religious and political masterpieces of art and architecture were produced at public expense for the edification and pleasure of the populace; both the wealthy and the destitute had access to visual and performance art. Theater was free, and the agora and the temples of the Acropolis were accessible; statues of Greek heroes and narrative sculpture programs stood as profound statements about the values and belief systems of Athenian democracy. Citizens of Greek city-states regularly commissioned artists to adorn their cities. In a formal oration after the Peloponnesian Wars, Pericles declared that beautiful Athens should be a model for other city-states. It is not a stretch to imagine that America's WPA public art program and the more recent efforts of the GSA and the National Endowment for the Arts are analogous to egalitarian access to culture in ancient Greece.

Historically, patronage resided with the church, royalty, government, and wealthy families, who commissioned the many examples of art in public places in Europe, Asia, and America. The Renaissance reintroduced the concept of secular public art, often intended to glorify the wealth of a patron or the status of a city or to honor the memory of a ruler. In his *Gattamelata*, placed

in a public plaza, Donatello invoked the symbolism of equestrian statues of antiquity to elevate the memory of a mercenary who had fought for Venice. Italian Renaissance gardens are filled with sculpture and water features. At the Villa d'Este, an extravagant array of jets, sprays, and streams from at least one hundred fountains, tranquil fishponds, and statuary create one of the most exuberant water gardens ever.

In the seventeenth century, French landscape architect André Le Nôtre designed formal gardens for the monarchy, including the Tuileries, Versailles, and Vaux-le-Vicomte. Today, they are grand public places distinguished by terraced parterres that relate to buildings on the site. Beyond are paths, typically terminated by a fountain or statue on a pedestal. Aviaries, waterworks, and ornamental statues are placed in balanced, symmetrical patterns. Versailles was conceived as an extensive water garden, where Bernini created its greatest fountains.

With the Arts and Crafts movement of the nineteenth century and Wiener Werkstätte (begun in 1903), de Stijl (1917–1931), and the Bauhaus (1919–1933) in the first half of the twentieth century, came an interest in the industrial and decorative arts and the impulse to integrate art and architecture.

Maren Hassinger
Monuments
2018
Studio Museum Harlem, New York, NY

An American Public Art Evolves:
The Rise of an American Cultural Heritage

*The monument in America has often had quite a different function from its
European models. Its outlook, even when it is a carbon copycat, is opposite.
For us, the present, not the past, was the great tense, and space was the arena
of action. For us, moreover, the present had only a forward face. We were
concerned to celebrate what was soon to be; to designate the place we would
occupy, would settle, next. We did not tend to define ourselves so much in
terms of ancestry as in the looser terms of our dreams. The Statue of Liberty is a
monument of welcome and promise: it says that you may start fresh here.*[16]
— William H. Gass

*The core American idea is not the fortress, it's the frontier. First, we thrived by
exploring a physical frontier during the migration west, and now we explore
technological, scientific, social and human frontiers. The core American attitude
has been looking hopefully to the future, not looking resentfully toward some
receding greatness. The hardship of the frontier calls forth energy, youthfulness
and labor, and these have always been the nation's defining traits. The frontier
demands a certain sort of individual, a venturesome, hard-working, disciplined
individual who goes off in search of personal transformation ... Americans have
always admired those who made themselves anew.*[17]
— David Brooks

Since the nineteenth century, not only have public and private sponsorship
and funding for public art in America and Europe experienced a dramatic
expansion, but expectations have changed significantly. In colonial America,
commemorative statues, obelisks, and stelae emblazoned with names of war
heroes marked town centers; gazebos functioned as bandstands. Public art was
associated with the memory of events or people: the man-on-a-horse or figure
on a pedestal – the archetype of the nineteenth- and early twentieth century –
signified the importance of the public square or town center as both the literal
and metaphorical shared space of the community. Commemorative value was
underscored by visibility and accessibility and an implied shared narrative.
Following this model, in the twentieth century, World War I cannons often
marked the lawns of town centers.

Public art evolved beyond the monument: Frederick Law Olmsted and
Calvert Vaux deliberately and artfully transformed the natural environment with
their landscape designs. Their meticulously designed parks suggested harmony
of nature and the city. Further, their parks were "treasuries" of neoclassical

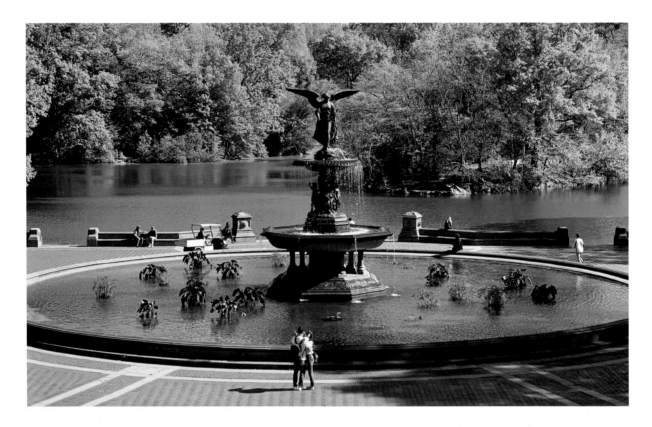

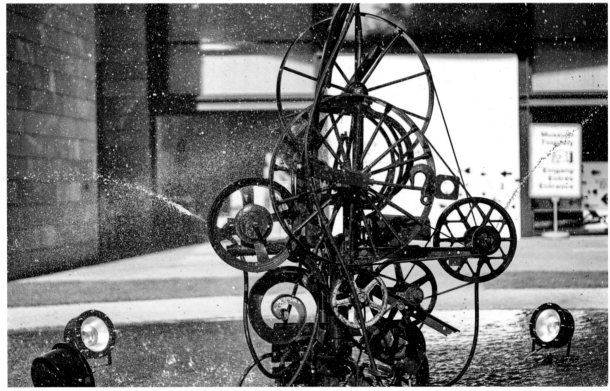

sculpture, fountains, and formal public spaces, including allées of trees, natural lakes, cottages, rustic loggia, seating, and bridges. Central Park's centerpiece, Bethesda Terrace, functions like a grand public living room. The focal point of its great fountain, *Angel of the Waters*, is the only sculpture commissioned as part of the original park design.

Nevertheless, much of the population viewed art with suspicion – as elitist and refined, incompatible with the raw individualism of the American frontier mentality. It was not until the Great Depression and FDR's creation of the Works Progress Administration (WPA) in 1935 (renamed Works Projects Administration in 1939) as a practical emergency support program for the nation's artists that a large body of public art emerged. Artists, like everyone else, were suffering: the WPA program provided employment. Art in public places was the byproduct, and the public the beneficiary. Harry Hopkins, who FDR put in charge of work relief, said of artists, "Hell, they've got to eat just like other people!"[18]

Professional artists, young and old, created grand public murals and sculptures in public buildings across the United States. The talent and skill of the commissioned artists and the caliber of their art are truly remarkable. It was not universally beloved or necessarily understood. Louise Nevelson, Arshile Gorky, James Brooks, and Willem De Kooning, among many now important artists, launched their careers, enhanced buildings, and introduced a broader public to art in their scenes and symbols of America on walls in hospitals, post offices, courthouses, schools and universities, airports, and train stations. In his 1973 report to Nancy Hanks (chair of the Arts Endowment), Irving Sandler stated: "Public art is not yet considered a category or a tendency in contemporary art … However a considerable number of artists are thinking consciously about the potential of a public art … significant part of contemporary art lends itself to exhibition in public places … and artists are aware of this."[19]

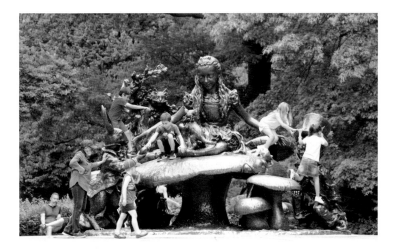

Page 44

Emma Stebbins
Angel of the Waters
1873
Central Park, New York, NY

Jean Tinguely
Schwimmwasserplastik
1980
Tinguely Museum, Basel, Switzerland

José de Creeft
Alice in Wonderland
1959
Central Park, New York, NY

Public Art in the Twentieth Century/Sources of Art in Public Spaces: 1960s–today

It is the land itself which is monumental: its canyons, prairies, deserts, national parks. The countryside measures our history like a sundial. We visit the future by driving west. We can afford to turn an entire battlefield, with all its valuable acreage, into a memorial. At Gettysburg, Lincoln reaffirmed what was no longer so securely true: the nation's commitment to the future. [20]
— William H. Gass

In America, cubism, constructivism, and environmental site-specific sculpture defined the context in which artists of the mid-twentieth century came of age. Galleries and museums held performances and resurrected photographs of work no longer in existence, sparking memory. Art and technology were celebrated as public events. In 1960, the Swiss artist Jean Tinguely built an elaborate machine that self-destructed in the open garden behind the Museum of Modern Art in New York, challenging the permanence of the physical object. (Ironically, Tinguely's works are now in the Museum's permanent sculpture collection.)

My own experiences with Jean Tinguely forever changed my receptiveness to all forms of the arts, including video, film and performance. Tinguely, after creating his work at MoMA and constructing a work in Columbus, Indiana, vowed never to work in America again. In my naiveté, twenty years later I called him about the possibility of creating a public project in New Orleans. We corresponded; he finally sent me a "letter" (actually an artwork, a drawing of his fountain near Saint-Merri created with Niki de Saint Phalle) with a note on the back telling me not to call him on the telephone, only to write, and asking how much the honorarium would be, in dollars. That work never came to be, but he did break his vow for his final work *Cascade*, in Charlotte, North Carolina.

The monumental social, political, and cultural upheavals of the 1960s put a new face on the First Amendment, civil disobedience, and ownership of the public realm. Counter-culture artists of the 1960s and 1970s challenged the museum's hegemony and its relevance to conceptual art.

Having moved beyond "art for art's sake" into conceptual and environmentally and socially relevant art, liberating themselves from the strictures of galleries and museums, and rejecting heroic art or art-as monument, artists claimed the country's varied, vast, and powerful landscape. It captivated, inspired, and would define artists as distinctly American. Nature and grand spaces – the "god-made art" of white sand beaches, high deserts, Rocky Mountains, expansive prairies and forests – were fertile ground for the articulation of an American aesthetic.

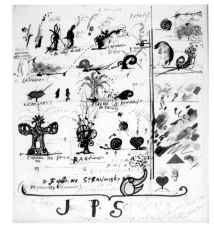

Jean Tinguely
Project sketches for "Fontaine Stravinsky: les 74 premiers éléments" with letter to Joyce
ca. 1985
Collection of Joyce Pomeroy Schwartz

In 1962, Rachel Carson's *Silent Spring* launched an environmental awakening, shining a light on the powerful – and sadly, often negative – impact human beings have on the natural world. Finding inspiration for both form and content in the physical character, archaeology, and socio-historic context of a site, and in many cases, in reverence for the grandeur of the Western frontier, artists followed suit, dramatizing our collective obligation to preserve limited resources and safeguard the future of our planet.

Robert Smithson was a great champion of reclamation art and earthworks. His appreciation of natural wonders, his awareness of their potential devastation by industry, and his critique of the thoughtless misuse of American resources brought artists and scientists together in common cause: "My own experience is that the best sites for 'earth art' are sites that have been disrupted by industry, reckless urbanization, or nature's own devastation … The Spiral Jetty is built on a dead sea, and The Broken Circle Spiral Hill in a working sand quarry. Such land is cultivated or recycled."[22] *Spiral Jetty* became symbolic of this environmental consciousness: articulating a vision of the American landscape and transforming it into art, Smithson shined a light on both its richness and its vulnerability. And in the Utah desert, artist Nancy Holt, his wife, created *Sun Tunnels*, a paean to the power of the sun and stars.

Virginia Dwan, noted gallerist known as a "Jet Age Medici," backed the new medium of land art. "When Robert Smithson wanted to work on the shores of the Great Salt Lake, her encouragement and funds led to his landmark *Spiral Jetty*. On a plot in Arizona, she commissioned Walter de Maria's first version of his great *Lightning Field*. She began to finance Charles Ross's *Star Axis*, a stellar observatory of sorts, still in progress today on a mesa in New Mexico."[21]

The land art of these artists and others – such as Agnes Denes (*Tree Mountain*, *Wheatfield*), Michael Heizer (*City*, *Double Negative*) and James Turrell (*Roden Crater*) – anticipated the functional and accessible public art of the 1980s, whose large scale, material quality, and energetic forms depended upon an understanding of engineering, construction, architecture, and landscape design. Urban contexts supplanted the rural sites preferred by artists of the 1960s and early 1970s. Many of these artists – Alexander Calder, Robert Irwin, Claes Oldenburg, and Jackie Ferrara among them – trained their intentions on the revitalization of urban centers, which had been decimated by post-war urban flight and suburbanization. Artist Patrick Clancy, co-founder of Pulsa, recognized that the concept of art was expanding: "Today there are many small centers where people meet, live and make art and achieve new levels of consciousness. Art is becoming an increasingly integrated part of life."[23] That said, shaping the built environment entailed the responsible participation of governments at all levels.

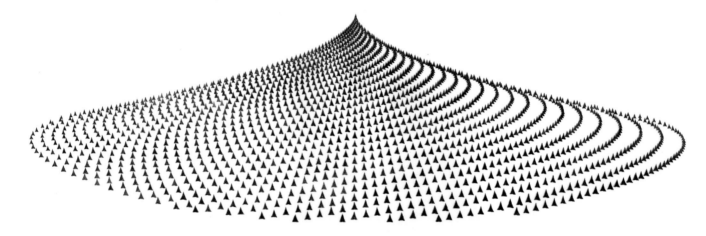

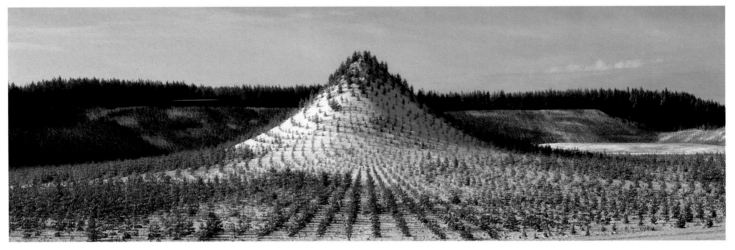

Agnes Denes
*Tree Mountain - Proposal for a Forest – 1,5 x 1,5
miles – 11,000 Trees;
Tree Mountain – A Living Time Capsule – 11,000
Trees, 11,000 People, 400 Years*
1983, 1992–96
Ylöjärvi, Finland

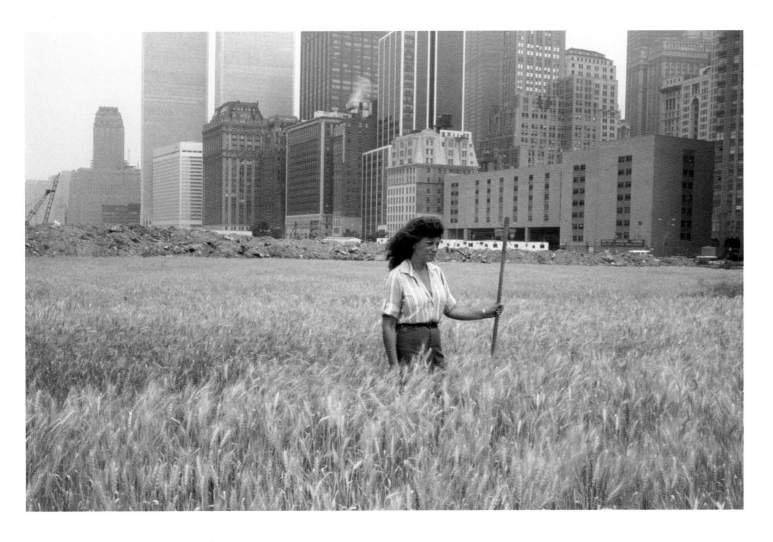

Agnes Denes
Wheatfield
1982
Battery Park landfill, New York, NY

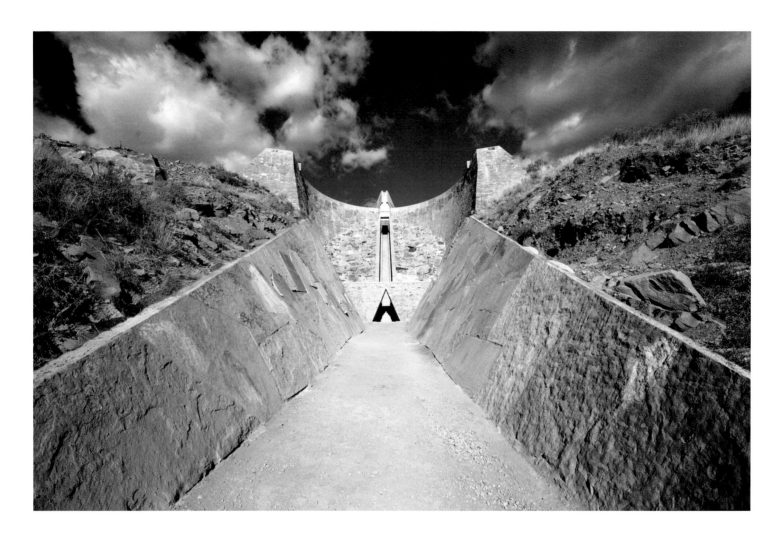

Charles Ross
Star Axis
1971–
New Mexico

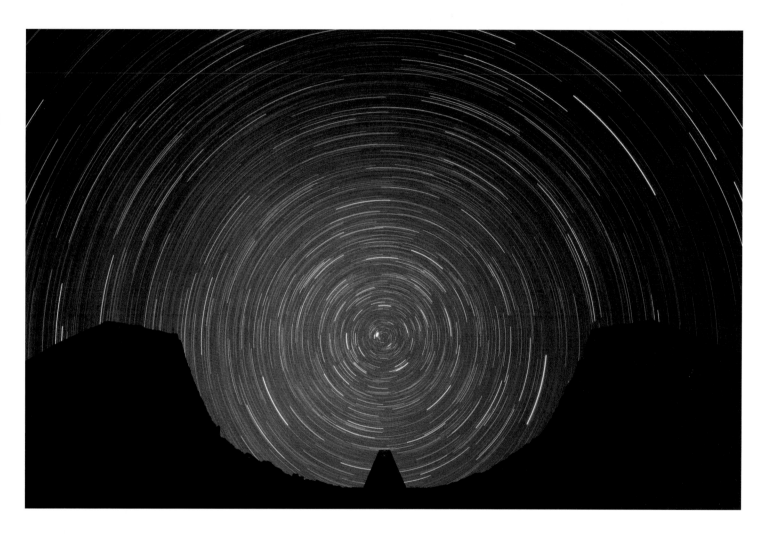

Charles Ross
Star Axis
1971-
New Mexico

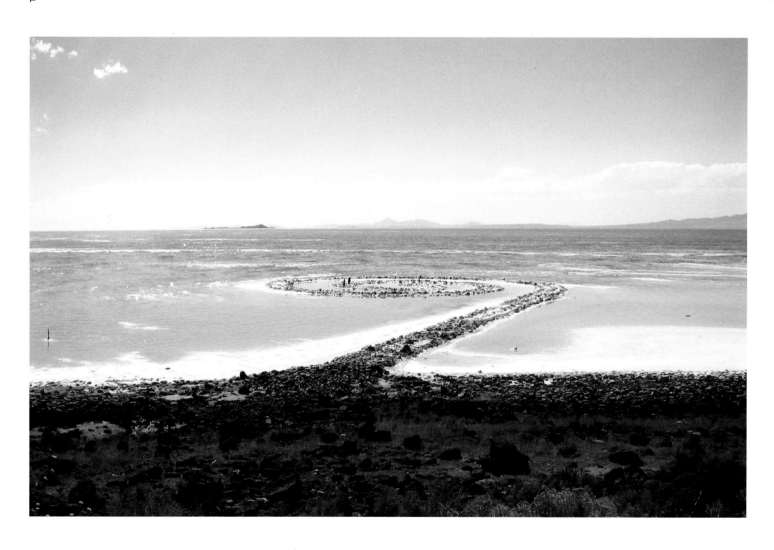

Robert Smithson
Spiral Jetty
1970
Great Salt Lake, UT

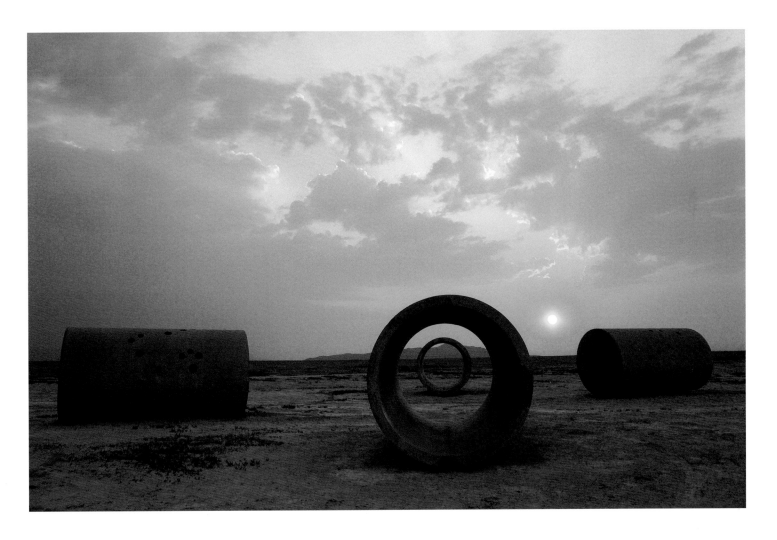

Nancy Holt
Sun Tunnels
1973–76
Great Basin Desert, UT

Government Public Art Programs and Percent-for-Art Legislation

All the recent works of monumental sculpture and painting commissioned by GSA have been chosen for specific sites, making each work more responsive and responsible to its immediate environment and to its physical and symbolic context. Such considerations suggest that a new idea of public art is emerging – one that draws on the creative energy generated by American artists during the last fifteen years.[24]
— Richard Koshalek

… the fact that GSA-commissioned works have been so heatedly debated, eliciting strong reactions … has, for the first time since the depression years, opened up a genuine dialogue between the artist and his public.[25]
— Sam Hunter

The Kennedy administration advocated for the arts, and Lyndon Johnson established the NEA in 1965. The Nixon administration embraced the new cultural policy. During this critical period in the evolution of American public art, support from the government's executive branch provided the guarantee of an arts program. William Schaefer (then-Mayor of Baltimore and later Governor of Maryland) underscored widespread optimism about the importance of art and architecture in the making or reinforcement of an engaged society, elevating creative endeavor to a philosophical imperative. "The question of financing art in new construction is not a matter of 'can we afford the experience of art in our new buildings, but rather, can we afford not to finance art' … Art gives meaning to life, and art must be seen to have meaning."[26]

In the early 1970s, Karel Yasko, Director of the General Services Administration, dreamed of reinventing the Depression-era WPA to sponsor contemporary art. His energetic young associate, architect Donald Thalacker, made Yasko's dream a reality. Under Thalacker's leadership from 1972–1988, the Art-in-Architecture program sponsored over three hundred projects, signaling a rebirth of government patronage. During this period, major conceptual artists, earthwork artists, and artists known for monumental sculpture were identified by peer juries of qualified art professionals and commissioned to make important large-scale artworks; notably Alexander Calder, Mark di Suvero, Fred Eversley, Al Held, Robert Mangold, Louise Nevelson, Claes Oldenburg, Beverley Pepper, Lucas Samaras, Tony Smith, Lenore Tawney, David von Schlegell, Sylvia Stone and Jack Youngerman. The GSA program nurtured artists' personal vision for creative freedom and at the same time demanded responsibility. This, along with NEA matching grants for cities, jumpstarted a major public art renaissance

Jack Youngerman
Sculpture Grove
1981
(Installation view with Jack Youngerman, 1981)
Doris C. Freedman Plaza, New York, NY

in this country. A signature work of public art became synonymous with the renewal of a city or downtown center obliterated by suburban decentralization.

The first project to secure a federal grant from the newly-established NEA Art in Public Places program, Alexander Calder's *La Grande Vitesse* exemplifies "the successful assimilation of a work of advanced art by a community which eagerly prepared itself for its reception," as Brian O'Doherty so aptly observed.[27] Placed on a public plaza, the stabile was intended to help rejuvenate the struggling downtown, which had once thrived with industry. Although initially considered too modern for conservative Grand Rapids, this non-objective work was adopted as the emblem of the city and is the centerpiece of the annual Festival of the Arts. Likenesses appeared on the city's official letterhead, on street signs, on sanitation trucks, and in the airport. *La Grande Vitesse* put Grand Rapids on the map as a progressive patron of public art, setting a high bar for works by numerous artists, including Robert Morris's first earthwork in the United States, which reclaimed an area in the city for a public park, Mark di Suvero's *Motu Viget* (1977), and Maya Lin's *Ecliptic* (2001).

Professional standards established by the NEA were applied equally to NEA-funded projects and those of the GSA and other federal agencies. Early encouragement and assistance from the NEA gave many embryonic programs the impetus to define a well-conceived process for selecting artists and managing projects. And importantly, with the NEA's imprimatur on public art consultancy as a legitimate profession, states, and municipalities engaged independent art consultants to evaluate art, to facilitate commissioning and executing projects, and, importantly, to manage them.

Europe had long encouraged percent programs with a customary generous budget of 2% of construction. America lagged. Enactment of percent-for-art legislation – a powerful force in support of the nation's artists and craftspeople – expanded to hundreds of cities, counties, and states and to other Federal agencies, including the Federal Aviation Administration, Department of Transportation, and Department of the Interior. Percent-for-art programs gave both renowned and many emerging artists their first opportunity to make a major work of art in a public setting.

However, as the programs proliferated, many bureaucrats charged with effecting art projects remained demonstrably provincial in their outlook, endorsing local over nationally-recognized artists. Whether their preferences stemmed from allegiance to their constituents exclusively, from concern that renowned artists would not be controlled, from lack of ambition, or from benign inexperience, the net result was the same: art in these communities tended to be limited in its reach and rarely broke new ground.

With a mandated one half of one percent of a building's construction

Page 56

Jack Youngerman
Rumi's Dance
1976
Edith Green – Wendell Wyatt Federal Building, Portland, OR

Page 60

Lucas Samaras
Silent Struggle
1976
James L. Watson Court of International Trade, New York, NY

Al Held
Order/Disorder/Ascension/Descension
1997
Social Security Administration Mid-Atlantic
Program Center, Philadelphia, PA

Beverly Pepper
The Sentinels of Justice
1998
The Charles Evans Whittaker U.S. Courthouse,
Kansas City, MO

budget, artists were commissioned to create large-scale works for plazas and interior spaces in new government office buildings and courthouses nationwide. Elevated standards were set for public art, architecture, and graphic design, reversing a trend that awarded government projects to the lowest bidder.

Government endorsement demonstrated that art and cultural development are vital to the economic and social well-being of cities and towns. In support of percent-for-art legislation as a way of improving the economy of cities, Robert Montgomery and Patricia C. Jones, President and Vice-President of the Alliance for the Arts in New York City, said: "Without the arts, New York City would lose up to $6 billion in business … [they are] not a "frill" … The arts attract more than 13 million tourists to the city each year. They are one of the main reasons that corporations and their highly-skilled, tax-paying employees move to and remain in the metropolitan area."[28] Indeed some cities, e.g. Philadelphia, have formally extended their percent-for-art programs to include private development, while others favor informal guidelines for civic enhancement. And in the private sector, in the 1980s and 1990s, many enlightened commercial enterprises and developers became avid art collectors, enhancing workplaces and civic spaces and expanding their role as active citizens in their communities.

Combined public and private funding sponsors the acquisition of public art. Art and cultural facilities are centerpieces of urban redevelopment. Initiatives that demand cooperation among artists, architects, city planners, landscapists, and developers proliferated as requests for urban-planning proposals include artists and public art consultants as team members.

Today it is a rare community that does not have some form of sponsorship for art in public places. But often legislation has been passed only after years of diligence by a few dedicated citizens. For almost ten years, Doris Freedman, my early mentor, founder of New York City's Public Art Fund, advocated vigorously for a percent-for-art law, which New York adopted only in 1982. In 2021, artist Sam Moyer was invited to make a sculpture for Doris C. Freedman Plaza at the entrance to Central Park commemorating fifty years of the Public Art Fund's placing of major works of art throughout New York City. The artist named the art *Doors for Doris*.

Sam Moyer
Doors for Doris
2020
Doris C. Freedman Plaza, New York, NY

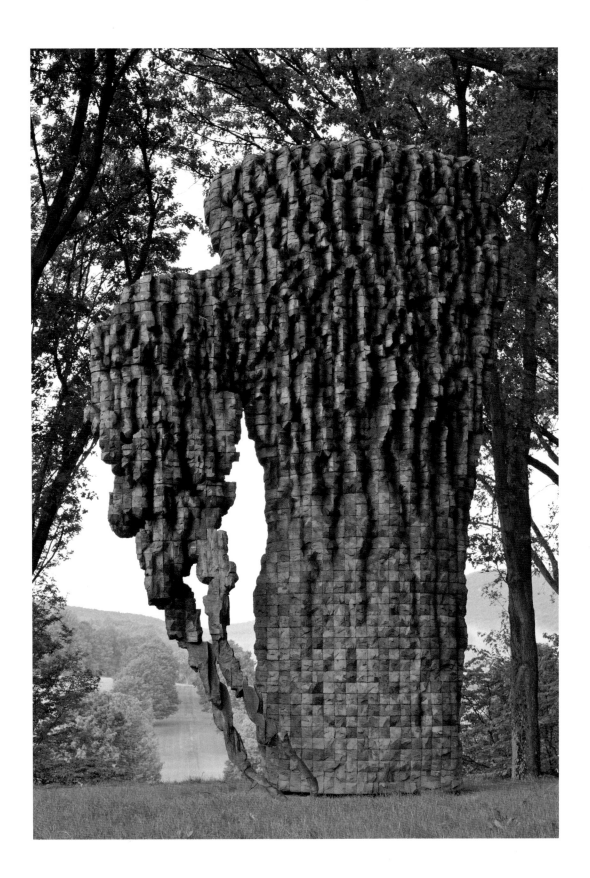

The Private Sphere and Public Art: Museums, Individuals and Institutions, Corporations and Commercial Developers

A work of art when placed in a gallery loses its charge, and becomes a portable object or surface disengaged from the outside world. The function of the curator is to separate art from the rest of society … Once the work of art is totally neutralized, ineffective, abstracted, safe, and politically lobotomized, it is ready to be consumed by society. All is reduced to visual fodder and transportable merchandise. [29]
— Robert Smithson

The first conceptual artists may have chafed at the restrictiveness of museums and galleries (perceived or actual), yearning to explore new territory and move beyond the security of the past. Robert Smithson, disparaged the museum altogether. He characterized them as tombs, asylums, and jails "filled with sequences of useless voids and collections of anachronisms" [30] and criticized their effect on works of art. But museums are the standard bearers, and in creating public art environments, not only have they effectively expanded their reach but they have legitimized the art. In turn, universities, the government, and corporations invoke museums' high standards.

Museum sculpture gardens and outdoor museums proliferated, among them the Louisiana Museum in Denmark, the Kröller-Müller in the Netherlands, Millesgarten in Sweden, the Vigeland Sculpture Park in Norway, the Billy Rose Sculpture Garden in Israel, and the Hakone Open-Air Museum in Japan, all of which place art in nature rather than in the "void" of Smithson's description. The Prato Museum for Contemporary Art, near Florence, Italy, expanded its collection to include works of public art that define the perimeters of the museum's property, attract visitors to the museum, and, visible from two major highways, enhance the civic landscape.

At Crystal Bridges (Bentonville, Arkansas), The Broad (Los Angeles), Martin Z. Margulies Sculpture Park (Miami), The Rubell Family Collection (Miami), Frederick R. Weisman Art Museum (Minneapolis), the Gemstone (Washington, DC), Sheldon Sculpture Garden (Lincoln, Nebraska), Frederik Meijer Gardens & Sculpture Park (Grand Rapids, Michigan) and many other public and private museums throughout America, sculpture and installation art are pre-eminent. Creating sculpture gardens for large-scale signature works of art allows smaller contemporary art museums to expand their collections and renew their identities without taking on the added burden of a new building. Changing exhibitions in gardens allow established museums to showcase more of their collections.

City agencies and museums have partnered creatively. Exemplary is the

Ursula von Rydingsvard
Luba
2009–10
Storm King Art Center, NY

Page 65

Mark Di Suvero
Mon Père, Mon Père, Mother Peace
1973-75, 1969-70
Storm King Art Center, NY

Sol Lewitt
Five Modular Units
1971 (Refabricated 2008)
Storm King Art Center, NY

Page 66

David von Schlegell
Two Circles
1972
Storm King Art Center, NY

Louise Nevelson
City on the High Mountain
1983
(Installation view with Maria Nevelson, 2010)
Storm King Art Center, NY

Page 67

David von Schlegell
Untitled
1972
Storm King Art Center, NY

Isamu Noguchi
Momo Taro
1977-78
Storm King Art Center, NY

Minneapolis Sculpture Garden where the city's Park and Recreation Board and the Walker Art Center joined forces. Director of the Walker from 1961 to 1990 and the driver behind the creation of the garden, Milton Friedman said the garden and its sculptures are meant to attract both art lovers and people who do not typically visit museums, reinforcing the role of public art in reaching diverse audiences.

As public artists reached beyond the museum and changed the landscape of contemporary art, individuals and patrons, academic institutions, and commercial enterprises created sculpture gardens and significant campus art programs. These efforts supported the arts, enhanced physical contexts, created new venues, and shaped or revitalized identities, signaling an institution's currency.

With its large-scale sculptures by Henry Moore, Jacob Epstein, and Auguste Rodin, Glenkiln Sculpture Park, a former sheep farm in the Scottish landscape, captivated American businessman Ralph Ogden. He and H. Peter Stern established Storm King Art Center in Mountainville, New York in 1958. Their original mission to create a museum for paintings of the Hudson River School evolved into an open-air sculpture garden featuring nonobjective sculpture in the arcadian landscape. Thirteen large welded-steel sculptures by David Smith, dispersed on Storm King's terraces and lawns were the first. Counterpoints to nature and architecture, they bore no direct relation to the specific landscape.[31] Following Ogden's death 1974, Stern continued to acquire monumental sculpture, and before site-specific became current in the art world lexicon, he commissioned artists to conceive sculptures for designated sites. David von Schlegell, among them, created five environmental site-specific sculptures with modern materials and technology and inspired by the site's topography. Louise Nevelson and Isamu Noguchi, also Pace Gallery artists, were also critical contributors to Storm King's superior collection.

Directed by David Collens, Storm King is one of the most visited sculpture parks in the United States. Members of Peter Stern's family are the second-generation stewards of the fabulous collection, which continues to expand, representing emerging artists and celebrating the work of major sculptors of our time, among them Andy Goldsworthy, Ursula von Rydingsvard, Alice Aycock, Maya Lin, Sol Lewitt, Chakaia Booker, Jean Chin, and notably Mark di Suvero, in depth.

With the creation of Fattoria di Celle, a contemporary sculpture garden in Tuscany, industrialist and art patron Giuliano Gori challenged artists to incorporate space into their art rather than consider space its container and to create a place where avant-garde art would transform the landscape organically. Site-generated works by Richard Serra, Dani Karavan, Alice Aycock, Dennis Oppenheim, Magdalena Abakanowicz, Ulrich Rückriem, Robert Morris, Anne

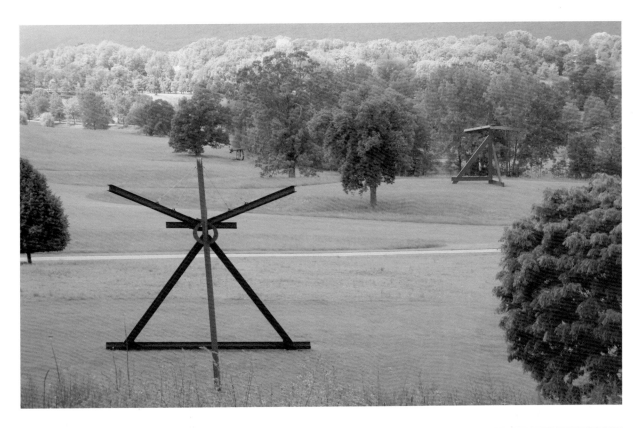

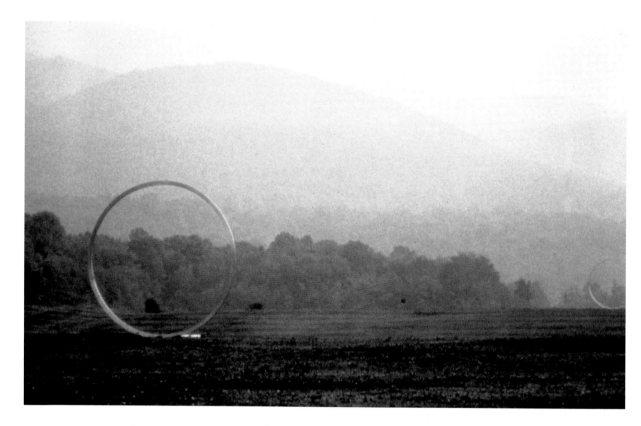

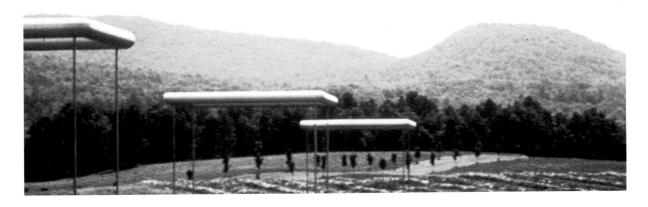

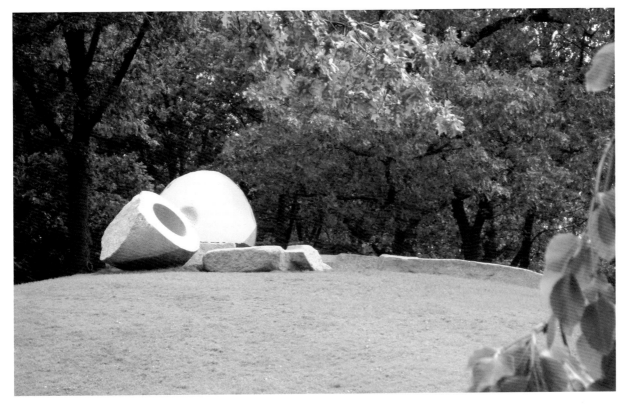

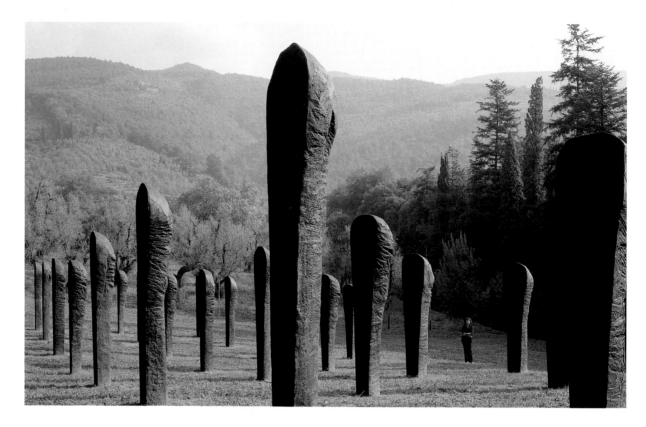

and Patrick Poirier, Max Neuhaus, Daniel Buren, Beverly Pepper, and George Trakas and others respond to the topography, vegetation, historical remnants, and cultural contexts of seventeenth-century Villa di Celle di Pistoia and the surrounding nineteenth-century English style park.

The university campus is also a venue for innovative permanent art. Institutions routinely collect large-scale art and commission artists to create site-specific works for new or renovated buildings and gardens. Countless universities, including MIT, University of Texas at Austin, Harvard University, Emory University, Florida International University in Miami, and University of Washington at Bellevue, and the University of California San Diego have sophisticated public art programs administered by professional curators and departments of buildings and grounds.

At the forefront of engineering and science, MIT also has had a commitment to major contemporary sculpture and is a role model for other universities. Its program effectively underscores the intellectual and aesthetic benefits of art for all and negates any perceived schism between art and science. Concurrently, artist György Kepes founded MIT's Center for Advanced Visual Studies in 1967 to promote interdisciplinary art practice and research.

A particularly fruitful collaboration between the University of California San Diego in La Jolla and art patron and businessman James Stuart DeSilva gave rise to the Stuart Collection, under the long-time leadership of curator Mary Beebe. Its stated purpose is to enrich the cultural, intellectual, and scholarly life of the campus and the greater San Diego community while providing a range of opportunities for artists pursuing new approaches to public art. Many of the artworks represent the artist's first permanent outdoor sculpture. *A Sun God* by Niki de Saint Phalle was the first commissioned work. Other provocative artworks include works by Robert Irwin, Alexis Smith, Kiki Smith, Richard Fleischner, and Jackie Ferrara; Terry Allen, Bruce Nauman, and Nam June Paik have created sound, light, and video art. The University safeguards both the integrity of the art and the campus environment; an advisory committee of internationally-recognized art professionals selects the artists; and works that specifically address a site, a context, or a functional need are commissioned.

Corporations and developers have long engaged prominent architects to create company headquarters, commercial and residential buildings, and hotels, among them Louis Sullivan's Wainwright Building, William van Alen's Chrysler Building, Gordon Bunshaft's and Natalie de Blois's Lever House, Mies van der Rohe's Lake Shore Drive Apartments, and Morris Lapidus's Fontainebleau Hotel. They have also commissioned art.

While an owner's motivation may be largely commercial, design excellence has, in fact, burnished the identities of corporate enterprises. Much of the art

Page 68

Magdalena Abakanowicz
Catharsis
1985
Collezione Gori, Fattoria di Celle, Pistoia, Italy

Patrick and Anne Poirier
The Death of Ephialte
1982
Collezione Gori, Fattoria di Celle, Pistoia, Italy

Page 69

Daniel Buren
La Cabane Éclatée aux 4 Salles
2005
Collezione Gori, Fattoria di Celle, Pistoia, Italy

Robert Morris
Labirinto
1982
Collezione Gori, Fattoria di Celle, Pistoia, Italy

Page 70

Kiki Smith
Standing
1998
Stuart Collection, UC San Diego, CA

Richard Fleischner
La Jolla Project
1984
Stuart Collection, UC San Diego, CA

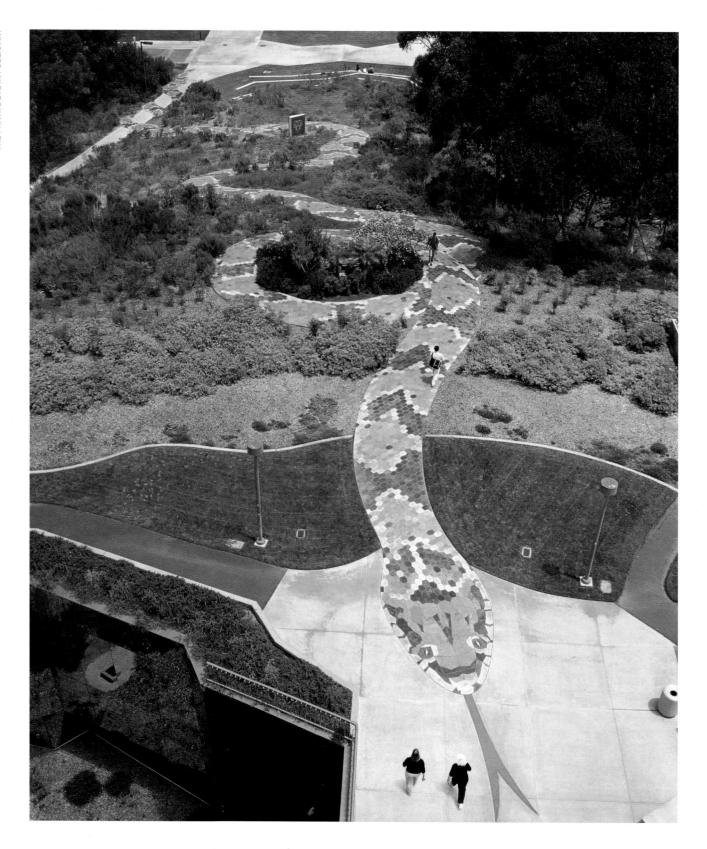

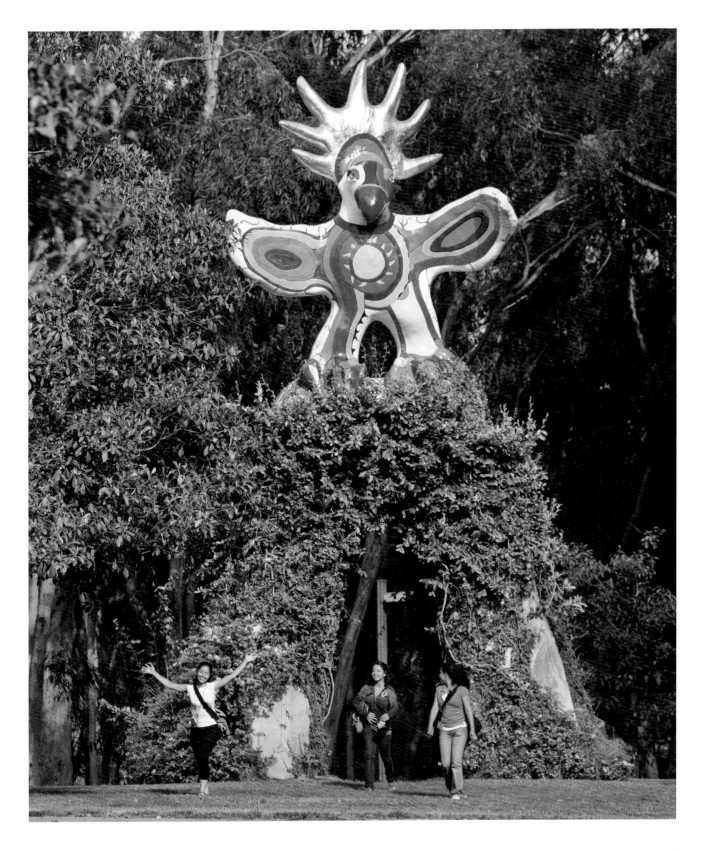

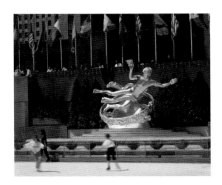

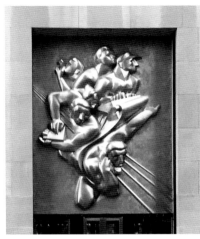

Paul Manship
Prometheus
1932
Rockefeller Center, New York, NY

Isamu Noguchi
News
1938
Rockefeller Center, New York, NY

Page 72

Alexis Smith
Snake Path
1992
Stuart Collection, UC San Diego, CA

Page 73

Niki de Saint Phalle
Sun God
1983
Stuart Collection, UC San Diego, CA

Page 75

Jean Dubuffet
Group of Four Trees
1972
New York, NY

is not truly public, but it is not truly private either: enlivening the public spaces of private buildings, it can have a powerful placemaking effect. A beautiful and exciting artwork can attract tenants, encourage employee creativity and productivity, and demonstrate corporate interest in the community and the environment.

Two historical examples stand out: Rockefeller Center and Cranbrook Academy are paradigms of integrated art and architecture programs. Cranbrook is a marvel of integrated architecture, landscape, and art. Eliel Saarinen insisted that sculpture was a necessary complement to architecture, and Carl Milles and Geza Maroti created sculptures accordingly. Not only do the wrought iron gazebos, ceramics, weaving, and decorative arts and crafts testify to the shared convictions of an extraordinary group of artists, architects, designers and craftspersons, but the unified aesthetic continues to have a profound impact on generations of artists and architects educated there.

In 1931, although the Rockefeller complex design was well advanced, architect Wallace K. Harrison convinced his patron, John D. Rockefeller, that architecture and art be integrated, that there be an unifying and uplifting theme underpinning architectural ornament. Huntley Burr Alexander, a philosopher, developed the theme and advised the artists on subject matter, decorative motifs, colors, and symbols.[32] The architects, developers, and certainly John D. Rockefeller Jr. were champions of "good taste" and competent mediocrity in art. The academic artists followed his instructions to the letter.

The exception was Nelson Rockefeller, who demanded that artists of international standing be invited to contribute. Matisse and Picasso declined, but José María Sert, Paul Manship, Gaston Lachaise, Giacomo Manzu, William Zorach, Yasuo Kuniyoshi, Stuart Davis, and Isamu Noguchi accepted the challenge. Even today Rockefeller Center's ornamentation, sculptures, murals, mosaics, doors, friezes – including the atypical but powerfully evocative Noguchi stainless steel wall panel – constitute an exciting urban artistic and architectural experience.

Rockefeller Center's integrated art and architecture program represented a new paradigm for private development. Indeed, almost five decades after Rockefeller Center's completion in 1939, the Equitable Life Assurance Society made a similar commitment to the visual arts: Chairman of the real-estate group and a founder of the corporate art program Benjamin D. Holloway stated, "It would be foolish as hell if I said the artwork wouldn't make it more attractive to tenants, but it wasn't done for that purpose alone – we wanted to extend the midtown concept of Rockefeller Center."[33] He presciently predicted that art and good restaurants would elevate the stature of the (Edward Larrabee Barnes-designed) building despite its location in Times Square, whose reputation at the

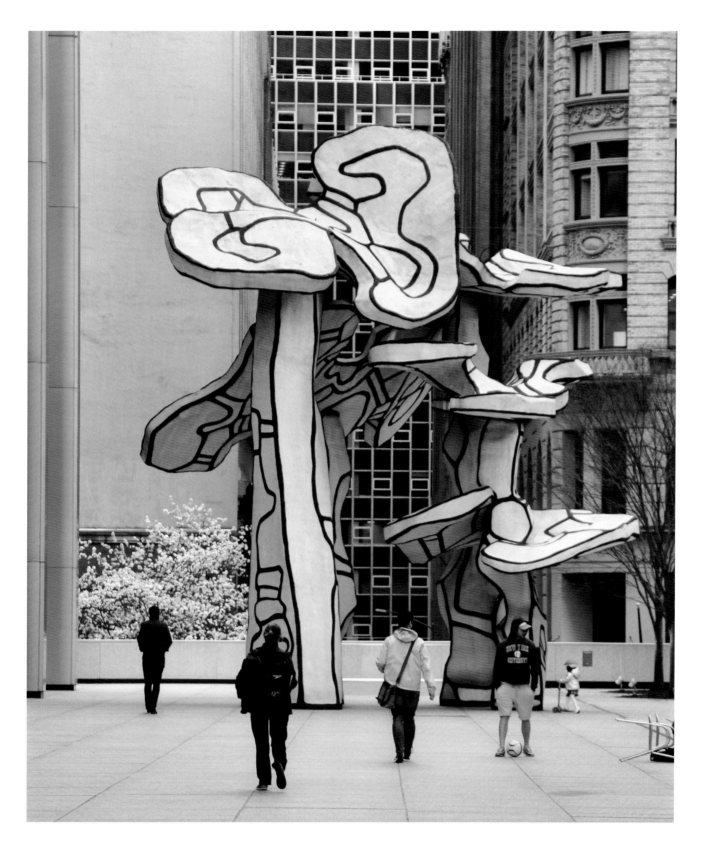

Jackie Ferrara
Stone Court
1988
General Mills Sculpture Garden,
Minneapolis, MN

Page 75

John Newman
Torus Orbicularis major
1988
General Mills Sculpture Garden, Minneapolis,
MN

Andrea Blum
Corporate Displacement
1992
General Mills Sculpture Garden, Minneapolis,
MN

time, was colorful but hardly elegant.

Banks have been dedicated corporate collectors of museum-quality art. Chase Manhattan Bank entered the world of art collecting in the late 1950s when Chairman David Rockefeller, himself a philanthropist and renowned art collector, commissioned Jean Dubuffet's *Group of Four Trees*, for its Gordon Bunshaft-designed headquarters. The sculpture identifies the Bank and enlivens and humanizes the building's public plaza. For the New York branch of the First Bank of Chicago, Agnes Denes enhanced the bank's image by transforming its lobby with *Hypersphere – The Earth in the Shape of the Universe*, a five-ton etched glass suspension ceiling.

Corporations have opened their sculpture collections to the community. A stellar example is General Mills' Skidmore Owings & Merrill-designed, 35-acre campus in Minneapolis. Launched by Chairman Bruce Atwater and curated by Donald McNeil, the art program, together with the plantings and landforms of William A. Rutherford's a landscape sculpture plan, rationalize circulation and soften and screen unattractive aspects of the site. Works include Jene Highstein's black granite *Egyptian Beauty*, Jonathan Borofsky's stainless steel *Man with a Suitcase*, Jackie Ferrara's *Stone Court*, John Newman's *Torus Orbicularis major*, and Andrea Blum's *Corporate Displacement*.

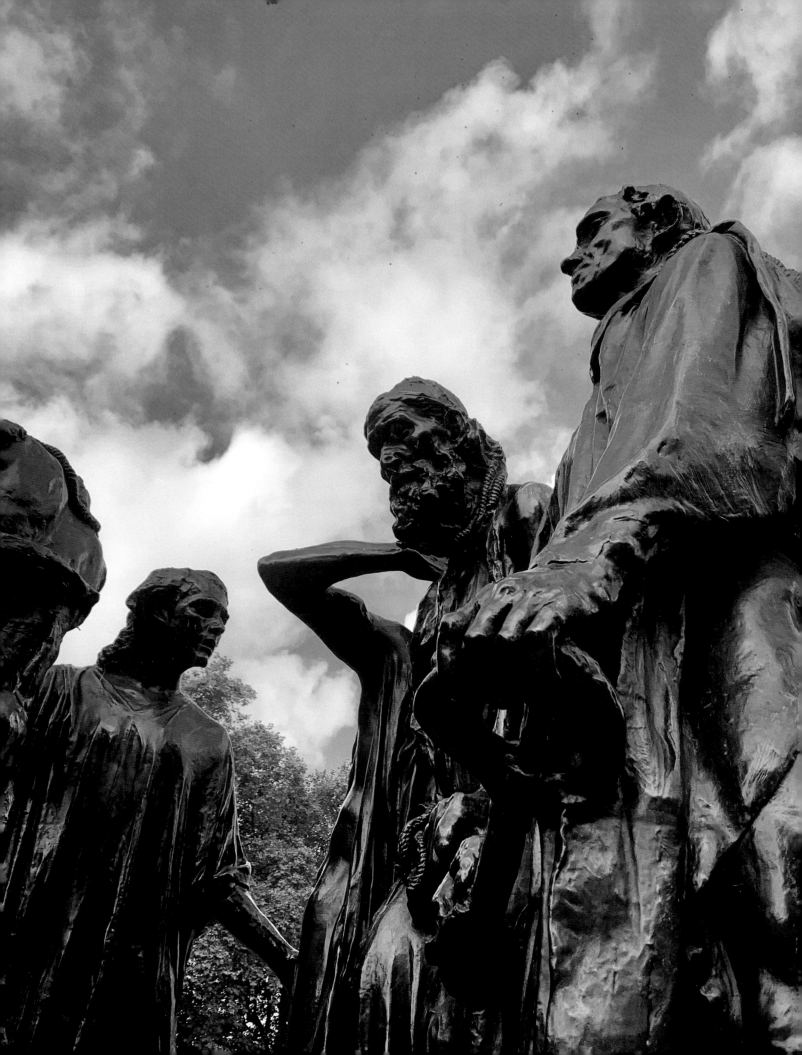

III
POINT OF VIEW

CONTROVERSY

Art is an activity of change, of disorientation and shift, of violent discontinuity, of the willingness for confusion even in the service of discovering new perceptual modes.[34]
— Robert Morris

The more controversy there is at the time [the art] is created by a tried-and-true artist, the more chance there is that it is a significant statement.[35]
— Robert Buck

The artist is frequently at conflict with the status quo. He takes us out of the realm of the ordinary, He captures our imagination. He stretches our minds. He changes the way we see the world. Art opens our eyes: it offers a new perspective and makes us turn an idea, a thought, and sometimes even a fact over and over until we see it in a new light with new eyes.[36]
— Joan Mondale

Public art is a venerable, if not always venerated art form. It is also vulnerable. Its long and honorable history includes unremitting controversy, spectacular and enduring art, bad and banal art, and significantly, many unrealized superior proposals. Dialogue and debate are positive and essential aspects of the public art process. Whether addressing specific content, chosen medium, celebrity of the artist, or politics, controversy engages people, to take notice, criticize, love, or hate an intervention in the spaces of their lives. Whether based on aesthetic preferences, the work's appropriateness to the site, or cultural identity, differing opinions are evidence that an artist has touched their audience. Unmitigated approval is not the measure of a work's success long term.

Robert Irwin has said that one primary intention of art is "to make people see a bit more tomorrow than they saw today."[37] In that regard, dialectical controversy is a measure of its reach. Can we shy away from controversy sponsored by the creation and placement of public art? Or conversely, should we encourage it?

Suppressing controversy or denying its positive impact on the public art process opens the door to banal and mediocre art. Among the most controversial works of art are those that break from traditional modes and explore new and unfamiliar ideas. They may not be universally accessible, challenging the general public as well as art critics and historians. Critic Arthur Danto has said: "It is the preemption of public spaces by an art that is indifferent, if not hostile, to human needs that has aroused such partisan

Agnes Denes
Model for Probability Pyramid – Study for Crystal Pyramid
1976–2019
The Shed, New York, NY

Page 78

Auguste Rodin
The Burghers of Calais
1889 (cast 1908)
Victoria Tower Gardens, London, UK

Page 80

I.M. Pei
The Louvre Pyramid
1988
The Louvre Palace, Paris. France

passions."[38] His cynicism may be recast in a positive light: these works defy preconceptions and demand alternative ways of seeing.

Examples of controversy in public art abound, and the issues that animate these debates are diverse. One need only look at Michelangelo and Pope Julius, who were known to argue continuously. Some shine a light on the politics of art in the public realm, some on procedures for engaging the public, others are related to social mores and preconceptions about the role of art in society, others to ownership of public space or the cost of art, still others to aesthetics. What the artworks share is the power to provoke discourse. Controversy is a visible indicator of a democratic society, where wide differences of opinion are celebrated for their ability to broaden understanding. It signals healthy engagement, expansiveness, and transparency.

This has been the most exciting aspect of my career. Underpinning all is my unwavering allegiance to recognizing the intentions and efforts of the artists who make art and protecting its integrity.

Many artworks appear without fanfare in the streets of our cities. Objections to the unfamiliar usually disappear, unless fueled by politics or prejudice. Interestingly, a community's response to art in its public spaces often changes over time: art that seems different and even provocative, in time becomes familiar, even beloved, absorbed by the community as part of its identity. Relationships are established between the viewer and the individual artworks when art is a permanent feature of the urban or natural landscape. Tacit acceptance morphs into active engagement, ownership, and pride.

The debates surrounding two of Auguste Rodin's most celebrated sculptures, *Balzac* and *The Burghers of Calais*, function as parables of a sort. *Balzac* was first conceived as a nude male figure. After significant public criticism, Rodin dressed *Balzac* in a bathrobe, which also gave rise to great public dismay. An oft-quoted statement testifies that despite the raging controversy, Rodin's confidence was unshaken: "I no longer fight for my sculpture. It has been able to defend itself for a long time … if truth is imperishable, I predict that my statue will make its own way."[39] Five decades passed between the completion of the model and the unveiling of the bronze sculpture. Installed in Paris on July 2, 1939, eighteen years after Rodin's death, it was embraced with tremendous pride. Now *Balzac* can be found throughout the world, including in the garden of New York's Museum of Modern Art.

Burghers tells the story of six distinguished citizens in the French coastal town of Calais who, in 1347 during the 100 Years War with England, voluntarily accepted captivity by King Edward III to save their town from extermination. Rodin won the Calais Municipal Art Committee's competition to commemorate the tragic burghers in 1885, when his first maquette was approved. To enhance

his chance of winning this public commission, the sculptor promised to deliver "six sculptures for the price of one."[40] His eventual creation, instead of idealizing the burghers sacrifice, revealed their misery by placing the six men level on the ground, instead of raising them to heroic heights, as would have been customary. Each was then perceived as being in personal conflict with the others. Completed in 1889, it was six years before the monument was installed, and then with great controversy over the work's lack of pedestal, its imagery, and siting. Today, some eighteen versions of this work exist worldwide, but it was not until 1924, seven years after the sculptor's death, that the incomparable quality of his now widely celebrated monument was truly appreciated.

Social, historical, and political events have been fertile fields for public artists. Post-war development had unintended consequences for both urban centers and the natural landscape. Indeed, artists Robert Smithson, Nancy Holt, and Robert Morris, among others heightened consciousness of the ways in which human industry and inattention were ravaging the natural environment.

Introducing a new element into an existing context (or removing one, for that matter) – whether sculpture, mosaic paving, billboard mural, street furniture, building, or sign – prompts a reassessment of that place. The difference may be purely visual, or it may demand navigating the space in a new way, but the juxtaposition of old and new and the disruption of the familiar alters one's perception, suggesting new references, associations, and meaning.

Interventions in historic places excite discussion and have triggered charges that the new addition has stripped a revered place of its identity, thereby degrading it. This sort of controversy is not new to architecture. When completed in 1989, I.M. Pei's pyramidal glass entry pavilion to the Louvre "[was] denounced by many critics as destroying the beauty"[41] of the historic structure. France's Minister of Culture, Jack Lang, welcomed the debate: "I think that when people see the pyramid they will say: 'It is only this? It is not bigger?' And perhaps they will protest because it is not sufficiently high. And in ten years they will organize a committee to ask the Minister of Culture to protect this pyramid as an historical monument."[42] (There were other controversies surrounding the Louvre expansion. Agnes Denes had presented her pyramid series to an NEA panel in the '80s, on which Pei was a panel member. In her presentation, Denes had reimagined her signature pyramid form as an architectural glass building, whose purity was uncompromised by any penetrations, and which was to be entered from below. In an interview with Maika Pollack in the May 18, 2015 issue of *Interview*, she said: "It's like if I built the crystal pyramid now in Paris, I'd be after I.M. Pei, and people would think I took his ideas. Once your ideas don't get out, you go to the next idea and the next and the next."[43])

Public artists are often brought in to reimagine and restore ill-conceived

Auguste Rodin
Monument to Balzac
1898 (cast 1954)
Museum of Modern Art, New York, NY

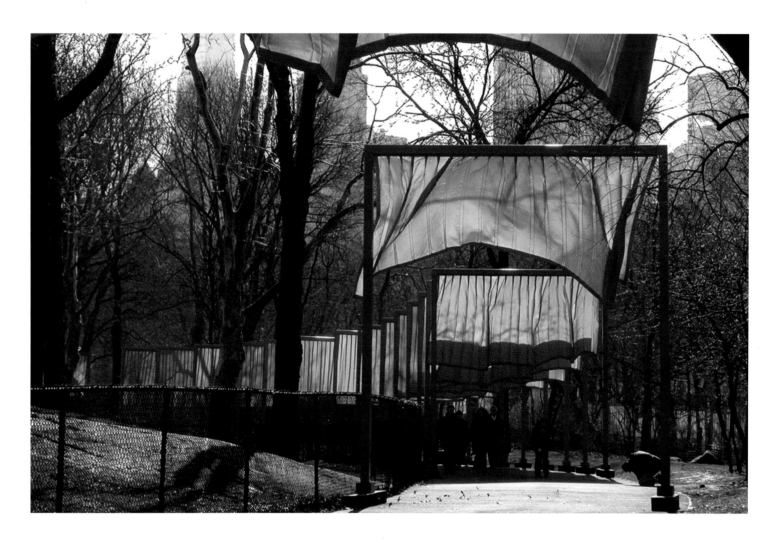

Christo and Jeanne-Claude
The Gates
2005
Central Park, New York, NY

or ill-used spaces. Although a courtyard of the colonnaded Palais Royale in Paris was used as a parking lot, detractors questioned the appropriateness and cost of a work by French artist Daniel Buren. Buren transformed the space, placing a series of boldly striped black and white columns of varying heights in a conceptual grid. His installation activated the grand architectural space, and the "void" became a beloved public place. Visitors are invited to sit, skate, walk, and cycle, and the juxtaposition of modern art and historic architecture heightens awareness of both.

Daniel Buren
Les Deux Plateaux
1985–86
Palais Royal, Paris, France

The consummate public artist, Christo grappled with the complexities and challenges of the public art process, successfully navigating bureaucracies and politics. He and his wife Jeanne-Claude were best known for their temporary artworks, superb examples of the power of an artist's vision to change public perception of a place. The *Surrounded Islands* in Miami Beach, Florida heightened consciousness about the local ecology. After twenty-four years of effort, and meetings with 352 members of the German Parliament, Christo and Jeanne-Claude were permitted to wrap the Reichstag, dramatizing its identity as a modern symbol of democracy. Conceived in 1979, *The Gates*, 7,503 saffron-colored fabric panels that meandered along twenty-three miles of pedestrian paths in Manhattan's Central Park, was installed in 2005 and remained for sixteen days.

Christo and Jeanne-Claude's convictions were manifested in their optimistic perseverance as well as their unusual financing strategies. Rather than depend upon taxpayers or patrons, who, they feared, would limit freedom of expression, Christo and Jeanne-Claude insisted on funding their work through the sale of Christo's drawings. They involved entire communities, craftspeople, construction workers, lawyers, and even politicians in their projects, securing necessary government permissions relating to land use and city planning. When interviewed in connection with *Mastaba for Serpentine Lake* in London, Christo underscored the unfortunate interdependence between freedom of expression and capital: "All the quality, all the decisions are made because it's our money. It's my money, it's my freedom. We never do commissions. This is why in all these years we realized very few projects and very many were not realized. We pay with our money. This is all our money."[44]

Celebrated for its central role in the emergence of a distinctly American architecture, Chicago is also a pre-eminent venue for public art. Its exceptional and thriving program is attributable in large part to concerned citizens and resident collectors, who, in the 1960s, set the highest standards for art in public places; the city passed its percent-for-art ordinance in 1978. Underscoring the necessity for excellence, Chicago initiated its program with works by Miró and Chagall, followed by Calder, Dubuffet, Nevelson, Oldenburg, and Picasso.

Fast forward to 2004: commissioned for Millennium Park, outstanding works by Jaume Plensa and Anish Kapoor have quickly become civic landmarks, evidence of a long-standing commitment on the part of Chicago city officials and farsighted, dedicated art patrons who believe that commissioning the best art by the best artists will inspire more of the same.

Exceptional art does not guarantee public acceptance, but avoiding controversy is the surest path to banality. Pablo Picasso's Cor-Ten steel *Head of a Woman* challenged expectations for a traditional monument to civic achievement: it was much criticized, and some called for its removal and replacement. Mayor Richard Daley, who at the 1967 unveiling said, "We dedicate this celebrated work this morning with the belief that what is strange to us today will be familiar tomorrow,"[45] stood firm.

A community's embrace of public art can be a double-edged sword: there is no question in my mind that the best art should enrich our public spaces, but I also recognize that it is difficult, if not impossible, to remove public art once it is installed. This applies equally to exceptional art and to mediocre works. The responsibility to select artists capable of creating meaningful public art looms large.

Alexander Calder's *Flamingo* in Chicago's Federal Plaza (1973) was one of the first public art commissions completed under the progressive leadership of the GSA's new art bureaucracy. Nevertheless, the GSA art program suffered attacks from those who questioned public expenditures for art and, harking back to the founding fathers' Puritan ethic, labelled art frivolous and dispensable. Although gradually accepted and appropriated as a symbol of the city, Claes Oldenburg and Coosje van Bruggen's *Batcolumn* (1977), a 101-foot Cor-Ten steel latticework bat standing on its knob was derogated by many Chicagoans as a waste of taxpayer money.

No matter whether artworks are enthusiastically embraced or mercilessly criticized, questions of ownership inform obligations to protect the integrity of works in the public realm, and questions of intention factor into the work's reception. For example, what limitations are imposed on the government as an owner of art? Are there limitations on artists' rights as creators of civic monuments; should community concerns limit artists' rights? Can the integrity and value of an artist's work be protected through restoration and maintenance procedures and principles?

An early GSA project and a pioneering functional and environmental public artwork, George Sugarman's *Baltimore Federal* (1978) endured a protracted court case and much public debate before it was installed on the plaza of a new federal courthouse in Baltimore. As Roberta Smith wrote in Sugarman's obituary, Federal judges "first opposed the piece on esthetic grounds but later said that

Claes Oldenburg and Coosje van Bruggen
Batcolumn
1977
Chicago, IL

Jaume Plensa
Crown Fountain
2004
Millennium Park, Chicago, IL

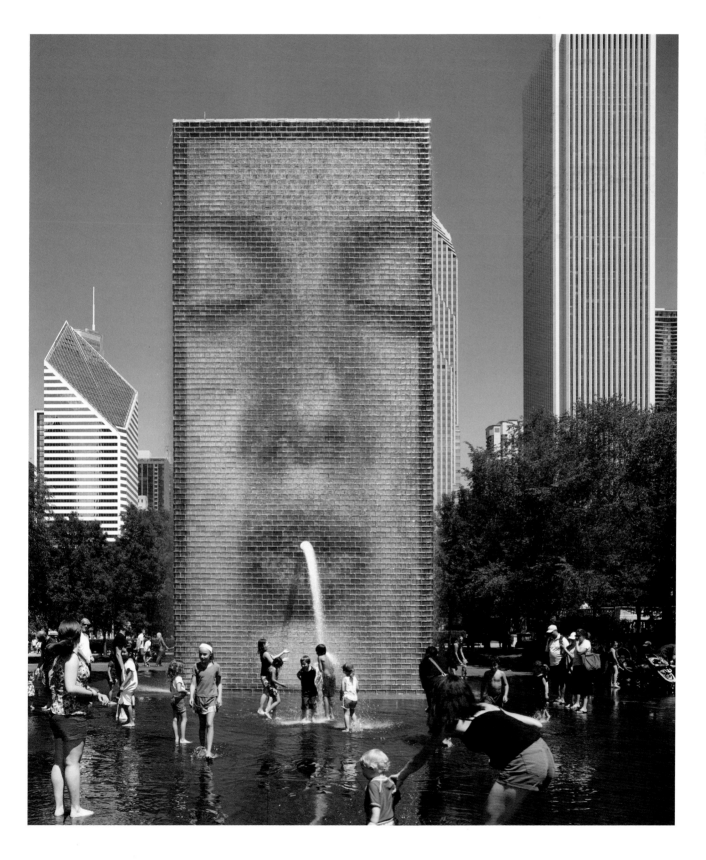

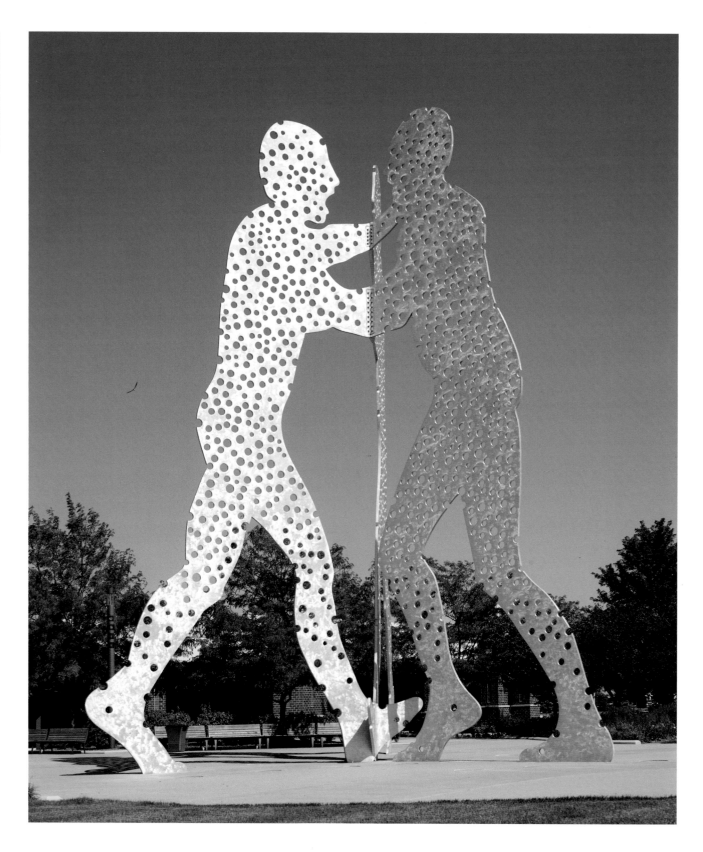

it could be dangerous for children or could be used as a soapbox from which protesters might make speeches."[46] Others claimed that the sculpture posed a security risk for judges as attackers could hide within it. In truth, its seating elements and color are welcoming, emphasizing accessibility and transparency of the United States judiciary.

Arguably the most extreme chapter in the recent history of controversy in public art was the dismantling of Richard Serra's *Tilted Arc*. The episode raised significant issues of free speech, artistic freedom, and the use and ownership of public space. Does the artist have the right to insist that their art remain in the public space if the immediate public is offended or uncomfortable or perplexed? Alternatively, should public art be subjected to pressures of public opinion when relocation threatens freedom of creative expression? Can we expect opposition to disappear with the passage of time as with Rodin? Some attribute a discernible and unfortunate shift toward more reassuring, less confrontational, non-subversive art to the *Tilted Arc* debate. Several museums offered an alternative site for the sculpture following its stealthily orchestrated removal from New York City's Federal Plaza. Later the museums rescinded their offers, respecting Serra's insistence that his work would be irrevocably compromised if placed anywhere but its original site.

In the aftermath, history, ideology, public policy, and the legal and moral rights of the artist intersect and diverge in debate that often subverts underlying issues. Controversy, especially if well-publicized, remains in one's memory. Objections aimed at Sugarman's *Baltimore Federal*, Jonathan Borofsky's *Molecule Man* and Tom Otterness's GSA-commissioned *The New World* in Los Angeles, Robert Graham's monumental bronze figures for the 1987 Olympics in Los Angeles, Jean Dubuffet's *La Chiffonnière* in New York City, and a Picasso nude at Baxter Laboratories in Chicago were as different as the works of art.

Akin to the debates about *Tilted Arc*, those surrounding these works are emblematic of an imagined disconnect between art and everyday life – that art belongs in museums and not in the public space – and constitute a rallying cry for the moral right of fine art to remain in the public realm until time, rather than subjective individuals, decides on its value.

Questions about ownership of public art and public space and the artist's right to control the disposition of their work are legion and outcomes inconsistent. The droit moral or moral right defines the ability and authority of artists to control the identity and integrity of their work. According to John Henry Merryman, a Stanford University law professor specializing in art and the law, "Distortion or misrepresentation of the work affects the artist's artistic identity, personality and honor and thus imparts a legally protected personality interest."[47] The Visual Artists Rights Act of 1990 was the first federal copyright

Jean Dubuffet
La Chiffonière
1978
(Installation view with Doris C. Freedman and NYC Parks Commissioner Gordon Davis, 1979)
Doris C. Freedman Plaza, New York, NY

Jonathan Borofsky
Molecule Man
1977
Los Angeles, CA

legislation to recognize moral rights of artists in America. In Europe such laws are more common.

Attorney Barbara Hoffman, who headed a subcommittee on public art law for the Association of the Bar of the City of New York, has written and litigated extensively on artists' rights and the complexities of public art. She has asked: "You have the government owning works of art, so the question is: what limitations are imposed on the government as an owner of private property when that property is art? Are there limitations that arise from artists' rights? Are there limitations that arise from community concerns? We are talking about defining private-property concepts as they relate to government ownership of artworks, and that definition has to include considerations of public interest as well as the interests of the artists."[48]

In response to objections by the California lawmaker for whom a federal office building was named, the GSA hastily removed two anatomically explicit female figures of Tom Otterness's *The New World*, which the agency had commissioned. This, notwithstanding the GSA's declaration that the congressman had no discretionary power regarding the disposition of the work of art. Whether the figures truly invited vandalism as was alleged or whether this threat was a convenient excuse for a subjective determination and interpretation of inappropriateness, the presiding judge ruled that the work was federal property and removing it did not deprive the artist of free speech. The art community protested, and a compromise was reached: the pieces were returned to the ensemble for the building's dedication, but a railing was placed around it to limit access. Otterness considered this a victory: "We don't have many victories in the public art scene. I'm happy if there is debate and discussion."[49]

Jonathan Borofsky's 1978 sculpture *Molecule Man*, which is on a site adjacent the Otterness, also suffered criticism. Objections to the four huge figures inclining toward one another focused on the holes that perforate their aluminum bodies. Although the artist intended the perforations to be read as the "molecules of all human beings,"[50] detractors claimed that they were bullet holes and as such, a problematic reference to the violent outbreaks in that city's streets. Again, is this valid criticism or a convenient but specious justification for removal?

In 1974, I worked with the Public Art Fund and The Pace Gallery to place Jean Dubuffet's *La Chiffonnière* temporarily at the entrance to Central Park at Doris Freedman Plaza. Questionable and subjective notions of appropriateness rather than artistic merit fueled criticism of the artwork. In this 19-foot-tall abstract sculpture, Dubuffet characteristically premiated reality over standard notions of beauty. Objections were couched in social terms: conscious of the city's homeless population, people argued that the sculpture, whose name

Tom Otterness
The New World (detail)
1991
Edward R. Roybal Federal Building,
Los Angeles, CA

Tom Otterness
The New World
1991
Edward R. Roybal Federal Building,
Los Angeles, CA

translates as bag or rag lady, would be an embarrassment.

In reflecting on the far-reaching value of public art, the commissioning process, and standards of acceptance and quality, I think often of the artist Joyce Kozloff's words, published a few decades ago: "Are we trying so hard not to offend or provoke that our only goal has become education? Is this why so many pieces seem to be pandering and talking down? Maybe our communities expect more and deserve better, and possibly art doesn't always have to feel so good, anyway. If we respect and trust ourselves as artists, we will be more able to make challenging, complex and moving works. There is a difference between public relations and public art."[51]

We must also note the distinction between public art and propaganda. Debates surrounding statues of Confederate war heroes, other questionable luminaries, and still other notable individuals, whose life's work may be noteworthy but whose characters are problematic foreground issues of ethics and public space. The controversial statue of Civil War General Robert E. Lee in Charlottesville, Virginia may have been the lightning rod that sponsored both peaceful protest and ignited violence in the summer of 2017, but it also highlighted the dangers of not distinguishing art from propaganda.

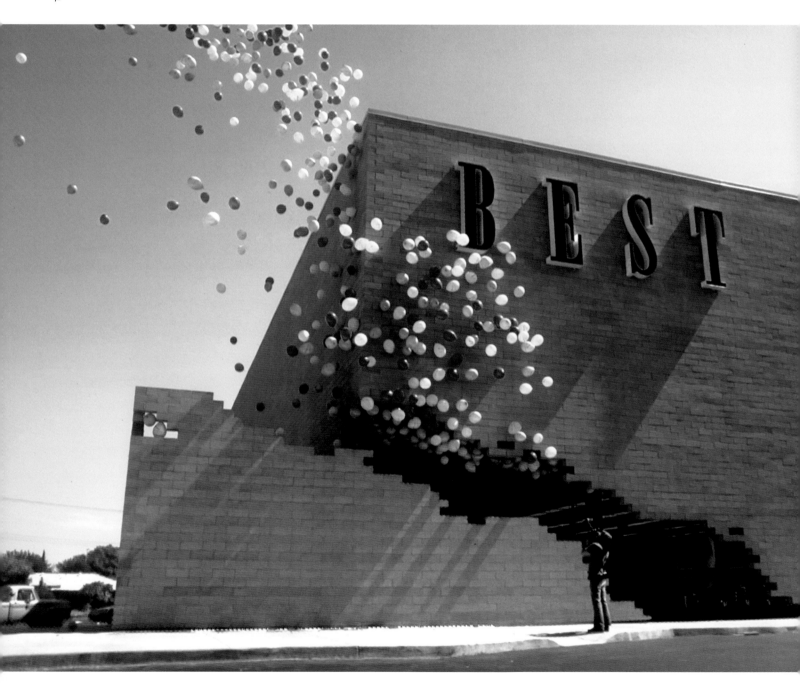

COLLABORATION

That's part of the collaborative effort – you really have to have a sympathy and an understanding and a willingness to open up and not feel threatened. The collaboration area is a constant contribution. It gets molded, sometimes modified, sometimes kept intact. But the idea of possessing or identifying with any one part of it is given up. [52]
— M. Paul Friedberg

Every work of public art is a responsibility that implies a great trust between the artist and the community. [53]
— Stephen Antonakos

Public art, architecture, landscape, and urban space can only become fully integrated when their academic definitions have been challenged and their distinctions as separate entities have been discarded ... when it finally becomes difficult to determine where one art form begins and the other ends. [54]
— James Wines

In 1985, I curated an exhibition at the Cleveland Center for Contemporary Art; the late Marjorie Talalay was then director. Entitled *Challenges in Collaboration*, the exhibition shone a light on a renewed interest in cross-disciplinary efforts and the joys and disappointments, hurdles and rewards of collaboration among creative individuals. Collaboration among artists, architects, and landscape architects is not a new idea. The timing though was important, coinciding as it did with artists' re-awakened interest in moving beyond the restrictions of museum and gallery, inspiring a broader public, and engaging social and environmental issues.

My exhibition postulated that orthodox modernism had displaced the characteristic integration of art and architecture seen in buildings of the classical world, the Middle Ages, the Renaissance, and the Beaux-Arts among other periods, and that the rise of postmodernism and the acceptance of ornament as well as the establishment of government programs that mandated art for architecture signaled a resurgent interest in meaningful collaborations. The catalogue essay put forward the idea that the success of public art is largely dependent on the willingness of the artists, architects, and all participants to engage in a multi-disciplinary respectful and creative process. My thinking remains essentially unchanged, my speculations proven time and again in the intervening years with ongoing projects.

Far from being a solitary creator in a studio, artists who make art for

James Wines
Antilia "Vertiscape" Tower Proposal
2004

Page 92

James Wines
BEST Notch Building
1977
Sacramento, CA

public places become members of a team, working with clients, architects, art professionals, and often regulatory agencies and community organizations. This meaningful collaboration can propel their work in significant fresh directions. While the social, political, and psychological dimensions of the public art process enrich the art-making process with creative tension and a complementarity of perspectives, the pain and pleasure of that process are much debated.

Theoretically, architects, landscape architects, and artists would be ideally suited to work together, particularly on complicated site-oriented art, in which the boundaries between art, architecture, and landscape design dissolve. The artist benefits from the architect's command of space, material, and function, knowledge of the regulatory environment, and ability to interpret the artist's concepts to the client. In turn, the artist can act as design catalyst for architectural planning groups by challenging thinking about art in the environment.

While art and architecture have co-existed for millennia, they are not the same, and it is a rare individual – Michelangelo, Bernini come to mind – who brilliantly straddles both worlds. In the contemporary world, exemplars are Tony Smith, Maya Lin, Alan Saret, and Gordon Matta-Clark, all of whom trained as architects. The pedagogies of the disciplines are different, and the approach to space and context are individual. However, an innate understanding of scale and space, akin to that of architects, characterizes the best public artists. Few schools of architecture teach painting and sculpture as part of the discipline.

A committee for the visual arts at MIT observed that "artists tend to engage the space directly, whereas the architects conceive and refine their designs and plans."[55] Architects are accustomed to creating over a long time period, accommodating the stops and starts inherent in the building process. In contrast, artists usually cannot, or will not, work for years on a single concept. Jackie Ferrara speaks for many artists: "As soon as I visit a site I cannot help but begin to think about solutions."[56] Ferrara finds it difficult to postpone action. It is noteworthy in this context that early in their careers, sculptors James Wines (SITE) and Vito Acconci (Acconci Studio) identified as serious architects. Their "artistic architecture" marries the two disciplines brilliantly.

Collaborations between artists and architects are legion, but successful collaborations depend upon a potent vision that results from dynamic interaction. Thus, works of art conceived during the early design stages of a building project tend to be the most successful. Integral to the architectural design, these works can help to shape space, reinforce building identity, and define a site's focus. This practice is not without challenges, but it thrives on different perspectives, sponsoring imaginative solutions.

Martin Puryear
North Cove Pylons
1992–95
Battery Park City, New York, NY

Rockefeller Center and Cranbrook come immediately to mind. A more recent example of a cohesive and comprehensive urban development with a robust public art program is Battery Park City in Lower Manhattan. There, the mandated art program has an immediate predecessor in the large-scale, site-specific works created by artists and architects – among them Andrea Blum, Maren Hassinger, Jody Pinto, Alice Aycock, and David Saunders – for Creative Time's *Art on the Beach*, which debuted in 1978 and Agnes Denes's *Wheatfield* in 1982 sponsored by the Public Art Fund. Artists and architects collaborate on all building projects. An early collaboration, and one that was considered pioneering, involved architect Cesar Pelli, landscape architect M. Paul Friedberg, and sculptors Siah Armajani and Scott Burton. Their seating, fences, gates, plantings, and promenades enliven the plaza and create a gathering space for both the residential community and daytime workers from the adjacent Pelli's World Financial Center. Other projects include *Upper Room*, an urban mosaic forest by artist Ned Smyth. Architect Stanton Eckstut, landscape architect Susan Child, and Mary Miss designed a 3-acre site with walkways, pilings, and pergolas that invited people to reconnect with the Hudson River. Battery Park City's roster of outstanding artists also includes R.M. Fischer, Tom Otterness, Martin Puryear, and Brian Tolle.

In the wake of the outcry against plop art (artworks dropped randomly in public places), art created conceptually had a new trajectory: to create opportunities for artists to shape public space, and in so doing, to enhance users' experience of it. These works were not decorative adjuncts in an urban environment: as art historian and critic Jean-Christophe Ammann urged, [we must] "urgently find new approaches and perspectives in order to redefine the artists' contribution to the utilization of public space."[57] Artists whose work in public places met his criteria include Robert Morris, Siah Armajani, Maria Nordman, and Jean Tinguely.[58] They and other publicly-oriented artists, working as peers with architects, urban designers, and engineers in a creative atmosphere of mutual respect, established new standards for art. Superior public design continues to depend on an interdisciplinary and participatory process with artists, architects, engineers, city planners, landscape architects, community representatives, construction workers, fabricators, business and financial leaders, and cultural institutions working together.

There have been detractors. With his declaration – "the architect is the enemy" – at a seminar sponsored jointly by the Skowhegan Art School and the AIA Committee on Design in 19[58], artist Richard Serra extrapolated from his ill-fated collaboration with Robert Venturi to condemn all such relationships between artist and architect. Their competing visions for a major work of art for Washington's Pennsylvania Avenue, overlaid with the question of who,

David Saunders
Lizzie and Gaffer Hexam
1980
Battery Park landfill, New York, NY

Page 96

Doug Hollis
A Sound Garden
1982–83
Seattle, WA

Siah Armajani
NOAA Bridge
1983
Seattle, WA

Page 97

Martin Puryear
Knoll for NOAA
1995
Seattle, WA

George Trakas
Berth Haven
1983
Seattle, WA

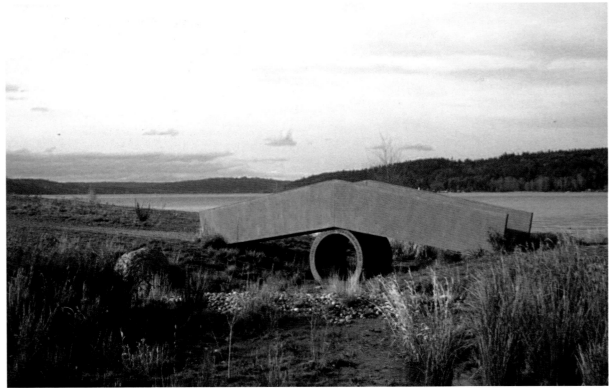

ultimately, controlled the project, led Serra to resign the public art commission.

Nancy Holt, whose explorations of natural light in her Utah *Sun Tunnels* and her associations with husband Robert Smithson ensure lasting expressions of Land Art, defined three modes of collaboration. In the first, two equal professionals conceptually collaborate to create a unique work that is greater than each could have accomplished separately. The second is a correlative relationship, in which an artist or architect informs the work of the other, and each brings their own special training abilities and intelligence to the project. The third is cooperative collaboration; a working team including construction teams, fabricators, architects, landscape architects, engineers, community workers, and representatives of civic institutions.[59]

Holt's *Dark Star Park*, the first work of public art in Arlington County, Virginia (1984) and Jackie Ferrara's work with Cardinal Industries are but two examples of productive collaborations involving client, artist, and workers, who together developed methods of design and expression. Holt always felt that her collaborations with workers in fabricating her sculptures affirmed her strong sense of artist as maker and builder. And chairman of the Arlington County Board Ellen Bozman remarked on another level of productive collaboration: "*Dark Star Park* is significant both as a work of art and as the product of a creative alliance among local and federal agencies and the private sector."[60]

A highly collaborative project at the National Oceanic and Atmospheric Administration (NOAA) in Seattle helped to reclaim the waterfront for workers and visitors and demonstrated artists' early sensitivities to the environmental implications of their work. In a loose collaboration, five artists synthesized landscape amenities and individual site-specific works. Each of the artists – Scott Burton, Siah Armajani, Doug Hollis, Martin Puryear, and George Trakas – staked out their own territory after a few group meetings. Trakas nominally took charge, but the artists' mutual respect characterized the effort. By building rustic bridges, rocks as seating, wind-harps as sound sculptures, and wildflower bordering walks along the water, the artists transformed nature, in keeping with the Agency's mission. The harmony of the waterfront environment owes much to the synergies among the artists as well as the sensitivity of the selection committee to the artists' work.

The city of Port Townsend, Washington employed an unusual, but successful, competition process for the design of a waterfront environmental art piece; the art committee selected artists individually and then paired them to create three teams. San Francisco artist Doug Hollis and Philadelphia artist Charles Fahlen had not previously known each other's work. Other teams were Lloyd Hamrol and Buster Simpson, and Joan Brown and Charles Greening. Brown, a painter who also works in tile, was wildly enthusiastic about her

Nancy Holt
Dark Star Park
1979-84
Rosslyn, VA

experience working with Greening, a sculptor she called a "Renaissance man." The artists felt their collaborations were conceptually and personally satisfying. Egos set aside, the teams were emboldened to take creative risks and to merge ideas and abilities in works that would not have happened had they worked separately.

Collaborations are not formulaic. Although in a traditional architect/artist collaboration, the architect created a place for art, and the artist conformed to the requirements of the design, in the best of collaborations, the distinctions between disciplines blur, and the relationship takes on a life of its own. The artist may act as design catalyst by challenging accepted thinking.

Scott Burton, Richard Fleischner, and Kenneth Noland collaborated with I.M. Pei & Partners on the Jerome Wiesner Building, home to the List Visual Arts Center. While other artists had been invited to participate, Fleischner ventured that they had declined because of "what seemed an overly controlled situation. Those who stayed to complete their artworks were challenged by the limitation, struggled with ideas imposed and believed they'd won."[61]

In Anchorage, Alaska, the city's Art Committee commissioned artists for the new Museum of Art and History without consulting the building's architect, Steven Goldberg, of Mitchell-Giurgola Architects. Goldberg and his firm had long been comfortable partnering with prominent artists: at stake was the art's appropriateness for the building. I was enlisted by the architects to identify an appropriate artist and to help change the client's mind. We selected Ned Smyth to create a work of art for the principal entrance. His work was appropriate in terms of scale, material quality, and sculptural form, but we also felt he could work with the demands of the committee for relevant Alaskan imagery. Goldberg flew to Alaska with slides of Smyth's work in hand and convinced the committee that any art integral to the building facade was the architect's rightful provenance.

Smyth had explored the site and studied the cultures of Alaskan peoples, concluding that the native-Americans and Eskimos seemed to be out of place in their own land. *The Intruder* is a huge marble, glass, and gold mosaic owl, a bird invested by native peoples with mystical and spiritual powers. Allegorically the owl was to "protect the museum and [to] reflect the museum's role as guardian of Alaska history and culture."[62] Unbeknownst to Smyth, the architects, and the museum, the native Tlingits regarded the owl as a symbol of death and would not enter the building under the mosaic. Underscoring the synergies between artist and architect, the architects added a new entranceway to accommodate museumgoers who found the art objectionable.

Doug Hollis
Sky Column
2021
Long Bridge Park, Arlington, VA

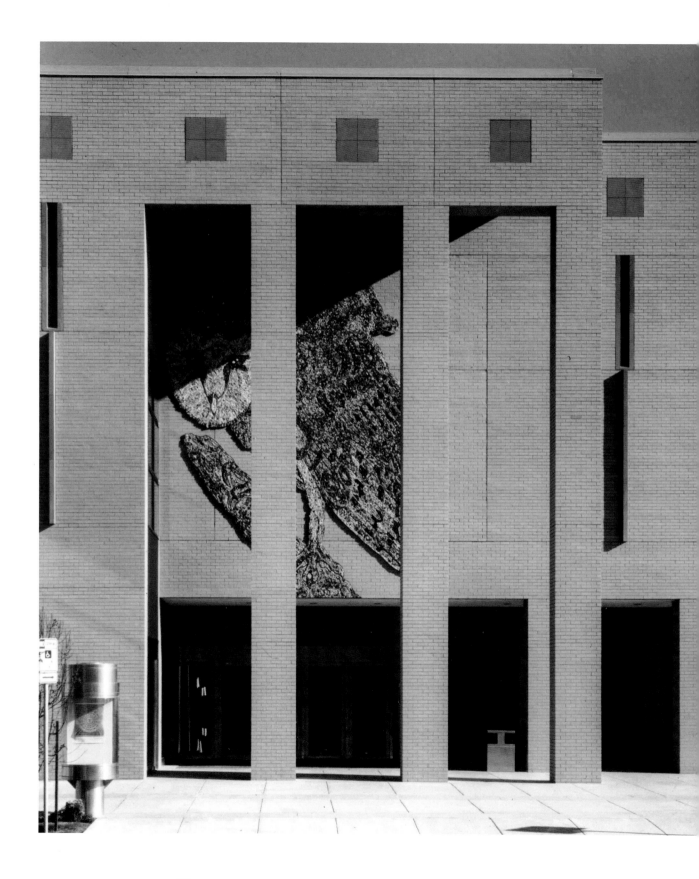

Ned Smyth
Intruder
1985
Anchorage Art Museum, Anchorage, AK

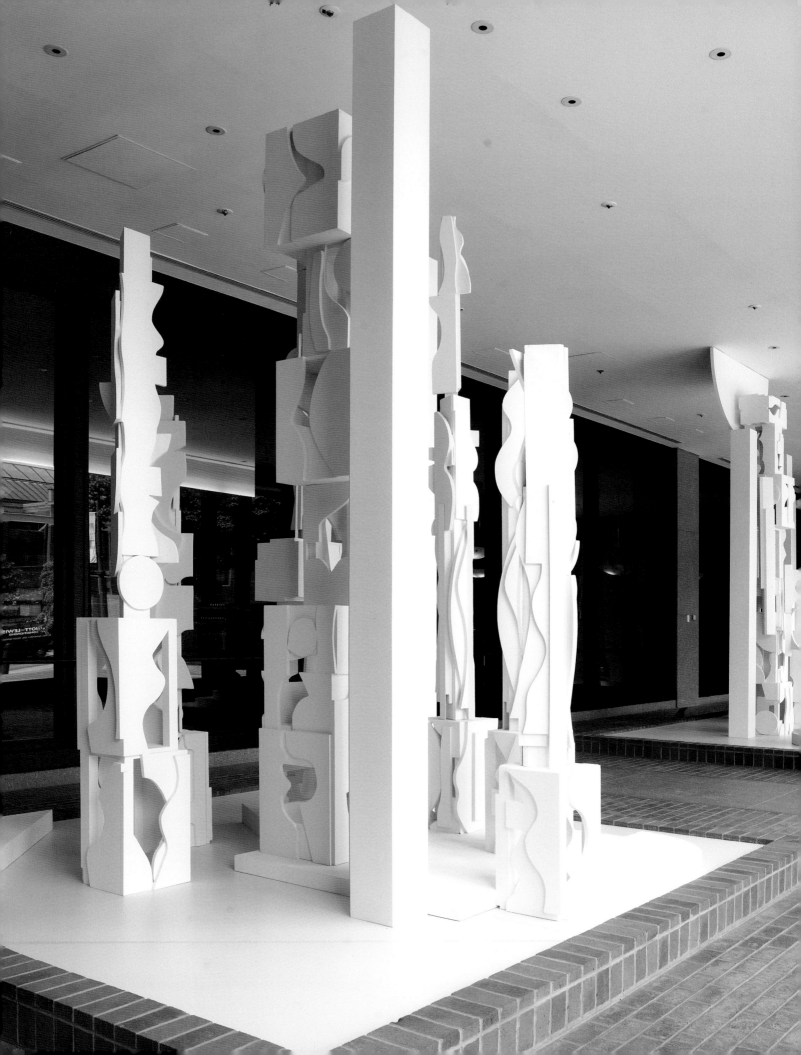

IV
PROCESS AND PRACTICE

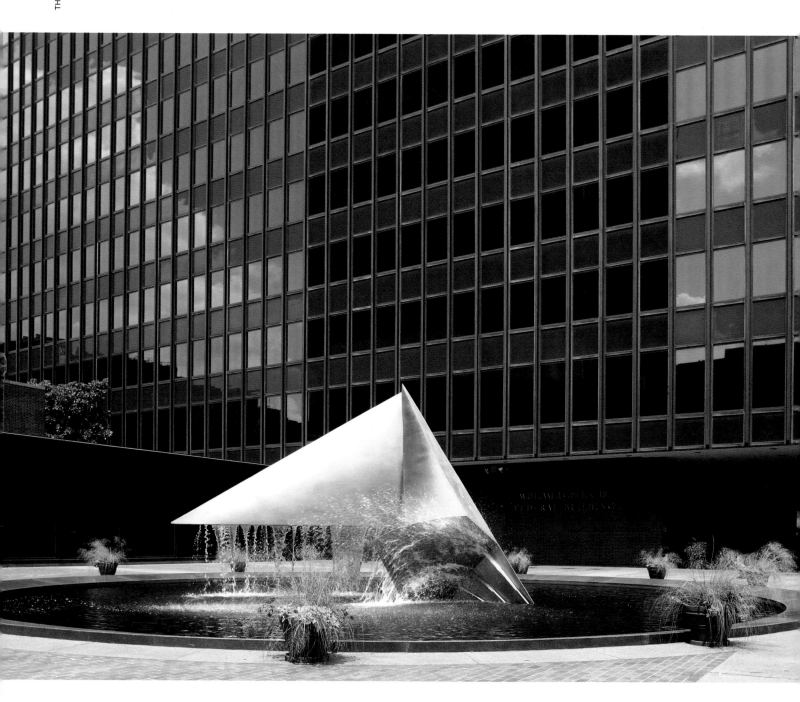

Entertaining them is all well and good ... but does it make them think? ... Don't ever give people the thing they expect just because they expect it. Our job is to surprise them, to shake them – to turn their expectations on their heads. And do you know why? ... Because that's when the MRI of their brain lights up, and they begin to see.[63]
— Ursula Le Guin

It is difficult to transfer whole cloth one set of guidelines to another context. Flexibility in defining guidelines is important, but once in place, you also have to aggressively facilitate guidelines in order for a project to work.[64]
— Patricia Fuller

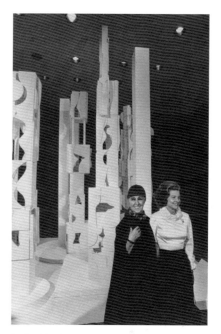

Louise Nevelson
Bicentennial Dawn
1976
(Installation view with Louise Nevelson and Betty Ford)
Philadelphia, PA

Successful public art does not happen by accident. Creating art for public places affords the artist an opportunity and a challenge not provided by producing works for galleries or museum exhibitions. The commissioning procedures affect the quality of the art and indeed, underscore its publicness. The process, with its inherent frustrations, achievements, and satisfactions, engages all the players, including architect, client, and artist in the total project, in bringing outstanding contemporary art into our daily experience. The commissioning process anticipates problems inherent in the uniqueness of the project and recognizes appropriate solutions. Creative tension is advantageous.

Process is not a sexy topic for a book – most contemporary books avoid it – but it is essential. Few projects would advance beyond the concept phase without a comprehensive process that embraces, educates, empowers and inspires, artists, stakeholders, and communities.

I left The Pace Gallery after ten years to establish my own practice as an independent consultant and curator of art in public places. I loved being at Pace: my years there taught me about the vulnerability of art and artists, about both the predictable hurdles and the unpredictable politics of effecting art in public places, and about the complexities and joys of negotiating among the competing interests of artists, clients, municipalities, regulatory agencies, and legal bodies. But I wanted to expand my reach. As independent public art adviser, I was able to work anywhere and with any and every artist. I was intent on being close to this energy and making public art happen. Notwithstanding enabling legislation and receptive communities, it would not be easy, but it would be exciting.

Particularly in the early years of my practice (which coincided with the new wave of art in public places), I was asked frequently about my role as a public art adviser: was I broker, public relations agent, artist's representative? And the existential corollary: why are public art advisers necessary at all? Public art coordination plays a vital role in mediating between artists' uncompromising

Page 102

Louise Nevelson
Bicentennial Dawn
1976
Philadelphia, PA

Page 104

David von Schlegell
Voyage of Ulysses
1977
Philadelphia, PA

commitment to their art, and the logistical, social, and developmental needs of the project. In a field fraught with egos, politics, interest groups, competing aspirations, and personal tastes, the power and meaning of a work is not always obvious to the client or to the public; and likewise, the artist is often naïve about the complexities of public responsibility. I have always described my role as interpreter.

My process is founded in essential precepts and confidence in the positive affective qualities of art – that it opens minds, stimulates, and challenges one to question and to see the world through an unfamiliar lens. Moreover, as a focal point of public open space, it sponsors shared experiences and reinforces community.

Many public projects are unable to attract our best artists. Laypersons – non-art professionals – generously devote time to artist selection committees and are a critical voice for the community but often prefer traditional representations to unfamiliar contemporary art. The involvement of clients, architects, engineers, community committees, and others can doom a project in the absence of proper management.

The dual role of an art coordinator is to impart understanding of the artists' compulsive quest for the integrity of their art and to make the artist aware of and knowledgeable about the community and development needs of the project. How do we identify the artists and what procedures can help artists achieve their goals? How can we convince clients, whoever they are, to take a leap of faith? My experience over many years illustrates that by and large artists will exceed our expectations if only we do not get in their way; ultimately, most care more about the integrity of their art than about pleasing their client.

Clearly defining project goals, management structure, and any other project requirements is an essential first step in ensuring all participants understand and appreciate each other's role in the project. While selection of artists is based on their work, managing their personae – how they see the world, how they think, how they define place, whether they are agreeable, testy, outgoing, reserved, communicative – is my challenge. My job is to ensure communication, to mediate competing interests: ultimately to interpret the artist for the client, the architect, or the developer and to facilitate the artists' understanding of public processes, the regulatory environment, and the client's aspirations. Both are crucial. I am an advocate for the project: if artists do their best work, everyone wins; if anyone adversely interferes with the artwork for whatever reason – including a misalignment of expectations with budgetary realities – everyone suffers.

What is your mission?

The short and obvious answer is to ensure excellence. But this begs the question: what is excellence in public art? Successful art in public places enhances architecture and the specific natural or urban context and at the same time authentically expresses the personal aesthetic of the artist. Advisors who commission living artists must be open to pluralism in form and imagery from the abstract to representational, from the object to art as environment. Advisers must be conversant in diverse new media used by innovative and inventive contemporary artists. While I certainly applaud originality, my primary criterion for recommending artists is an authentic and uncompromising personal viewpoint. Any artist considered for a commission must be "museum-qualified." I grappled with philosophical and practical issues: public spaces should be enriched with the best art, and mistakes cannot be hidden in the archives. Our best public artists are problem-solvers, fully aware of the permanence of their work and its impact over time.

What is the role of the independent adviser in the art-making process?

My role in the art-making process is a balancing act. Internal percent-for-art staff, for example, in the office of a mayor or cultural administrator, may have an insider's knowledge of people, places, and politics. But their agencies often do not support travel to see the fresh and new. The independent public art adviser is a neutral participant. The adviser is the seasoned outsider who brings a fresh, expansive, and non-politicized viewpoint to the process. We have no insider knowledge or prejudicial information. We are free of allegiances. We are given the opportunity to re-direct established viewpoints and concerns in an open and positive way. We offer our experiences with other projects and other commissioning groups; discussion of alternative processes illuminates the challenges at hand.

Of great significance is that we prompt the client or community to explore issues openly, voice disparate ideas about artists and content, and formulate a meaningful mission, all of which can positively inform the final artwork. We counter the inclination of committees and juries, who in thinking immediately of artists they may know or artists that petition them, short circuit the selection process. Many artists tell of submitting for projects only to learn that local artists were preferred. They wonder whether they were truly considered? Whether the process was subverted by local interests? Disagreements between local artists and politicians can be averted or placed into context by referencing the conflicts and resolutions of other communities. Every jury or artist selection committee needs an objective "outsider" to provide a clear unbiased opinion about artists and process.

That said, not all public art advisers work the same way. Too many percent-for-art professionals encourage artists to find them rather than actively seeking out exceptional artists. On the flip side, too many "public artists" develop an acceptable but colorless vocabulary rather than defining their personal vision and pushing boundaries. Too many percent-for-art programs fail to recognize the value of staff members' attending international art fairs such as Documenta, Venice Biennale, and Art Münster, where they would encounter the work of new artists with inventive ideas and highest standards.

How do you secure your commissions and what is your scope of work?
I am asked how I find my clients or alternatively, how does a municipality, government agency, corporation, or university find me? I cannot say the business aspect has always been easy, but the profession is a "world" of its own. As in other disciplines, contacts and reputation are important – I have been at this a long time. I am a member of the Association of Professional Art Advisers; advisers do not all do the same thing – some consult privately, some assemble corporate collections, some advise institutions or developers on public art – but we know one another, and we share information. Sometimes I have been contacted directly by a client; other times I have participated in an open call for consultants, a selection process requiring interviews and presentations.

An art consultant's scope of work encompasses a synthesis of all the players' needs. We are the problem solvers, art educators, and project managers, acting as liaison for everyone from attorneys to installers. The quality of the art, its creative integrity, and its appropriateness to the architecture, spatial environment, and function are preeminent. Access to the user community is an additional critical factor for public success. My work may begin with artist selection – the most important decision in the commission process – but it does not end there. Diverging from traditional practice, my preferred scope includes managing the entire process to ensure the physical realization and placement of the art. Navigating these requires a strong advocate.

Have you any role models?
Since the advent of percent-for-art legislation, cities and government agencies have typically employed internal public art consultants. For me, Donald Thalacker, a brilliant, enthusiastic, and open-minded young architect at the GSA, who became a great friend and collaborator, was the apogee.

As part of the GSA's renewed commitment to elevating the quality of design for new and renovated government buildings throughout the country, Thalacker was tasked with selecting and facilitating all major public art projects. Working with the NEA, which assembled juries of art professionals as decision

makers, Thalacker was responsible for hundreds of art projects during his tenure from 1972–1988. One need only refer to his 1980 book, *The Place of Art in the World of Architecture*, to appreciate his impact.

During my years at Pace, Thalacker and I worked on several projects together, among them Louise Nevelson's *Bicentennial Dawn* and David von Schlegell's *Voyage of Ulysses* at Independence Mall in Philadelphia but as importantly, we brought our respective worlds together. I mentored him informally about the art world. And with other art professionals, including NEA officials and museum curators (notably in the early years, Brian O'Doherty and Richard Koshalek), I helped GSA to identify the best aspiring and established American public artists for consideration.

Thalacker was one of my important resources for process and procedures. I adopted his GSA selection process for ranking artists; i.e. ranking three to five artists appropriate for the project, but asking only the highest-ranked for a proposal. If that artist's proposal did not move forward, for any reason, the process had additional worthy candidates to consider. I shared Thalacker's conviction that many serious artists generally do not respond well to competition; therefore requiring multiple formal proposals often severely limits the field. Regrettably, many percent-for-art projects throughout the country insist that competitions are the fairest and most objective means to assess an artist's appropriateness for a commission.

What does the client typically want?

My work begins when a client contacts me, typically after having identified a specific place for art. Whether a municipality or a corporation, the client depends on me to introduce appropriate artists. I meet with the clients and visit the site. I ascertain whether they want to engage in a limited selection process, where I suggest just a few artists, or an expansive open call. Do they want to dramatize the process? Do they want a highly transparent artist selection process? Do they have an established art program, and if so, what role does art play in the identity of the town or company? How much money do they have? Will they consider only local or regional artists, or do they have national or international ambitions?

Oftentimes this work entails my working directly with internal corporate art advisers, whose purview is consulting on collections and who are not familiar with the complexities of realizing public art.

How do you organize the client?

Evaluation and selection are ideally based directly on artists' past work and a determination of appropriateness for the project. Limited competitions invite

a selected number of qualified artists. Open calls advertise publicly and, for government groups, are considered most democratic. I structure selection processes to meet clients' specific needs. Combining experience and intuition, I have been involved with countless artists, percent-for-art projects, corporate and private clients across the country and in the world.

Regardless of project parameters, the first order of business in an artist selection process is to assemble a committee. I prefer working with large committees, which reflect many points of view, bring extensive experience to the table, and best articulate community desires and issues. Encouraging all members of the art committee to appreciate the value of working together toward a common goal is central.

I do not limit the number of committee members; four or five participants tends to be the norm, but I have managed successful committees of fifty or more. I insist though on having at least one museum curator and an "outsider." The professional's experienced eye and knowledge of art and artists and the outsider's distance from local artists, residents, and politics balance the investment of interested participants, who take ownership because they work in the building or are residents of the community. I want the committee to reflect its community, and I depend on authentic participation.

Artist Selection: Open Minds, Educate

Shortsighted civic leaders and overly politicized processes sometimes infantilize the viewer, assuming the untutored will neither understand nor appreciate art. The problem may lie not with avant-garde art per se, but with bureaucratic selection committees, which, in setting their sights too low or bowing to politics, decide ultimately in favor of banal familiarity over enduring public art. Public art that succeeds despite initial reservations defies selection processes that try too hard to play it safe. Are selection committees too fearful of controversy? Does an enshrinement of political correctness and committees' advocacy of artists with limited ability doom some worthy projects? Do inadequate proposal fees discourage well-qualified people? Does a focus on practical issues overshadow art's potential for universal meaning?

Innovative proposals may be voted down by skeptical selection committees dominated by lay people lacking a background in art. Sometimes they are rejected because the art is thought to be unfamiliar, political, or controversial; judgments that often as not, spring from social and cultural forces.[65] But even well-qualified committees have been stymied by the complexities of bringing a work to fruition or finding ways to ensure that the best artists are encouraged to participate. A project by a superior artist may be undermined by the difficulty of coordinating input from various constituencies:

Michelangelo
David
1501–04
The original outside the Palazzo Vecchio, Florence, before it was moved in 1873.

architects, engineers, fabricators, funders, community groups. Politics aside, formal processes and risk-averse committees can conspire, sometimes unwittingly, to favor safe art over art that challenges us to broaden our perspectives. That art may remain only a vision.

For these reasons, critical ingredient in the artist selection process and, subsequently, a successful outcome, is an informed client. At the beginning of a project, my immediate goal is to open the minds of the committee members who may understandably have pre-conceived ideas and personal preferences. I re-direct their enthusiasms by educating – I give a visual presentation of historic and modem public art from all over the world as well as successful examples of contemporary public art. I do not suggest specific themes or images, but rather introduce an extensive and diverse program of proven excellence that excites, educates, and illuminates the potential of the field.

It works. I show images of Michelangelo's *David*, Bernini's *Fountain of the Four Seasons*, Rodin's *Burghers of Calais*, which took sculpture off the pedestal and brought emotional realism in art to a larger public. I show contemporary representational art by Oldenburg, Lichtenstein, and Donald Lipski; abstract art by Noguchi, Calder, Mark di Suvero, Tony Smith and Louise Nevelson. Maya Lin's *Vietnam Memorial* created a new paradigm for the commemorative monument while the Eiffel Tower and Saarinen's St. Louis arch proved that feats of engineering and architecture could be considered public art. Ecological concerns pioneered by Robert Smithson and Nancy Holt forever brought earth and landscape art into a vital contemporary idiom. We show Central Park's *Balto*, the heroic Husky, and Jose de Creeft's *Alice in Wonderland,* which have delighted generations of New York City children, and WPA murals that helped artists survive in the Depression and left a legacy of outstanding art in government buildings across the country. In the 1960s, Nam Jun Paik gave us new media artworks that paved the way for later artists to bring light, sound, and moving images to public places; I introduce video and performance art inspired by the curator RoseLee Goldberg's long history with performance art revitalized in the 1990s.

During the innovative 1960s, visual artists, film, theater, music, and dance artists encircled each other and drew out alternative mediums to further their own art, forever opening the arts to collaborative actions. RoseLee Goldberg, a critic, early on documented these happenings (and performances) and forty years later founded PERFORMA to bring new multimedia artists into the mainstream. A strong and diverse committee is the springboard for a project evolving into a meaningful artistic expression rather than simply being an object within a plaza or a lobby. I emphasize that in the last fifty years, public art has matured from commemorating a place, an individual, or an historic moment into statements about urbanism and the passion for making places.

Nam Jun Paik
Something Pacific
1986
Stuart Collection, UC San Diego, CA

Mark di Suvero
Joie de Vivre
1998
Zuccotti Park, New York, NY

Donald Lipski
Spot
2018
Hassenfeld Children's Hospital, New York, NY

Artist Selection: What are the possibilities?

When we begin to talk about the specific project, probing beyond the obvious and teasing out the underlying desires of the committee members is my quest. I introduce a long list of contemporary artists whose work is relevant to the commission. Depending on the project, that list would include fifty to one hundred artists, selected from my archive of over a thousand artists. I updated the archive by constantly visiting galleries, museums, and art fairs worldwide.

I also rely on the leaders of non-profit organizations such as Residency Unlimited, No Longer Empty, Creative Time, American Federation of the Arts, Independent Curators International (ICI), Art21, Sculpture Center, Artists Space, The Mattress Factory, RxArt for Hospitals, Capp Street, among many, and importantly art curators for their fearless pursuit and presentation of emerging artists and progressive ideas and movements in the arts.

Further ensuring the currency of the archive, I continually ask artists for slides of their new work, including importantly, any unrealized proposals. These complex, exotic, even shocking proposals typically are important indicators of new directions. With interpretation, they can expand the visual knowledge of lay committees, public officials, architects, and community agencies. Many artists have dreamed visionary ideas that, although unrealized, deserve to be considered. If art in public places identifies the distinctiveness of our cities, plazas, and public spaces, it may be instructive to revisit unrealized proposals and to imagine what noteworthy unbuilt art might do to enhance our environment and our lives. Frequently, artists' most innovative and meaningful works are their personal favorites; at the same time, they acknowledge that these may be less accessible to artist selection committees. These concepts are not necessarily more authentic or inventive: but they add another dimension to an artist's oeuvre.

Open, educative discussions that guide interested parties to discern quality tend to promote a better understanding of artists' ideas and to encourage a more adventurous selection process.

How do I define relevance? I identify artists whose ideas are most likely to resonate with the site, the community, the aspirations, and whom I believe can work within a budget. Whether the committee knows of an artist but is not familiar with the art I present or is familiar with the work but cannot identify the artist or neither is immaterial. I want people to experience art in the moment, to look with their eyes and not their "ears"; the goal is to reinforce the affective and affirmative power of public art. If internationally or nationally-known artists are members of the community, I place their names on my longlist for a commission with an important caveat: familiarity with the local context is secondary to the stature of the artists and nature and quality of their work.

Artist Selection: How do you arrive at a consensus?

Perhaps ironically, given that consensus is the ultimate destination, I am adamant about limiting conversation. I have found that critical commentary among committee members at the beginning of the selection process can prejudice jurors (whether neophytes, aficionados, or connoisseurs), skewing the evaluation to the detriment of the project.

I have many anecdotes – or call them horror stories – about how a single remark can poison a process, prejudicing a committee against good and appropriate artists. A colleague chaired a committee to select an artist for a site at the future home of the Charlotte, North Carolina basketball team. Joel Shapiro, known for his athletic and dynamic sculptures, was chosen. Apparently, one dissenting committee member opined that the prototype looked like a child's toy – a Gumby. Negativity took hold, extending to local talk radio, which labeled it a "Headless Gumby." Shapiro hadn't a chance, and the project was awarded to another artist. Whether a committee member derides purposefully or is simply joking, comments can be deadly. I strenuously limit conversation that is not meaningful or positive during review of artists' works. We see this in political competitions. It's the negative soundbite that negates often the most qualified candidate.

A level playing field is critical: I organize my presentation alphabetically by artist, showing ten to twelve works of each – enough to demonstrate an artist's scope and reach and potential appropriateness. As we move through the presentation and with no discussion, I ask committee members to rank the artists on printed scorecards that list the artists' names alphabetically. They rank them on an ascending scale of one to five. Those who receive a designated number of votes comprise the shortlist; sometimes I intercede, suggesting that we retain an artist who has been eliminated and asking if anyone has strong feelings about any other. At least three to five "elimination rounds" are required to generate a shorter shortlist of ten, all of whom are capable of completing the project. I then present the artists' work in greater depth, we talk about each and rank the remaining artists, one to ten. Through further discussion, we generate a shortlist of three to five, which we rank again. By this point, the committee has taken ownership of the process, the list, and the project.

I contact the highest ranked artist. Should the winning artist not work out for any reason, I approach the next ranked. Following Thalacker's practice at the GSA but unlike the selection process of many municipalities, I neither inform artists that they have been shortlisted nor do I ask them to compete. Treating artists as working professionals dignifies their art and creates value that is reflected ultimately in public acceptance and appreciation. In my experience, when artists agree to a undertake a commission, they commit

wholeheartedly; if the selection process pits one proposal against another, a curious reluctance tends to inhibit artists from producing their best work. All of which is emblematic of a critical distinction between artistic production and commodification. In truth, the selection of an artist for a work of public art is based on confidence that their creative intellect will engage the particulars of the problem in a most inventive way; we are not buying a product.

Is a formal open competition a viable option for artist selection?

Only once have I ever conducted a competition: resolution of the political and cultural complexities of the *Irish Hunger Memorial* in Battery Park City demanded a formal public design competition. Although competitions for public art, like those for major architectural projects, often inspire adventurous and unusually imaginative entries, the mediocre, familiar entry can become the winning choice.

It is true that competitions offer inexperienced younger artists great challenges and visibility. They often will throw their hat in to the ring. However, commissions awarded on the basis of a competition may lose the participation of mature, highly qualified artists with extensive experience. For them, formal competitions, whether compensated or not, are expensive and time-consuming.

Well-conceived competitions have value as community events that draw positive attention to public art, build anticipation, and promote civic ideals. For the *Irish Hunger Memorial,* we compensated the artists generously encouraging well-developed proposals and large-scale macquettes. To underscore the Memorial's importance in illuminating current issues related to immigration, world hunger, and democracy, and as a further incentive to the artists, we envisioned an exhibition of all five proposals to be held in the fall of 2001. In the wake of the 9/11 terrorist attacks, we were unable to follow through with these plans.

My Job: Managing the Process

Crucial to a successful project is management. Public art advisers and consultants can have a pivotal role in guiding the process from artist selection to installation. We try to synthesize the needs of all participants. We help to mediate interpersonal relations, establish and maintain a positive climate. We expedite contract negotiations, fabrication, site planning and preparation, shipping, insurance, and installation. In the interest of the project, the consultant communicates effectively with appropriate government agencies, fabricators and subcontractors.

As I reflect on my fifty-year career in public art, I realize how spectacularly lucky I was to have begun my working life at The Pace Gallery. Pace represented

artists in the fullest sense, establishing and cultivating their reputations through exhibitions and promotion encouraging them to realize their best work. The driver was not profitability, but support of the individual artist's creative mission. As Director of Commissions, I was also committed to the artist from the beginning of a project until its installation on the site.

My business model for "Works of Art in Public Places" is the legacy of my experiences at Pace. Coordinating and curating the selection process is a first and vital step but ensuring that realization of the work never compromises the integrity of the artist's concept is crucial. Critical to my practice has been remaining as the project's manager during the entire process. This allows me to fully address the problems that inevitably arise in connection with project implementation and construction. I act as the artist's advocate, to ensure that their work is never compromised, which as I explain to the clients, is in their best interests as well.

In addition, I always suggest that the selection committee – who chose the artist, and presumably wants the completed work to fully reflect the artist's intentions – to remain available in an advisory role, should any problems occur. Thus, we expand the committee's role as an additional guarantor of the successful fulfillment of the project. To that end, I try to keep the committee apprised of all developments. It was Victor Ganz, a prominent art collector and an initial sponsor of public art at the Hugh Carey Battery Park City Authority in New York, who suggested this significant role for the art committee. I have followed his suggestion ever since.

Do you guide the artist?

The best public art reflects the artist's creative vision, and at the same time, responds to the unique circumstances of the project. That said, I have little patience for artists who proudly proclaim that they always give the community what it wants. Writing in *The New Yorker*, William Shawn eloquently and directly captured the fallacy of indulgence: "In the realm of literature, of art, of creative journalism, to attempt to give readers what they 'want' is, circularly, to give them what they already know about and have already had, and thus to give them nothing. People who are creative are eager to strike out into new territory and to see, discover, and say what has not been seen, discovered, or said before. The writers and artists and editors of *The New Yorker* simply go where their own talent, imagination, energy, curiosity, and conscience take them."[66]

The process is nuanced; the artist empathizing with underlying passions, aspirations and the issues that truly matter to the community. Among informative examples are Lauren Ewing's sensitivity to the threat posed by extensive urban renewal to the history of a Philadelphia neighborhood *(Subject/*

Object, Memory), Brian Tolle's intuitive understanding that a visceral connection between the *Irish Hunger Memorial* and "a piece of the old sod" would be critical to the project's success, and Maya Lin's employing a beloved skating rink as the central element in the transformation of downtown Grand Rapids (*Ecliptic*).

Who are the administrators of public art processes and what is the origin of guidelines?

Most often, my client is a city appointee tasked with administering a percent-for-art program. The consultant's role is to help the client and the community understand the creation of the work from proposal to installation. They could be from the mayor's office, the Office of Economic Development, or the public art commissioner. Imperative is an awareness of the entire design, fabrication, and installation processes and faith in the artist's ability to develop a meaningful public art work from concept to realization.

Most cities today have an Arts Administration. Philadelphia is an early positive model for public art programs in America: their visionary city planner Edmund Bacon largely shaped the modern city. During his tenure as Executive Director of the City Planning Commission from 1949–1970, the Redevelopment Authority was established; its fine arts division is responsible for hiring art consultants to coordinate artist selection for the city's exceptional art program, which continues today.

Currently, there are over five hundred percent-for-art programs in government administrations, cities, counties, and states throughout the United States. They are not all perfect: as every city or government agency has its unique character, so too will its arts program. What they share is their purview: in the United States, and in fact, the world, public commissions tend to be works for courthouses, post offices, municipal buildings, libraries, schools, parks, etc. Atypically in Philadelphia, Alexandria, and Baltimore, the reach of the art commission extends to corporate and commercial buildings as well.

How are art projects funded?

Underlying any project is the need for a realistic art budget. Although percent-for-art legislation mandates allocations for government projects, others are funded by developers or corporations to underscore a building's identity, elevate a company's stature, enhance the surrounding community and the workspaces of employees, and often improve tenant, community, and employee relations. As in government projects, ideally the budget for art is allocated early in the process and is a percentage of the total construction budget.

Spending one-half of one percent to two percent of a project's construction cost is customary and realistic. Responsibility for planning the

budget is shared by all participants. The artist requires resources sufficient to create and construct a work of appropriate, durable, and maintainable materials on a scale appropriate to the site, the building, and the larger context. The budget is apportioned to cover artist's fees, materials, fabrication, administrative costs, legal fees, travel, engineering, site preparation, installation, shipping, and insurance. Throughout the process, clients' incremental payments are protected by project insurance.

Why is a contract necessary?

Contracts between the artist and client are best written in clear language and executed before any work begins. Contracts state the responsibilities of all parties, anticipate problems, and outline mechanisms for solving them. In disagreements, contractual arbitration is preferred. By law, copyright and reproduction rights reside with the artist, but the use of images for public relations is a client's right. While the client/owner is responsible for restoration or repair, the artist must provide instructions for maintenance. Absent, or in addition to such guidelines, requiring the client to seek the advice of the artist is advisable, thus ensuring the integrity of the art, the artist's reputation, and the value of the work itself.

Does the process make a difference?

The process most definitely affects the quality of the art. One can easily name those cities and other entities that sought experienced role models for setting up their programs. Unfortunately, those that did not often fell prey to inferior art and difficult procedures that mitigated against better artists participating. Well-conceived guidelines lead to the best art and help new percent-for-art programs define procedures that have been successful. Why reinvent the wheel? My own projects have benefited from guidelines that are comprehensive and logical. I can share them with my clients, which lends credence to better practices.

Pages 120–121

Michelangelo
David
1501–04
Galleria dell'Accademia, Florence, Italy

V
PROJECTS

CAN PUBLIC ART ENHANCE PRIVATE LIFE?

In his landmark television series, Civilization, *standing before Notre-Dame, the art historian Kenneth Clark asked: "What is civilization? I don't know. I can't define it in abstract terms – yet. But I think I can recognize it when I see it." He turned toward the cathedral: "And I am looking at it now."* [67]
— Michael Kimmelman

Art sharpens our perceptions. To walk into a public building and see works of art may cause us to stop in front of an abstract painting and wonder, "what is it, what was the artist trying to do?" At that moment, the blinders that habit puts on us come off, and we really begin to see. Later during the day we may find ourselves looking at familiar things in an uncommon way. [68]
— Joan Mondale

In the 1950s and 60s when artists began to move beyond galleries and museums, public art gave them a unique place to continue making art. The greatest, most lasting public art has always reflected the intense personal vision of a superior artist, from Michelangelo's *David* to the great contemporary public art of the last century.

Contemporary public art celebrates with a diversity of imagery and ideas. The obsessive creative energy found in those conceptual artists of the 1950s and '60s who actively sought to make their art in the public realm gave rise to a new kind of problem-solving public art, far beyond stone and steel "Plop Art."

Superior artists are perfectionists. An artist's integrity is built upon the obsessive pursuit of their personal vision and their self-disciplined artmaking. Imagination, originality, passion, and even impulsiveness fuel artists in their search for new meanings that challenge the rules and social practices of the community. Paradoxically, these artists seek to reach a larger public with their works, and to enrich the public's understanding of the arts.

In the more than four decades since 1972, when I became the Director of Commissions at The Pace Gallery New York, I have been actively planning artist selection processes, managing projects, writing guidelines for public art programs, and advising municipalities on issues of placemaking, preservation, public/private partnership, and positivism. This allowed me to best address artists' intentions, the realization of public art, and the threats to its existence.

Page 122

Robert Morris
Steam Gardens and Framed Vistas
1992
(Installation view with Joyce Pomeroy Schwartz, 1992)
Pittsburgh International Airport, PA

Page 124

Man Ray
Untitled (Paris Street Scene with Notre Dame)
ca. 1925
The Israel Museum, Jerusalem, Israel

Placemaking

… to my mind, the basic issue of a work of art, whether it is architecture, painting, or sculpture, is first and foremost, for it to create a sense of place so that the artist and the beholder will know where they are. [69]
— Barnett Newman

Q: Why didn't you make it larger so that it would loom over the observer?
A: I was not making a monument.
Q: Then why didn't you make it smaller so that the observer could see over the top?
A: I was not making an object. [70]
— Tony Smith

Art is becoming a tangible reality to the public. People are beginning to pass this stuff on their way to work. As art becomes public in this way, people will develop a judgement about it, a sense of universal style. [71]
— Tony Smith

As we have learned from major European cities, whose histories are long and whose commitment to art in public places is undeniable, public art can have a perceptible and positive impact on the urban environment, permeating the greater public consciousness over time; and over a long term a sense of belonging.

Two seemingly contradictory tendencies emerged in the 1980s: a return to art for art's sake, and a renewed interest in socially and environmentally responsible art. Art in public places had rapidly evolved beyond the traditional commemorative statue and "plop art" to conceptual placemaking. Said artist James Wines, "I wrote a critical essay for *Art in America* titled 'Public Art– Private Art' in January 1970. The essay introduced two terms – 'plop art' and 'turd in the plaza' – as disdainful descriptions of interior objects masquerading as public works." [72] Object-gallery-museum art coexisted with art created for a specific public context. Committees' ambitions for artists shifted; communities understood that art could profoundly enhance their public places; and artists were excited to engage new contexts, content, scale, materials, and audiences. In other words, expectations expanded, stakes were higher, and the processes more complex. The artwork's relationship to its site became ever more important. Site and art became one.

Urban revitalization efforts of the 1980s were intended to infuse new life into cities' downtowns, which had suffered from the suburbanization of the

Bernar Venet
Ligne Indéterminée
1992
Norfolk, VA

Nancy Holt
End of Line/West Rock
1985
Newhaven, CT

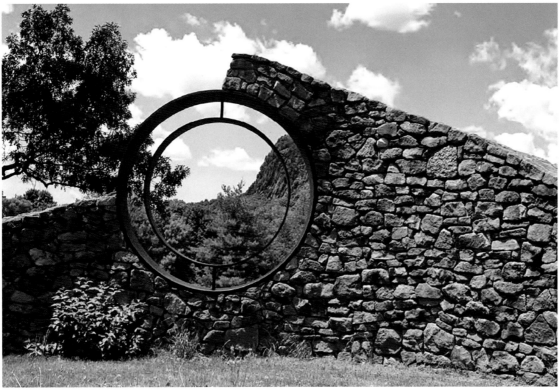

1950s. Small cities were designated by the NEA Livable Cities Program to place signature works of public art in city centers. The revaluation of Main Street signaled a move away from the decentralized, homogeneous suburban malls that had become America's town centers. Percent-for-art legislation concretized and accelerated the reconsideration of urban city centers such as universities, parks, and main streets as stages for art, architecture, and landscape. Examples are Bernar Venet's *Untitled* in Norfolk, Virginia, Doug Hollis's *Untitled* in Willimantic, Connecticut, Jene Highstein's *Tem Ptah* in Lincoln, Nebraska, Lenore Tawney's *Cloud VII* at Western Connecticut State University in Danbury, Connecticut, and Nancy Holt's *End of the Line/West Rock* at Southern Connecticut State University in New Haven, Connecticut.

All of the artists I worked with in my long public art practice were conceptually oriented, rather than followers of the steel and stone schools of public sculpture. My earliest mentors when I worked at The Pace gallery, Isamu Noguchi, Tony Smith, and David von Schlegell, who did work in stone and steel, always created sculptures that were actively placemaking. As Tony Smith liked to say, his monumental works made the places they were in. A good example is *Tau*, one of the few permanent works he realized in steel at the corner of Lexington Avenue and 65th Street in New York City at Hunter College. David von Schlegell's site specific *Floating Squares* and Isamu Noguchi's participatory stone sculpture at Storm King Art center are other noteworthy examples that are placemaking.

Two theorist educators – an artist and a planner – had a profound effect on my thinking about placemaking and urban revitalization. György Kepes (1906-2001) emigrated from Hungary in 1937, taught design at the New Bauhaus (now Illinois Institute of Technology), and in 1967, established the Center for Advanced Visual Studies at MIT. Kepes's focus on the experiential is important: for him, the sensory qualities of art and architecture are a legitimate and necessary concern of city planning. "In becoming a collaborative enterprise in which artists, scientists, urban planners, and engineers are interdependent, art clearly enters a new phase of orientation in which its prime goal is the revitalization of the entire human environment – a greatly-to-be-wished-for climax to the rebuilding of our present urban world. The artist ... forges a new relationship of social responsibility with respect to his fellow man and a new relationship of interdependence between man and his environment ... The values that he uncovers become the values of the rest of us, giving sharpness and definition to our sensed need for union with our surroundings and intimate involvement with them."[73]

Among Kepes's students was urban planner Kevin Lynch. To Lynch "city-making is a fine art ... The city is an intended landscape ... Paris, Rome are cities

Doug Hollis
Untitled
1985
Willimantic, CT

Jene Highstein
Tem Ptah
1985
Old City Hall, Lincoln, NE

Lenore Tawney
Cloud VII
1983
Western Connecticut State University, Danbury, CT

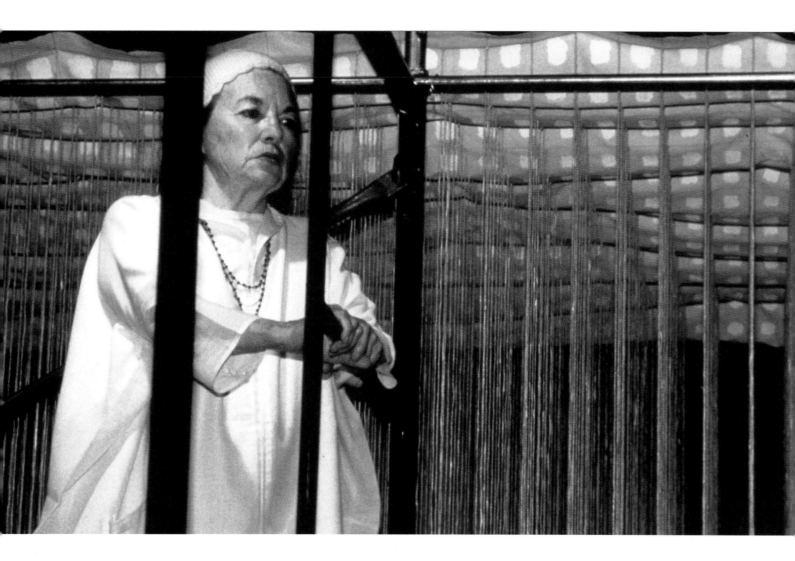

that are deliberate acts of city design … "[74] He described the artist as one who creates an object or event to convey meanings or feelings to a critical audience. "City design … must deal with continuous change, a plurality of clients, conflict and participation, and yet leave room for the creative act and the aesthetic response. It should be possible to create new forms and styles and to convey meanings and feelings worthy of critical judgment … Programs and criteria are effective ways of improving the quality of everyday life, even if their composition is a rational exercise rather than a creative act. Creative artists work within them, and are supported by them. I am convinced of their importance, and city planning is at least beginning to move in this direction."[75]

Lynch's city-making theories demanded the inclusion of the visual artist, whose "special thinking" is necessary to the creation of great cities. Ordinary citizens participate in transforming cities: "Images arise from changes in perception, as well as physical changes. Newspaper critiques, "town trails," new viewpoints or entrances, painters' or designers' visions, or the enthusiasms of renovators, all remold a city's image."[76] Great cities link citizen and place, enhance the significance of everyday life, and reinforce the identity of the group and the individual: with evident pride in his ancient city, Paul of Tarsus declared, "I am the citizen of no mean city."[77]

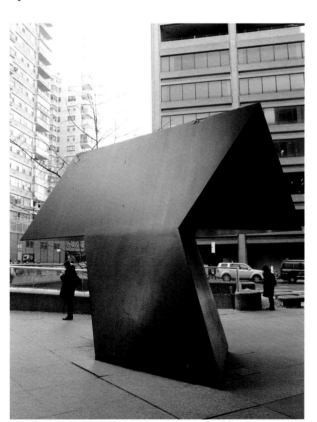

Tony Smith
Tau
1961–62
New York, NY

Preservation

People who alter or destroy works of art and our cultural heritage for profit or as an exercise of power are barbarians.[78]
— George Lucas

As dismantling of the structure began, The New York Times' *editorial board wrote, "Until the first blow fell, no one was convinced that Penn Station really would be demolished, or that New York would permit this monumental act of vandalism against one of the largest and finest landmarks of its age of Roman elegance."*[79]
— *The New York Times*, "Farewell to Penn Station," 1963

The very nature of public art – its being in the public realm – underscores threats to its existence. No matter whether the work of art is celebrated or derided, whether it shocks or comforts, measures must be taken at the outset to ensure its future. Its integrity and continued existence are not guaranteed. Horrific examples of wanton desecration and destruction, including the Bamiyan Buddhas in Afghanistan by the Taliban in 2001 and priceless antiquities at the Mosul Museum by ISIS in 2015, underscore a terrible truth: the deliberate ravage of art is the negation of humanity and the obliteration of culture, whether general or specific.

Public art is a public trust. Installation marks the beginning of its life, but stewardship from then on is critical. Will the art be exposed to the elements? To extreme fluctuations in temperature? To human touch? Is it permanent or temporary? Does the work utilize public infrastructure? Does it require a power source? Is it graffiti-proof? Protected from other sorts of vandalism? Can it be removed easily or is it placed securely?

Articulated plans for preservation, maintenance, and restoration are essential, and restoration requires trained professionals. But ultimately, who is responsible? Innovative programs that enlist public and private support have yielded positive results. Cognizant of limited resources, the non-profit Municipal Art Society of New York City created the Adopt-a-Monument program in 1987 to address the deterioration of public monuments. In conjunction with the Public Design Commission and the Parks Department, the program rallies corporations, foundations, and private individuals to rescue monuments and safeguard their futures.

Stories of careful and considered maintenance and restoration may foretell an optimistic future for public art. Louise Nevelson Plaza in Lower Manhattan is the first instance of a street or plaza in New York City being named for an

Bamiyan Buddha
1930
Bamiyan Buddha destroyed by Taliban
2011
Bamiyan, Afghanistan

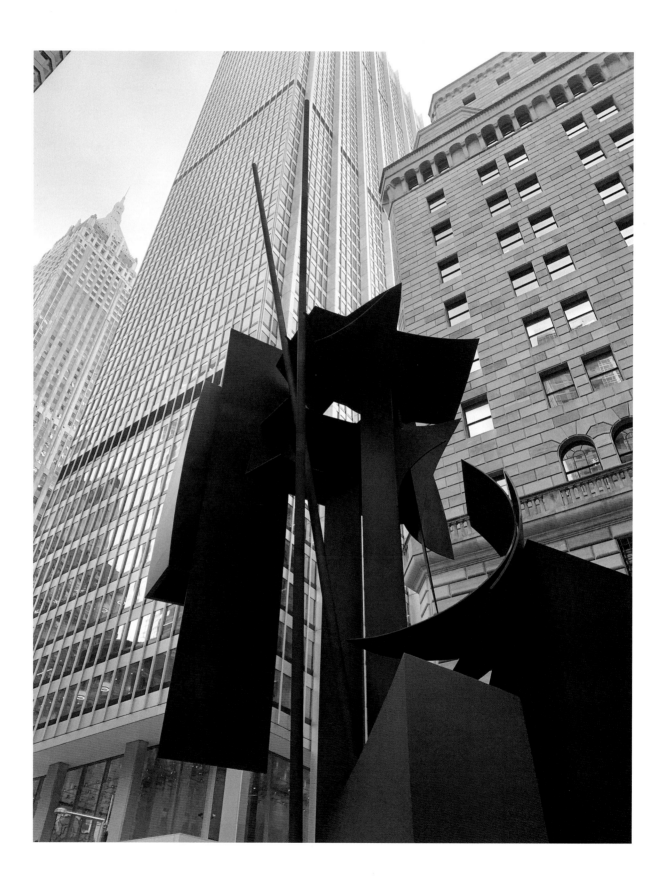

artist or a woman. This itself is remarkable. Of equal consequence is that Doris Freedman (Director and Founder of the Public Art Fund), the New York City Parks Department, and I (representing The Pace Gallery) enlisted eight corporations in the immediate area to provide funds in perpetuity for the preservation of the sculptures and the urban park, including benches designed and the plantings selected by the artist, Louise Nevelson. Guidelines for restoration were codified, and the New York City Parks Department committed to executing the work. Years later, the existing fund was employed to completely renew and restore the plaza. This was a good outcome, but not a perfect one; the restoration architects took it upon themselves to destroy the artist's benches and design their own.

Louise Nevelson
Louise Nevelson Plaza
1977
(Before 2010 restoration)
New York, NY

Although not foolproof, the inclusion of a clause in the artist's contract requiring that the artist, their estate, or a designated steward be consulted in connection with the restoration and maintenance of a work is well-advised. Ultimately, how much control the artist can expect to retain over a piece that is "owned" by another remains a question.

The saga of Giuseppe Penone's *Bifurcated Branch and Three Landscapes* in Philadelphia demonstrates that an artist's specific maintenance guidelines do not necessarily ensure the integrity and continued existence of the art. Trying to recollect or divine the artist's intentions when guidelines never were articulated or communicated has an equally difficult history. A most striking battle ensued among scholars and conservators over the restoration of Michelangelo's Sistine Chapel ceiling. Closer to home in New York City was a debate among preservationists regarding Augustus Saint-Gaudens's statue of Civil War General William Tecumseh Sherman, which, once gilded, had turned almost black. Not surprisingly, some advocated re-gilding the landmark to restore its original appearance; others, preferring the dark patina, thought it should be allowed to weather. Once re-gilded, controversy persisted as the tone was deemed too bright. Donald Trump, at one time, owner of the Plaza Hotel adjoining the statue's site opted for bright bronze. It eventually darkened.

We must also consider the consequences of practical necessities conflicting with the protection of art, even if inadvertently. A poignant example is the extraordinary rediscovery in the 1970s of two in a series of ten monumental Arshile Gorky murals at Newark Airport created under the WPA, a late '30s art program. Were it not for art historian Ruth Bowman's having found a small Gorky drawing of one of the airport murals in the Brooklyn Museum archive, the WPA commissioned works would likely have been lost forever.

Bowman hunted throughout the airport for the murals. The young airport attendant showing her around became so invested in the story, that after she left, he continued the search. Eventually, he found a little thread sticking out from one of the walls. Pulling it, he discovered that the murals, painted on

Louise Nevelson
Louise Nevelson Plaza
1977
(After 2010 restoration)
New York, NY

canvas, were still there, but so heavily painted over as to be invisible. Despite being on canvas, and therefore easily removable, the murals had instead been severely cut into when the airport installed its first air-conditioning ducts.[80] Incredibly, the placement of these ducts and apparatus had outweighed the art on the walls. Was art by Arshile Gorky expendable? Two of the ten murals were intact and restored and are now in museums. They are now specific examples of works by a major contemporary artist and yet another story of how badly we maintain our country's public art heritage.

Museums are active players in the conservation and preservation of public art. Architectural ornaments rescued prior to a building's demolition and works of public art that have been deemed inappropriate or otherwise suspect have found refuge in museums. The trading room of Adler and Sullivan's 1893 Stock Exchange Building and the living room of Frank Lloyd Wright's Francis W. Little House were reconstructed in The Art Institute of Chicago and The Metropolitan Museum of Art respectively. When Frederick William MacMonnies's *Bacchante with an Infant Faun* was condemned for "wanton nudity and drunkenness"[81] and ordered removed from the courtyard of the new Boston Public Library, The Met took it, promising never to remove the sculpture from public view.

But museums cannot ensure the continued existence of all works. In 1979, The Metropolitan Museum of Art looked forward to the donation of a renowned Art Deco sculptural relief from the facade of Warren & Wetmore's 1929 Bonwit Teller building, which was soon to be demolished and replaced by a developer's residential and commercial tower. The Met's enthusiasm had allayed widespread fears for its future, but ultimately, it was "smashed by jackhammers … on the watch of real estate developer [Donald Trump]."[82] Yet another example in New York's midtown changing art and architecture landscape is the Museum of Modern Art's premature destruction of the American Folk Art Museum, designed by Tod Williams Billie Tsien Architects, with only a token preservation of a portion of the facade.

Bonwit Teller Building Relief
1929 (destroyed 1979)
New York, NY

Arshile Gorky
Activities on the Field
1936
(Installation view with Gorky)
Newark Airport, NJ

Patronage

If a patron buys from an artist who needs money (needs money to buy tools, time, food) the patron then makes himself equal to the artist; he is building art into the world; he creates.[83]
— Ezra Pound

Since the 1960s and 1970s, the vitality of public art in America has owed much to the aesthetic sensibilities and civic and personal goals of great patrons, public or private, as it has traditionally in other nations. Enabling legislation and government-sponsored programs forged a path, and cultural and academic institutions, private individuals, and commercial enterprise took up the mantle. Motivations ranged from high-minded civic responsibility to promoting contemporary art and artists to corporate beneficence and individual philanthropy to public relations. Whether on college or corporate campuses or in the public spaces of commercial buildings, public artists have appropriated and transformed space as an active participant in the work of art.

At the Entex Building in Houston, Robert Kushner, who cofounded the Pattern and Decoration movement of the mid-1970s/early 1980s,[84] created four allegorical figures representing principal agricultural products of Texas. Sand-cast in bronze and representing wheat, cotton, rice, and citrus, the works enlivened the original wood-paneled walls of the building's second floor lobby, until they disappeared without a trace and without consultation with the artist. This cavalier approach to public art undermines its value in defining civic or corporate identity and providing beauty and uniqueness in our cities and towns.

A similar work by Kushner was commissioned by Tishman Speyer Properties (owners of Rockefeller Center) for the lobby of 1270 Avenue of Americas in New York City. Despite the contract stating the work was there for permanent display, the work was surreptitiously removed several years later, again without informing the artist.

A required art appreciation course in MBA and Executive Education programs or a company-sponsored seminar for corporate executives would provide a much-needed counterbalance in standard business curriculums and traditional corporate culture.

Robert Kushner
Agricultural Arabesques
1986
Entex Building, Houston, TX

Positivism: Memorials

Even when we haven't forgotten (the founding of our country, for example), it is sometimes vitally necessary to focus the thoughts of a group upon some past person or event, to get people to remember together, perhaps because we have a new and common enterprise in mind which demands we act together, but often simply because the unity of the group is thereby affirmed, and in that way kept in strength and readiness, inasmuch as social unity is called upon subtly during every moment of community life.[85]
— William Gass

A monument in its oldest and most original sense is a human creation, erected for the specific purpose of keeping single human deeds or events (or a combination thereof) alive in the minds of future generations.[86]
— Alois Riegl

Whether intended to celebrate, condemn, document, validate, or bear witness, the memorial stands apart from other public artworks. It is about remembering and not forgetting. More than simply etching an event, a person, a place in one's consciousness, the most powerful engage the emotions and intellect; art and design compel one to confront history.

In his profile of Maya Lin in *The New Yorker*, Louis Menand declared: "There can be no doubt that her Vietnam Memorial changed the popular understanding of what a memorial should be, and it thus set the bar very high for future memorialists."[87] Until Lin's memorial on the National Mall incontrovertibly altered expectations for the type, most memorials in America were representational.

Not only does the *Vietnam Memorial* establish a new formal paradigm – employing abstraction rather than representation – but more importantly, its meaning derives not from a shared narrative about a deeply unpopular war but from individual reflection. The power of Lin's brilliant design is to evoke a profound emotional response regardless of one's politics or one's position on the nation's involvement in the Vietnam War. The memorial design is an expression of the artist's personal sensibility, its impact undeniable, universal, and emotional.

While Lin's *Vietnam Memorial* encountered controversy on artistic and political levels, it became one of the most poignant, expressive, and provocative memorials and ultimately redefined the genre. Objections to its formal abstraction became moral imperatives based on specious precedent: the notion that war monuments historically had been and should be figurative, representing people involved in the war. A compromise allowed two traditional sculptural groups – one of three male soldiers and one of three uniformed women – some distance from, but in view of Lin's work of art. Politics had intervened. Fortunately, these unanticipated intrusions have not diminished the power of her work.

Maya Lin
Vietnam Veterans Memorial
1982
Washington, D.C.

Maya Lin
*Vietnam Veterans Memorial
Competition Drawing*
1981
Prints and Photographs Division, Library of Congress

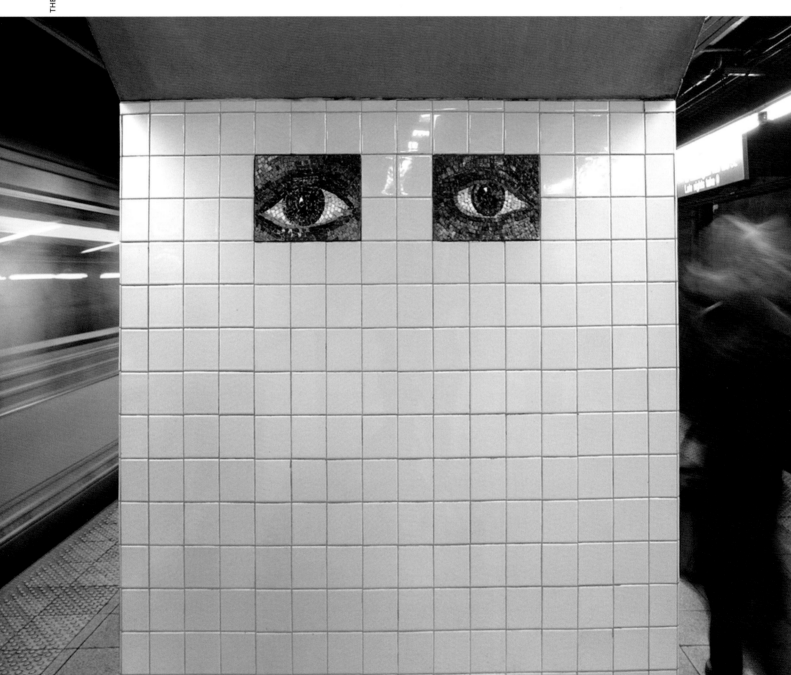

ART AND TRANSPORTATION

People usually encounter public art by accident; one rarely goes to a subway station for an art experience, but rather happens upon it while waiting for a train.[88]
— Cher Krause Knight

Two sorts of people inhabit airports – the idle and blasé and the nervous and harassed. For both the artworks come as a surprise and a distraction, a relief from the tedious chain of events leading from departure to destination.[89]
— Peter Morrin

Among my most impactful projects are those in transportation facilities: intended both to delight aesthetically and to elevate the travel experience, which can be at once exhilarating, frustrating, mundane, and anticipatory.[90] As Jackie Ferrara has said: "Airports are strange places – once in them one seems to exist in a type of limbo – a place that transports you."[91]

Our airports, train stations, and bus depots serve both visitors and residents; they are gateways for departure and arrival. Often, they are a visitor's first encounter with our great cities, framing his or her experience. And as one departs the city, the experience enlightens final memories. Historically, great architecture and artworks defined these terminals – connectors of people and places across our vast nation, an emblem of the American cultural dream. A relatively new phenomenon considers the airport as destination: as air travel has become more complicated, and (un)anticipated wait times longer, food, retail, and other amenities, including art, have become ever more important.

Public art in transportation centers confronts and stimulates the viewer and activates its context, oftentimes an extremely populated terminal. Art defines a human scale and intimate experience. Art rationalizes circulation and creates distinct and recognizable zones, terminating axes, marking intersections, and identifying focal points such as ticketing and amenities.

I oversaw major projects at three airports and various subway stations in the United States at a most exciting time: they are emblematic of the terrific advances in public art programs in American transportation facilities, which had lagged behind those in many European systems. These major works of public art have become studies in preservation as well as identification of a specific place.

Andrew Ginzel and Kristen Jones
Oculus
1998
New York, NY

A Story of Three Airports

My efforts to realize comprehensive art programs at Pittsburgh International and John F. Kennedy International in New York City, and my contributions to San Francisco International tell different stories, but all are emblematic of the complexities of collaborating with public agencies and of mediating the aspirations of the artist and the client.[92] Maintenance and conservation of public art are critical concerns, particularly in America, where art is often viewed as an unnecessary frill, where culture is itself suspect and deemed elitist, and where major artworks are destroyed or mutilated as often as they are well maintained.

From the beginning, San Francisco International cultivated an institutional culture which protected the art without compromise. It has subsequently proven to be one of the most innovative of modern airports and has gone on to introduce diverse art experiences for travelers. Their temporary art exhibitions in vitrines and their site specific innovative public art by leading museum quality artists was forerunner to innovative museum quality art happening in airports throughout the country. They were among the first to commission multimedia kinetic participatory art in airports, such as Eric Staller's *SpiroGyrate* (2014). This environment greatly benefited one of my projects – Joyce Kozloff's *Bay Area Victorian, Bay Area Deco,* and *Bay Area Funk* (1983), though it could not prevent this loss of the other, Charles Ross's *Light Lines* (1987).

The Pittsburgh and JFK Terminal One projects also had great promise: both were extensive programs featuring site-specific pieces by multiple artists; architecture and art were to be fully integrated; and collaboration was key. Although largely successful in the short term, each ran headlong into unanticipated hurdles.

Jacob Hashimoto
This Infinite Gateway of Time and Circumstance
2019
San Francisco International Airport
Grand Hyatt Hotel, CA

Eric Staller
Spirogyrate
2014
San Francisco International Airport, CA

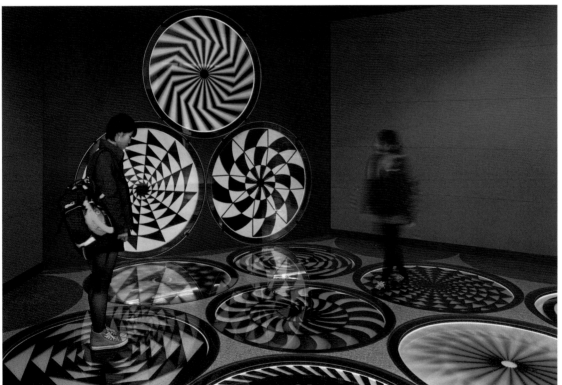

145

San Francisco International Airport

Joyce Kozloff's 1983 installation at San Francisco International Airport was my first project as an independent public art adviser and her first realized public commission. Her vision aligned perfectly with the terminal's architecture and with community concerns.

A leading figure and founder of the Pattern and Decoration movement of the 1970s, Kozloff wanted her art to reach and affect people who were more and less educated in the arts. In her work, she employs architectural elements – ceilings, walls, floors – as armatures for art. Furthermore, Kozloff 's art offers significant cultural and political content, moving far beyond the purely decorative, which is why the movement is now undergoing a renewal.

Kozloff's popular and numerous tile and mosaic murals and public art installations are a testament to her considerable attention to obsessively detailed imagery and layering of intellectual content relevant to the diverse themes of her visually extravagant works. Of her art, Kozloff has said, "What I respond to in the world, and aspire to in my art, is an 'aesthetics of profusion,' a visual field so dense that one can't grasp everything at once, that requires a close meander through and across its surfaces, that surprises with abrupt and unexpected juxtapositions, that has multiple and layered meanings, as well as humor, a personal touch and lots of sensuous, evocative color!"[93] Her focus on the decorative is linked to both her deep involvement in the feminist wave of the early 1970s and an early trip to Mexico. Captivated by the rich heritage of pattern, she became more aware and critical of the Western taboo regarding the decorative, concluding, "the decorative arts are the carriers of popular culture."[94]

The site – a 200-foot-long wall in the baggage claim area – presented both opportunity and challenge. Kozloff created three site-specific mosaic murals, with imagery of three Bay Area districts at distinct periods in their history: *Bay Area Victorian*, *Bay Area Deco*, and *Bay Area Funk*. The panels combined handmade, hand painted ceramic tiles with glass mosaic of brilliant color and design.

Initially, Kozloff had wanted to cover the entire wall with a mosaic mural, but it was not supported by her budget. The architects, M.A. Gensler Associates, highly sensitive to the artist's intention, came to the rescue; Gensler specified commercially available blue Italian tiles in place of vinyl wall covering, creating a field for Kozloff's work by expanding the tile concept to the entire wall. The additional cost was absorbed by the construction funds, enabling Kozloff to remain faithful both to her concept and to her limited budget.

When located in the baggage claim area, Kozloff's mural provided arriving

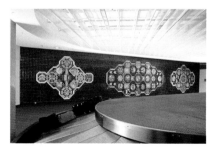

Joyce Kozloff
Bay Area Victorian, Bay Area Deco, Bay Area Funk
1983/2000
San Francisco International Airport, CA

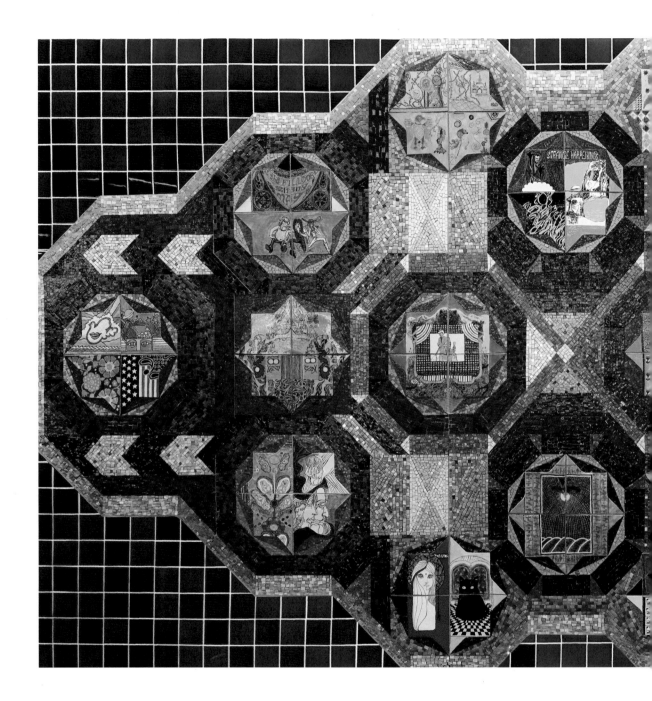

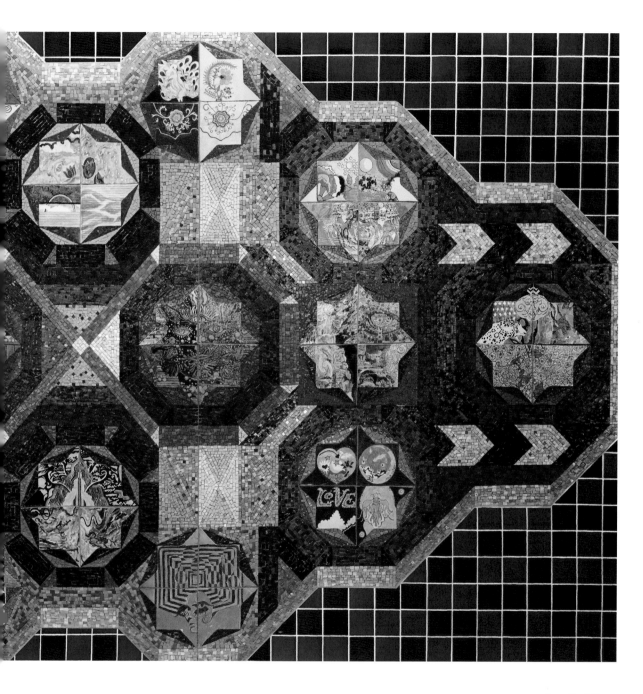

Joyce Kozloff
Bay Area Funk
1983
San Francisco International Airport, CA

visitors their first glimpse of San Francisco. *Bay Area Victorian* draws its sources from the style and ornamentation of old houses in several San Francisco neighborhoods, such as the Mission District, Pacific Heights, the Western Addition, and Potrero Hill. *Bay Area Deco* refers to downtown Oakland in its heyday, when the Fox and Paramount movie houses were built. The celadon grey-green tile ornament of the I. Magnin Department Store and the cobalt blue and silver facade of the Flower Depot were also sources. *Bay Area Funk* is a collection of Berkeley memorabilia from the '60s. Kozloff's sense of humor is evident, as she combines images from comic books and record album covers with flyers and posters from clubs popular in the 1960s, such as the Fillmore and the Avalon ballroom.

Fabricated by Costante Crovatto, the tiles were painted in Kozloff's studio. Concerned that affixing the tiles directly to the terminal's walls would inextricably bind the murals' fate to that of the building, Crovatto insisted that the murals be assembled on thin wood panels, and he gave specific instructions for dismantling and packing should the need arise. His measures proved prescient: ten years after installation of the artwork, the building no longer met regulations for international travel, and the baggage claim area was divided into small offices. Under the watchful guidance of the San Francisco Arts Commission, the work was designated to be re-installed in the new International Terminal at a site selected with the help of the artist. In 2000, Skidmore, Owings & Merrill's new International Airport Terminal opened; Kozloff's work was re-installed to advantage on a new field of deep cobalt blue tiles in a glazed pedestrian bridge between two buildings – a triumph for the preservation of public art in America.

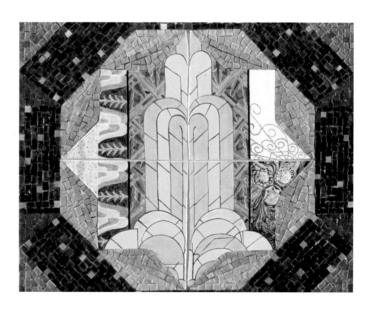

Joyce Kozloff
Bay Area Deco (detail)
1983
San Francisco International Airport, CA

Joyce Kozloff
Bay Area Victorian
1983
San Francisco International Airport, CA

Pittsburgh International Airport

At its opening in 1992, the new Pittsburgh International was the country's third largest airport. Designed to accommodate air travel in the twenty-first century as a form of mass transit, its design was to be symbolic of Pittsburgh's progressive viewpoint, economic expansion, and civic responsibility. Most exciting to me, when asked to be the art consultant for the project, was the mandated integration of architectural design and a comprehensive art program on a vast scale – a declaration about travel and the design of holistic environments to dignify the airport's essential function – to facilitate the traveler's transition between air and ground.

The commitment to locating important works of art in the Pittsburgh airport begins with the original Pittsburgh International. Created for the 1958 Bicentennial International Exhibition of Contemporary Art at the Carnegie Museum, Alexander Calder's black and white mobile, *Pittsburgh*, was purchased by G. David Thompson, donated to Allegheny County, and installed in the original Greater Pittsburgh International Airport, where it activated the central space. Clearly oblivious to the value of the work or overzealous in their fealty to the county, officials painted the mobile green and gold (the county's colors), weighted the arms, and motorized it to spin continuously rather than move with the natural currents of air. Fortunately, in 1979, at the urging of the county art administrator, the mobile was removed from the airport, meticulously restored to its original white with black struts, and the arms liberated. It was installed for "safekeeping" in the Carnegie Museum. The saga ended in 1992, when it was hung in the rotunda of the new Airside Terminal.

As public art adviser, I was asked to oversee the formation of a dedicated professional Art Committee, manage the artist selection process, and also see the project through to completion of the complex. William Lafe, a financial development professional, worked with me and the committee to fundraise within the Pittsburgh corporate community. Leaders of the city's cultural and business communities – art collector and businessman Michael Berger (Chair), Carol R. Brown (Pittsburgh Cultural Trust), Phillip M. Johnston (Carnegie Museum of Art), Barbara Luderowski (artist and Founder of The Mattress Factory), Maura Minteer (Director of Events, Senator John Heinz History Center), and William E. Strickland Jr. (community leader and CEO of the non-profit Manchester Bidwell Corporation) – architect Tasso Katselas, and I comprised the Art Committee.

Bill Lafe and I bonded over this project, and I learned a great deal from him about how Pittsburgh as a city was dedicated to the arts. Noting that I was Jewish, he said his mother always told him the Jewish community of Squirrel Hill was consistently active in supporting the arts in their city.

Alexander Calder
Pittsburgh
1958
Pittsburgh International Airport, PA

Roberto Burle Marx
Copacabana promenade
1970
Rio de Janeiro, Brazil

Roberto Burle Marx
Copacabana promenade
1970
Rio de Janeiro, Brazil

The design concept for the huge complex of landside and airside terminals combined standard industrial dark grey concrete with Bauhaus-inspired color, texture, architectural detailing, and the integration of fine art. Katselas said: "It's a no-pretense building. There is a clarity of purpose throughout and a strong sense of direction. It teems with lyric possibilities."[95]

The art program, as we discussed in committee meetings, was to exploit these possibilities. Indeed, the entire airport was to become an art environment intended not only to delight, but to help travelers orient themselves, facilitate movement, and provide a sense of human scale within the huge airport spaces.

Our open call drew over 450 submissions from regional, national, and international artists. Western Pennsylvania's irregular topography and the airport's location in a "basin" ringed by wooded hills influenced the Art Committee's preference for artists whose work employed natural materials or whose concepts derived from nature. Our program called for a few large, environmentally-scaled works commensurate with the vast expanses of the buildings and able to hold their own amid the sea of information, signage, and movement.

Not long before I accepted the commission, I had experienced the work of avant-garde artist and landscape designer Roberto Burle Marx while visiting Brazil. His works at Copacabana Beach and throughout the streets of Rio de Janeiro are legendary. Burle Marx's masterful use of color and pattern in broad swaths of landscapes and hardscapes, and by extension, the strong tradition of patterned flooring in many equatorial and Mediterranean countries, strongly affected my thinking during artist selection. The patterning offered a solution to the scalelessness of an airport's vast spaces. I showed my photographs of the streets of Rio to the Art Committee who embraced the idea. We sought artists accordingly. Ultimately Jackie Ferrara, Maren Hassinger, Michael Morrill, Robert Morris, and Alan Saret were chosen to create expansive art environments throughout the airport.

Working relationships among artists, architect, engineers, construction crews, materials suppliers, and airport staff were close and collaborative. The participants demonstrated remarkable problem-solving, decision-making capability, and flexibility in the face of a strict construction budget and ongoing modifications to the architectural design over four years of construction. Tasso Katselas, the architect, worked closely with all the artists. Alan Saret visited Italy to learn firsthand about how to select and install tile for public places. A trained architect, he assisted Jackie Ferrara with selection of her tiles and worked closely with Maren Hassinger during the design phase of her "architectural environment."

The art budgets were calculated as a percentage of the overall airport

budget. Art expenditures were optimized: design fees were realistic, artists' fees for the implementation phase were allocated, and relevant architectural elements, such as paving, glass walls, and concrete structures were funded separately. Artists were required to meet all building codes and safety and security regulations as well as consider maintenance needs and requirements.

From proposal through completion, the rational attitude of all players and the successful collaboration of the artists and architects benefited the project. Crucial to the process, the Public Art Adviser and Art Committee did not disband as customary after the artists were selected but stayed on as advisers and mediators until the airport's completion and dedication in the fall of 1992.

Each of the five artists considered the ways airports are used and perceived, how people move through various spaces, and how the voluminous integrated interior and exterior environments could best be utilized. References to nature serve as a common thread for all the artworks.

In his *Steam Gardens and Framed Vistas*, internationally acclaimed artist Robert Morris created a series of five walled gardens with clouds of steam rising from beds of river washed stones. Visible from the air as a monumental minimalist sculpture, the work measures 700 by 70 feet. At ground level, two promenades provide powerful vistas for pedestrians moving between the parking garage and landside terminal.

Ferrara's and Saret's expansive tile works cover the floors of two terminal buildings, examples of placemaking scaled appropriately to the huge spaces. Recognizing that the sheer size and apparent scalelessness of modern airports can be both confusing and intimidating, Jackie Ferrara created *Paths*, ceramic tile floor mosaics that employ direction and diversion to rationalize experience and reinforce psychological comfort. Inspired by a science fiction tale and informed by Ferrara's interest in mathematical progressions and modular units, the distinctive colorways and asymmetric designs, which are composed of minimalist geometric shapes and patterns of alternating red, blue, and charcoal gray, wend their way through 65,000 square feet of the ticketing and transit levels of the landside terminal.

In the atrium of the huge X-shaped airside terminal, Alan Saret's many-hued blue mosaic tile patterns, *Home and Away*, form paving systems that direct travelers to their designated gates and destinations. Intricate decorative flooring designs covering 55,000 square feet in concert with the Alexander Calder mobile suspended in the skylights above transform the central concourse level into an animated art-informed public mall experience. Saret's intention was to "clarify and brighten the path for inbound and outbound travelers and at the same time afford a sense of place."[96]

Painter Michael Morrill created *Compass*, a subtly colored, etched, and

Jackie Ferrara
Paths
1992
Pittsburgh International Airport, PA

Alan Saret
Home and Away
1992
Pittsburgh International Airport, PA

Jackie Ferrara
Paths
1992
Pittsburgh International
Airport, PA

Alan Saret
Home and Away
1992
Pittsburgh International
Airport, PA

Michael Morrill
Compass
1992
Pittsburgh International
Airport, PA

158

Maren Hassinger
Cloud Room
1992
Pittsburgh International
Airport, PA

Robert Morris
Steam Gardens and Framed Vistas
1992
Pittsburgh International Airport, PA

sandblasted glass mural in the International Holding Area. The wall creates a light-filled, open, and lively space; it screens the passenger waiting room from the corridor, and with its painterly textural and abstract imagery visible from both sides, serves as a diversion during waiting periods.

Airports traditionally set aside a place for quiet meditation. Maren Hassinger's gently kinetic *Cloud Room* on the mezzanine floor of the airside building was a total environmental experience with video, sound, seating, and flooring patterns simulating cloud formations. The visitor became a participant in a twenty-six-minute, multi-projector video of moving clouds in changing skies – from storm to sunlight, day to night – which was accompanied by the natural sounds of crickets, birds, thunder, wind, rain, and the syncopation of beating drums. A self-contained and tranquil and comforting space created by upbeat sound and sights, it offered a retreat for stressed or weary travelers. This project was one of the first permanent video art installations in a major public building.

Paving patterns, etched glass walls, video, steam gardens, and river stones are not always perceived as the materials of art. And because these art landscapes were so well-integrated with the airport architecture, the public was not always aware that they were experiencing fine art. Which raises the question of whether a work of art can be recognizably distinct from and, at the same time, integrated with its immediate context. This specious "invisibility" may shine a light on unfortunate developments that undermined works of art by Morris, Saret, and Hassinger.

The utter disrespect for the art of three internationally renowned artists testifies to the critical importance of maintenance, preservation, and legal protection, not to mention the appreciation of art to our cultural heritage. Robert Morris's stone and steam gardens suffered due to the limiting of rocks and water during construction, as well as the steam features that had already been compromised. Airport employees took advantage of the privacy of Hassinger's meditation space, using it inappropriately. Citing security issues, airport authorities closed the room to the public. Although the architecture and the video screens remain, pedestrian office furniture has transformed the space and fully undermined the intentions of the artist.

Saret's unique work of art – floor patterns integral to the architecture for which they were created – has been partially destroyed by the redesign of the atrium as an upscale shopping mall. A local artist was invited to design new floors in the central space. Evidence of Saret's brilliant floor remains only in some of the retail shops surrounding the atrium. Neither the artist nor the architect was consulted. Would any European city having significant works of art have allowed this to happen? I am reminded of my response to the removal from Avery Fisher Hall of Richard Lippold's *Orpheus and Apollo*, which was

Maren Hassinger and Alan Saret
1991

quoted in *The New York Times*: "Would Italy and the Italian people allow Bernini and Michelangelo's public artworks to be removed, or changed willy-nilly for ridiculous or expedient reasons?"[97]

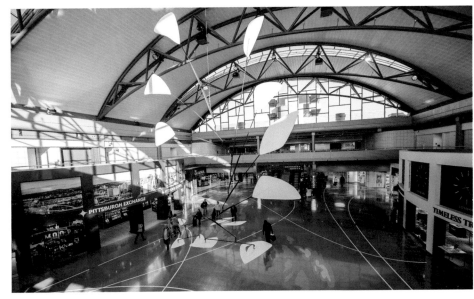

Alexander Calder
Pittsburgh
1958
(After 2015 airport renovation)
Pittsburgh International Airport, PA

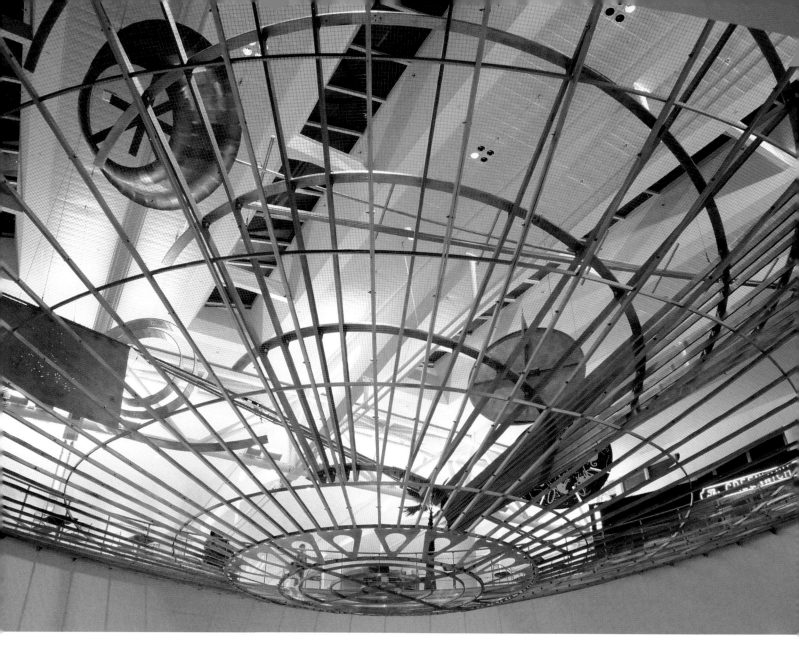

Alice Aycock
Star Sifter
1998
New York, NY

Can a lawsuit solve a problem about Public Art?

A promising program for John F. Kennedy International Airport yielded an important work of public art but also illustrates a process gone awry. At its completion in 1998, Terminal One was the airport's first new passenger facility in almost three decades. It announced a new era in building as part of the Port Authority's overall $5.4 billion redevelopment plan for New York City's major gateway.

Deciding that existing facilities were out of step with technological advances, the demands of twenty-first century travelers, and emerging notions of the airport as a center of commercial activity, Air France, Japan Airlines, Korean Airlines, and Lufthansa German Airlines agreed to build the terminal. They formed a consortium, the Terminal One Group Association (TOGA), whose leaders were Alan Content, John Leaver, Kyong Moo-Moon, and Dieter Bergt respectively. A capital bond underwritten by the New York City Economic Development office was to fund the art program. William Nicholas Bodouva and Associates were the architects.

Although initially enthusiastic and supportive, the directors of the four airlines often were deadlocked on issues concerning the building design, the art program, and cost overruns. As art adviser to TOGA, I had envisioned major art installations throughout the terminal. R.M. Fischer envisioned a futuristic ceiling of light fixtures suspended throughout the public spaces of the ground floor. Red Grooms created a three-dimensional frieze on the surrounding soffit about immigration; an informative welcome to the city, the frieze was to have carried signage showcasing theaters and businesses in Times Square. For the International Arrivals corridor, Jim Andersen's installation projected video and advertising imagery – a work of art introducing New York City commerce without creative compromise.

Unfortunately, these three proposals, having significant content about New York City, were unrealized. Divergent management factions, a bottom line-oriented management group hired to address ballooning costs, and the absence of a forceful and compelling voice insisting that the integrated art program was essential to the overall architectural impact, quashed them.

Of the planned four works of art, only Alice Aycock's was completed, and fortuitously at that. It is an important work of site-specific art that underscores the artist's imaginative problem-solving. The TOGA consortium embraced the work as an aesthetic solution to an unanticipated security breach of the building design.

Central to Boudova's architectural concept for the 634,000-square-foot terminal was a 60-foot diameter rotunda, open from the floor of the Departures

Alice Aycock
Proposal for Star Sifter
1998

Level to the building's glass skylight, three stories above. The design intention for this open volume was admirable – light penetrating to the center of the vast space would provide outside awareness and daylighting. Only when the terminal was nearing completion was the inherent security risk realized: an ill-intentioned person on the accessible public floors conceivably could toss contraband to a departing passenger in the post-security departure areas below.

Fortunately, the problem was discovered in the early stages of the artist selection process: in lieu of expensive building redesign, I suggested to the TOGA Art Committee that a conceptual artwork might remedy the breach and ensure public safety. I recommended Alice Aycock, whose "poetic machines" evoke the elegance and beauty inherent in high-tech industrial materials.

Her suspended multi-faceted *Star Sifter* maintained the rotunda's sense of lofty height and open space, while providing a graceful and airy barrier between the secure departure level and the public spaces above. A metaphorical vortex composed of a stainless-steel screen attached to a conical frame of radiating spokes activated and covered the atrium's opening. Above the frame, another series of radii formed a curved rectilinear configuration whose elements launched over the railing on the mezzanine level. The syncopation of apparently floating elements and spatial forms, some of which reached heights of up to 30 feet, maintained the openness. The dynamic structural elements referenced the movement of comets in relation to planetary motion.

The sculpture reflected the terminal's futuristic design, while its energized forms invoked the exhilaration and romance of flight. At the time, the artwork was lauded by representatives of the consortium for creating a focal point for the central space, humanizing the enormous scale of the building, and causing people to linger in proximity to retail and other commercial establishments.

Countless promotional photographs of the terminal featured Aycock's iconic piece. After fifteen years without incident, a plan to repurpose the open rotunda as a food court threatened its existence. It was only because TOGA notified the artist and asked that she remove the work at her own expense that it survives today. Not so Alan Saret, whose mosaic floor at Pittsburgh International was replaced without the artist's knowledge.

Aycock filed a civil lawsuit charging that removal of the sculpture constituted both breach of contract and injury to her reputation. Aycock's legal brief acknowledged that a provision of the original contract allowed for removal in the event the sculpture became dangerous (even due to negligent maintenance), the building was demolished, or the work "posed an unresolvable problem for the public." But none of those obtained, and her attorneys argued that the contract disallowed removal "merely for a commercial purpose or on a whim. Such an interpretation would be inconsistent with how such clauses

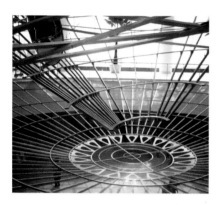

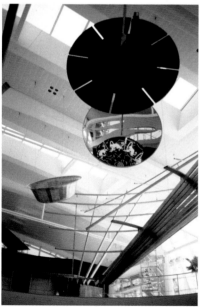

Alice Aycock
Star Sifter
1998
John F. Kennedy International Airport, NY

typically function in public art contracts, which is to give the artist an assurance that their work will remain in place and on display for the public."

Aycock's lawsuit underscored her reputation as an artist. Her attorneys deposed art professionals, artists, curators, and critics to establish her stature in the art world. Robert Hobbes, who had written the definitive monograph on Aycock's work, made an eloquent case for the overriding importance of public art to the nation, not least because they are not subservient to commercial interests with limited long-term value.

Extensive legal wrangling highlighted the central conflict, which pitted immediate economic needs against a celebrated cultural icon. The need for an active droit moral for permanent public artworks in America became central. The day before the case was to go to court, Terminal One lawyers conceded the public's right to art in public places and the artist's right to preserve her professional reputation as an artist.

The outcome though was mixed; some would call it a Pyrrhic victory: Aycock was invited to reimagine her artwork in another highly visible site in the terminal, but the consortium was permitted to proceed with the atrium redesign. Effectively nullifying the spatial quality of the huge open atrium, the soaring three-story central space became a mundane food court.

Alice Aycock
Star Sifter
1998/2013
John F. Kennedy International Airport, NY

Subways and Trains

I felt I moved into the twenty-first century in the 1990s on my first trip to Japan. Invited to speak in centers all over the country, I traveled in comfortable, elegant, incredibly high-speed trains, dining on bento boxes and enjoying the exquisite views. It raised questions – rail transportation was significant in the creation of America. Why have we, a country built on a unique rail system connecting remote parts of the American wilderness, abandoned it? Even California's long-awaited high-speed line has been indefinitely postponed. Our reliance on planes and cars made us miss a new way to connect (and to experience) the American Heartland.

Train stations in city centers have always been grand works of architecture that identified our countries' growth across the grand expanses of our landscape. One need only look to great stations of the past, among them New York's Grand Central Terminal and Pennsylvania Station, Washington D.C.'s Union Station, Kansas City's Union Station, and Philadelphia's 30th Street Station in this country, and countless other examples in Europe. They are emblematic of arrival, a gateway marking the city as a destination, a source of pride for residents. They made America.

Works of art imbue subway hubs and individual stations with the distinct character of particular neighborhoods. The critical criteria established by the Massachusetts Arts Council and the Back Bay Transportation Authority for their "Arts on the Line" progressive public arts program are exemplary. The works must embody artistic excellence, site appropriateness, durability of design and materials, and minimal maintenance, and aesthetic decisions were to be made by art professionals, with artists involved at early design stages with architects.

In Pittsburgh, the Allegheny Transit Authority marshaled corporate support for its station revitalization program. Working with the Pittsburgh Art Commission and architects Parsons-Brinckerhoff Quaid & Douglas, I advised the art committee on the selection of Sol LeWitt to create a 203-foot-long wall relief at the underground Wood Street station. The background surface material for the wall was left unspecified, intentionally awaiting the artist's choice. Visiting the site with LeWitt, he was told that the artist could choose the background material for the wall. LeWitt's immediate idea was to use white marble as a background for black slate geometric reliefs. This was unanticipated, and the cost exceeded the Transit Authority's allocation. However, the Heinz Foundation, whose offices were in the building housing the station, generously provided the extra funding. When I recently visited, almost four decades after its completion, the marble and slate work is well maintained and respected: not only does the Transit Authority refrain from posting signage on the art walls, but neither

Sol LeWitt
Thirteen Geometric Figures
1984
Wood Street Station, Pittsburgh, PA

graffiti nor other blemishes is evident.

New York City adopted percent-for-art legislation in the late 1970s, a charge spearheaded by Doris Freedman, then director of the Public Art Fund. Immediately thereafter, the Metropolitan Transit Authority asked Suzanne Randolph (another independent art consultant) and me to assist their architects and art committees in selecting the first artists for the City's new Arts for Transit program that enhanced and continued the superior art and design of New York subways.

Crucial to my understanding of partnerships between artists and architects were many hours of discussion with my architect brother, Lee Harris Pomeroy, about his work with the Transit Authority. Lee appreciated artists and their personal aesthetics, focusing on seamlessly integrating the art with the architecture, and helping the artists realize their works of art as conceived. "Lee was the quintessential New York City architect," said Sandra Bloodworth, director of arts and design for the Metropolitan Transportation Authority. "He loved New York, and he loved the civic side of historic preservation and transportation."[98] While I worked on only one station with Lee, I feel close to others that resulted from productive collaborations between him and artists Nancy Spero (*Artemis, Acrobats, Divas and Dancers* at 66th Street) and Mary Miss (*Framing Union Square* at 14th Street).

At Fulton Street – one of the MTA's earliest efforts to integrate art and architecture – Lee and I worked with Nancy Holt. Although not a conceptual collaboration, the artist and architect informed each other's approach. Confident that Holt would bring a fresh and unencumbered eye to the design of the station, Lee said: "Where the architect stresses social and technical issues, artists can supply the intuitive substance that comes from their more abstract thinking."[99] Holt immersed herself in the history of the subway system; following from her environmental explorations, she was particularly interested in lighting strategies for the space, which was distinguished by historic tile motifs depicting Fulton's steamboat. A functional lighting system configured as five constellations, *Astral Grating* illuminates the passageway between Broadway-Nassau Street and Fulton Street subways. The fixtures were fabricated by the same Brooklyn manufacturer that had produced the original lamps for the subway. Removed to allow for the reconfiguration of the station as the Fulton Center, the work awaits re-installation in an appropriate place.

The Westchester Square–East Tremont Avenue train station in the Bronx is the story of an extraordinarily balanced collaboration between artist and artisan and of the fusion of art and craft and the consequent advancement of both. A prominent and influential artist, Romare Bearden was a native New Yorker, well-acquainted with the subway system. He was known for his paintings

Lee Harris Pomeroy in DeKalb subway station
2000

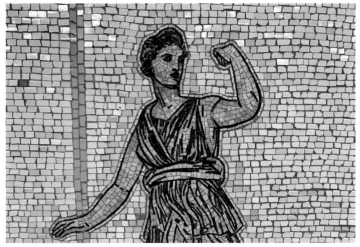

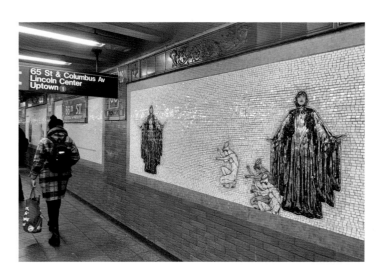

Nancy Spero
Artemis, Acrobats, Divas and Dancers
2001
New York, NY

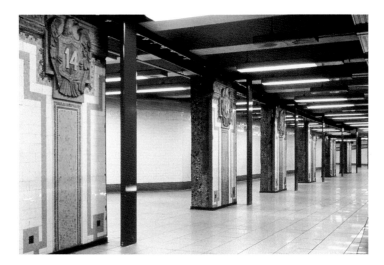

Mary Miss
Framing Union Square
1998
New York, NY

171

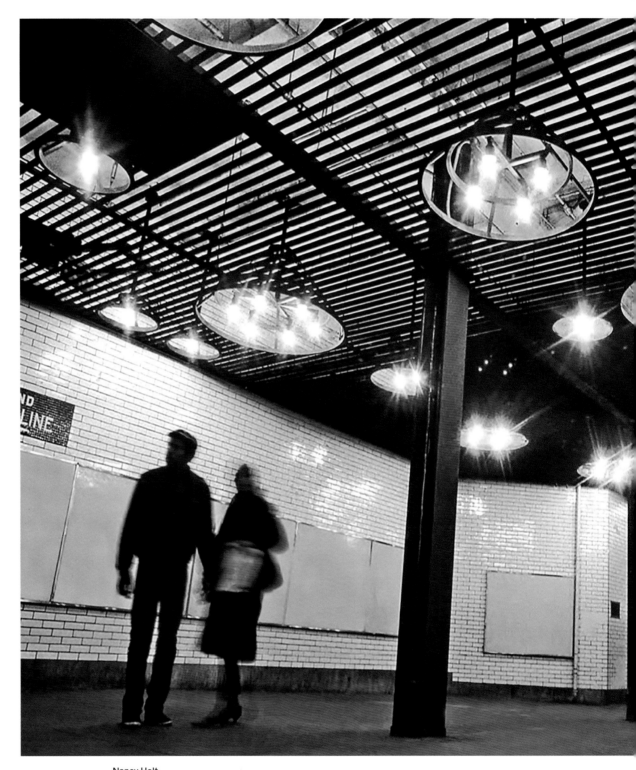

Nancy Holt
Astral Grating
1983–87
New York, NY

173

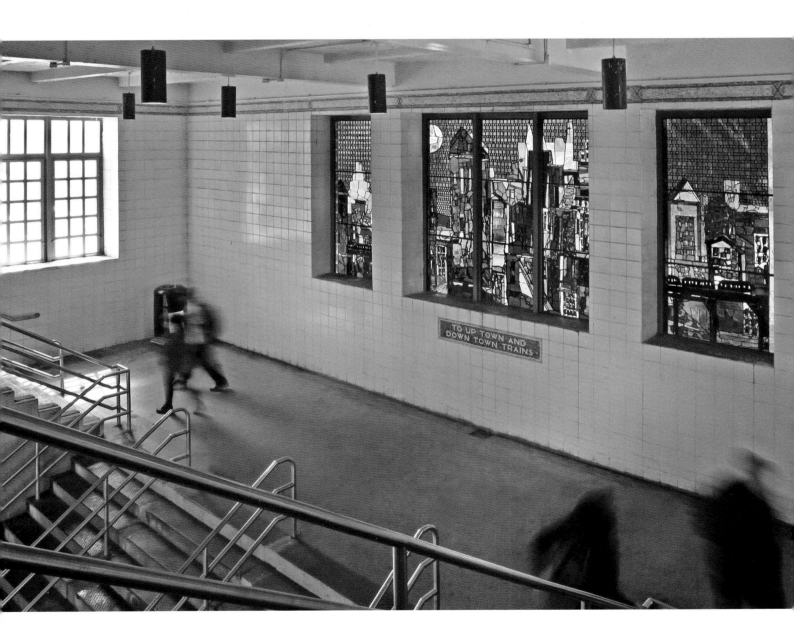

and collages that reflect the African American experience in America and for major tile walls in cities around the country, notably Charlotte, Pittsburgh, and Berkeley.

Westchester Square is uncommon among New York City stations: it is elevated, open, and daylit. The Transit Authority had recommended framing a large glass block window – the dominant feature of the stair landing – with mosaic tile. Bearden was known for his tile work, and that was what the MTA expected from him. Bearden and I visited the site together; seeing the glass block window, I turned to Romare and said, "Have you ever thought of working in stained glass?," which piqued his curiosity although he had never worked with the material. I knew of the work of Belgian glass artist Benoit Gilsoul, whose company had recently completed outstanding work in several churches and public buildings in the tri-state area. Gilsoul and Bearden were intrigued by the idea of working together. The complementarity of their skills sponsored a remarkable collaboration.

Mutual respect pushed the skills of both artist and artisan to new levels for the art windows. Gilsoul immediately suggested using "faceted glass" in such a public area: not only did he assure Bearden and the MTA of its resilience – certain that the material would withstand an assault with a sledgehammer – but his exceptional craftsmanship demonstrated that he was able to realize Bearden's painterly textures and colors. With poetic wit, Bearden created *City of Glass*, which depicts the neighborhood tenements and city skyscrapers passengers encounter as the train moves along its path. Gilsoul accurately realized the collage maquette; set in an epoxy matrix, the facets of glass glisten in the sunlight. Implementation was delayed due to complications with subway renovation, but Wendy Feuer, the first director of the MTA Arts-for-Transit and since 2007 New York City Department of Transportation assistant commissioner for Urban Design and Art, continually assured me that the work would be installed as conceived by these two mature artists. Gilsoul supervised installation of the glasswork, which was realized only in 1993, five years after Bearden's death and fully eleven years after it was begun.

Today, Arts-for-Transit flourishes under the guidance of its energetic and imaginative director, Sandra Bloodworth. Beginning in 1986, the Arts-for-Transit program has commissioned hundreds of permanent works of public art for the city's subway and commuter rail stations. In compliance with New York City percent-for-art legislation, the program typically spends between .5 and one percent of the construction budget. An element of the overall physical rehabilitation of the sprawling system, the works of art underscore the civic nature of the stations and the notion of shared public place.

The program encourages artists to look to the history of the subway

Romare Bearden
Maquette for City of Glass
1982
New York, NY

Romare Bearden
City of Glass
1993
New York, NY

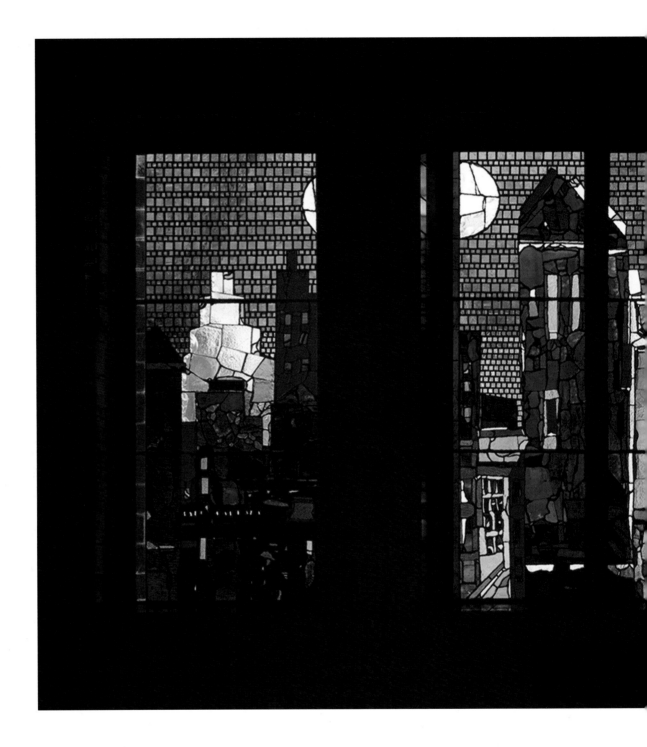

Romare Bearden
City of Glass
1993
New York, NY

system and to its great tradition of ceramics and mosaics for their inspiration. The material is both practical and evocative: resilient and durable, the material unifies past and present. Bloodworth's recent volume is a wonderful survey of the MTA's art program, among the most extraordinary of any city. Works by an astonishing roster of artists are represented.

Highways, Freeways, and the American car culture

America's freeways, highways, and roads encircle and cut through our cities, traverse the landscape, connect destinations. Sometimes considered a blot on the visual environment, they are fertile ground for aesthetic embellishment.

The highways in France and Belgium are a perfect example; there a government beautification program requires that corporations contribute art for designated stretches of roadway. In 1976, the Nebraska State Arts Council held a percent-for-art competition, inviting artists to create work for truck stops on the long, flat stretches of I-80. In 1988, artists and design professionals collaborated in a competition seeking art for Houston highways. Also in that year, Phoenix developed a public art program master plan for the city's infrastructure, notably identifying opportunities for art with special attention to vantage points from which art may be viewed (i.e. from airplanes, automobiles, freeway overpasses, and by pedestrians). Like earlier GSA and NEA initiatives, in 1981, the Department of Transportation (DOT) launched a Design-for-Transportation national awards program to honor both design and design management. And the agency instituted a combined city/DOT program that advanced projects in airports and rail facilities.

Page 181

Bernar Venet
Arc Majeur
2019
Permanent installation for autoroute E411,
km marker 99, Belgium

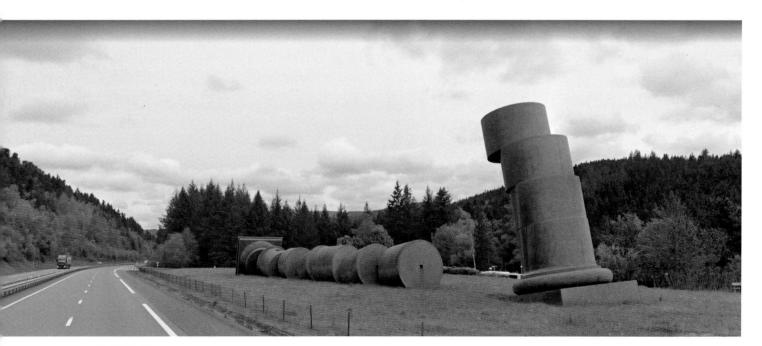

Anne and Patrick Poirier
La Colonne Brisée
1984
A89, Salles, France

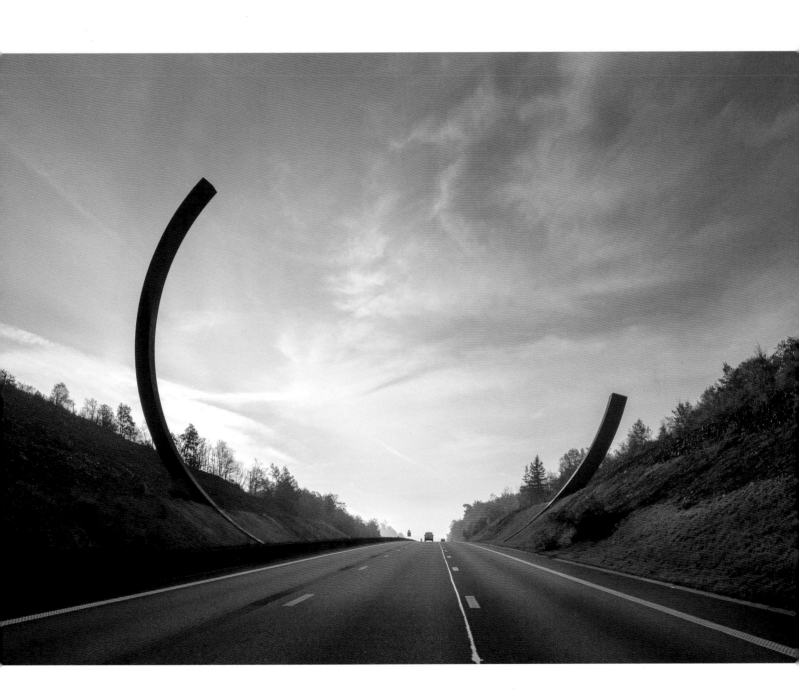

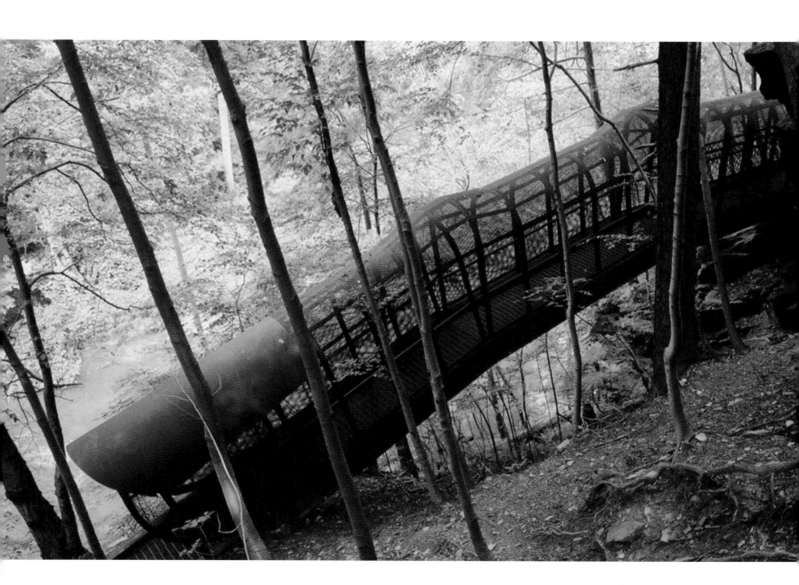

LIVABLE CITIES

Philadelphia, Pennsylvania

By the time I began my first public art project in Philadelphia, the city's progressive position had long been codified in an ordinance requiring all public and private development to allocate a percentage of a building's construction budget for public art. My projects in Philadelphia – Sheraton Hotels, Buttonwood, Penrose Plaza, PNC Bank Operations Center – were collaborations with private developers.

A model for other cities, Philadelphia's percent-for-art program was the remarkable work of visionary city planner Edmund Bacon.[100] The city established a national standard for percent-for-art legislation in 1959, founding the Redevelopment Authority of the City of Philadelphia (RDA) Fine Arts Program. Unusual in that it applies not only to public buildings but also to the private development which benefited from Bacon's planning, the city's mandate not only requires that one percent of all building construction costs under the RDA be budgeted for original works of art, but those works must be created specifically for public spaces within the development. Philadelphia's long-standing commitment to public art had long been set by the Fairmount Park Art Association (founded 1872; now the Association for Public Art), another program supporting art in public places, now directed by Executive Director and Chief Curator Penny Balkin Bach. It has produced such innovative works as Jody Pinto's *Fingerspan*. One good program in a city encourages another.

Philadelphia has one of the most exceptional public art collections in the country, including sculpture by three generations of Calders. The RDA seeks artists internationally, but local and regional artists have benefited as well. Hundreds of works enhance diverse developments: high-rise commercial and residential towers, industrial plants, universities, hotels, hospitals, libraries, and schools.

Developer, architect, and artist work together from the inception of each construction project, selecting a public art consultant or panel of art professionals to guide the process. The site for art, the artists selected, and the proposal must be approved by the Fine Arts Committee of the Redevelopment Authority (RDA), which includes at least one contemporary art professional, architect, landscape architect, artist, and lay-citizens with an interest in the arts. That the private developer has an integral role in the process is a testament to the city's commitment to public/private collaboration.

One of the first projects I did for the RDA was with the Korman Company, the developers of a project for Penrose Plaza, a private shopping mall in

Jody Pinto
Fingerspan
1987
Fairmount Park, Philadelphia, PA

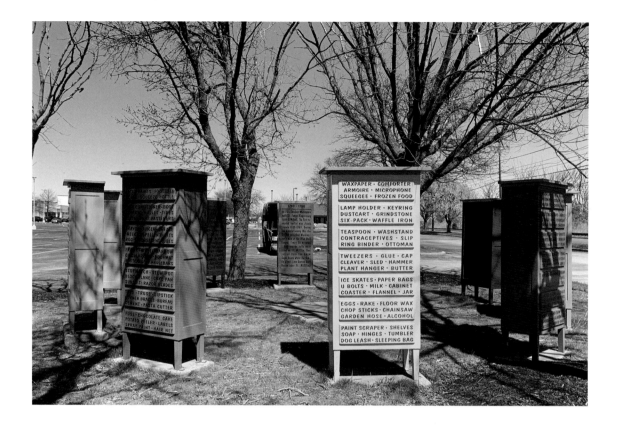

WAXPAPER · COMFORTER
ARMOIRE · MICROPHONE
SQUEEGEE · FROZEN FOOD

LAMP HOLDER · KEYRING
DUSTCART · GRINDSTONE
SIX-PACK · WAFFLE IRON

TEASPOON · WASHSTAND
CONTRACEPTIVES · SLIP
RING BINDER · OTTOMAN

TWEEZERS · GLUE · CAP
CLEAVER · SLED · HAMMER
PLANT HANGER · BUTTER

ICE SKATES · PAPER BAGS
U BOLTS · MILK · CABINET
COASTER · FLANNEL · JAR

EGGS · RAKE · FLOOR WAX
CHOP STICKS · CHAINSAW
GARDEN HOSE · ALCOHOL

PAINT SCRAPER · SHELVES
SOAP · HINGES · TUMBLER
DOG LEASH · SLEEPING BAG

Lauren Ewing
Subject/Object Memory
1990
Philadelphia, PA

an historic section of southwest Philadelphia. Although the area had a rich and varied history, modern developments had changed the neighborhood, supplanting many private homes. Lauren Ewing, whose many installations have engaged memory and landscape, became the perfect artist to create a site-specific work relevant to the cultural history of the city. Although they had no vote, community members were always invited to sit in on the selection process and to voice their thoughts and concerns. Ewing, recognizing residents' attachment to the three-hundred-year history of their neighborhood, which they feared was being obliterated by new construction, hired a researcher of local history. She studied the social and physical histories of the community as the first phase of concept design.

Ewing's response to this context was *Subject/Object Memory*, a complex environment which transformed a portion of the Penrose Plaza parking lot into a small park with trees, seating, and over-scaled traditional Philadelphia High Chests. Painted in colors associated with eighteenth-century America, the cabinets were arranged in a circle. The chests' drawers list merchandise for sale at Penrose Plaza, while each of their backsides carries a separate story about a significant moment in the history of Philadelphia going back to the 1600s. White Adirondack chairs in the center of the circle invited people to sit and relax.

184

Ewing's piece both honors and educates, reinforcing the identity and memories the community feared losing.

Years later, Ewing's work still exists in its original site, although the surrounding areas have been drastically altered with new highways, commercial buildings and landscaping.

Also for the Korman Companies, I was asked to lead the process to select artists and manage the implementation of artworks for Buttonwood Square residential complex (now CityView Condominiums) in Center City Philadelphia. Three diverse large-scale works of art are a counterpoint to the residential architecture. Together they exemplify unique civic placemaking. Winifred Lutz's art garden unifies the two buildings and landscape. Stephen Antonakos's *Neons for Buttonwood* identifies the development at the skyline, and John Dowell's *Spirit Dance* enlivens a passageway in the building's interior.

While often the development of a building site eradicates the boundaries and features of its former existence, a kind of "site amnesia," the Buttonwood site had an irrepressible and tangible history. In the 1950s, the nineteenth-century Preston family home (the Preston Retreat) which had become a maternity hospital, was razed. Twenty pieces of white marble from four massive portal columns were shunted off to the side of the plot only to be forgotten,

Columns retrieved from the Preston Retreat
1989

Winifred Lutz
*How to Retain Site Memory
While Developing the Landscape*
1991
Philadelphia, PA

left to age, and gather moss. Years later, the developers suggested to me that the artist about to be selected under the percent-for-art mandate of the Redevelopment Authority might be able re-use the marble column segments in their artwork for the project. It definitely was a factor in thinking of the artists I would recommend.

Winifred Lutz, a Philadelphian and College Art Professor, was known for her use of natural and existing site materials for her always well-researched public projects. *How to Retain Site Memory While Developing the Landscape* was a unique urban landscape that Lutz ultimately created for Buttonwood. She was asked to create an art environment for the development's gardens. Lutz, distinguished by her ability to "transform ordinary space into fantastic, reflective kingdoms through her inventive employment of ordinary elements,"[101] welcomed the opportunity to recycle the existing historic marble columns and infused the garden with her magical sense of place and time. Her design subtly choreographed the visitor's experience, enabling them to remember and explore the architectural and natural histories of the site. The fallen column segments, a leitmotif throughout, were engraved with meaningful legend and transformed in function. The garden includes native stone, indigenous flora and Mica schist of the same variety used in the nineteenth-century walls that surround the site. Harmonious and transitional landscaped spaces unify zones of activity throughout. Landscape designer Richard Vogel collaborated with Lutz to locate unusual trees, groundcovers and other plantings.

In the spirit of the early walled gardens of historic Philadelphia, the *Entry Circle* can be viewed from the street by passersby. Surrounded by pleached American Hornbeams, a 25-foot-tall column of stacked marble sections echoes the original Preston Retreat columns; it can be seen as a center of memory – a memorial. Concentric arcs of radiating Belgian granite pavers form circular patterns repeated elsewhere in the garden.

From the entry point, Lutz's meandering pathways lead one to a Japanese-inspired dry stone garden screened by a stand of cedar trees. Beyond this "most quiet place," one continues to the main theater, or center court, a lushly planted classical garden. There the marble sections, which have been engraved with concise and provocative texts referencing the history of the site, function as seating and sculptural markers. Marking the garden's outer limit is a single Metasequoia that was allowed to grow unrestrained beside a stacked column that reminds of the garden's entry.

Philadelphia artist John Dowell's etched glass *Spirit Dance* enlivens with abstraction and color the pedestrian internal link between the lobbies of Buttonwoods two residential buildings. Music, movement, symbolism, and spirituality figure importantly in Dowell's evocative painting and photography.

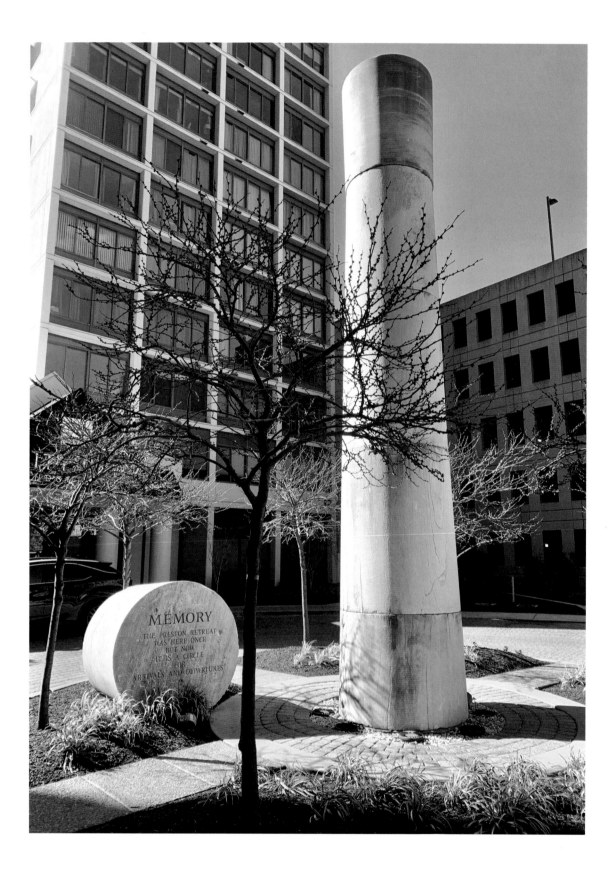

MEMORY
THE PRESTON RETREAT
WAS HERE ONCE
BUT NOW
IT IS A CIRCLE
FOR
ARRIVALS AND DEPARTURES

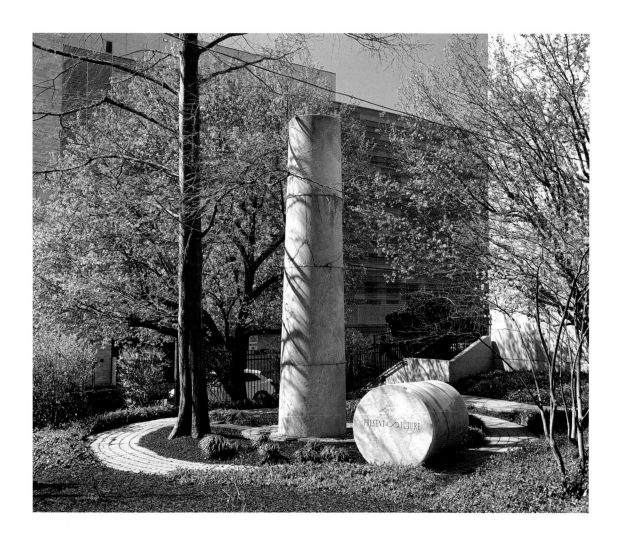

Winifred Lutz
How to Retain Site Memory
While Developing the Landscape
1991
Philadelphia, PA

John Dowell
Spirit Dance
1988–89
Philadelphia, PA

190

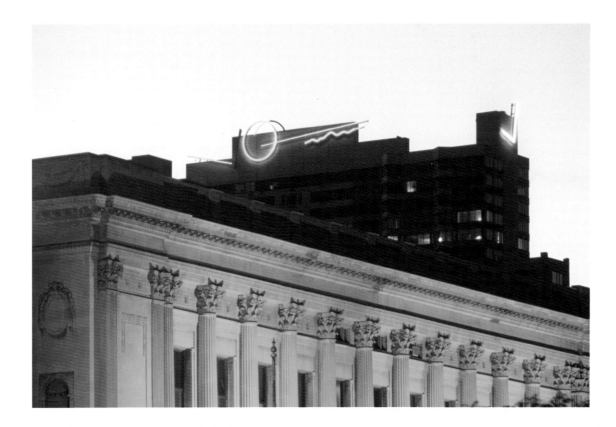

His fluid artworks and ability to capture movement made him a particularly appealing choice for the articulation of this passageway.

Stephen Antonakos' kinetic neon sculpture, *Neons for Buttonwood*, is a beacon, always visible across the city of Philadelphia, marking the development. A minimalist sculptor, Antonakos explains his affinity for neon, which he has employed in monumental works for airports, train stations, theaters, office buildings, and schools around the world: "For me, neon is not aggressive, but it has certain powers. It can be seen from great distances, and it can be used not just linearly but spatially ... I simply thought that so much more could be done with it abstractly than with words and images. I had a feeling it could connect with people in real, immediate, kinetic and spatial ways."[102]

In 2018, new building owners CityView Condominiums assumed responsibility for conserving all the original Buttonwood artworks. They engaged conservators and restorers and, importantly, contacted the artists Winifred Lutz and John Dowell, and in Antonakos's case, his wife and executor of his estate, for their consideration and involvement. The owner's commitment is exemplary, a role model for the necessary maintenance of public art.

Not every project that I did for the Redevelopment Authority of the City of Philadelphia Fine Arts Program has had such a happy ending. The developers Rouse Associates had a genuine desire to commission an important and appropriate work of art for the lobby of their new Sheraton Society Hill Hotel. To its credit, the art committee, including architects Welton-Becket, the developer, and representatives of the Sheraton, was determined to avoid "plop art." As is typical in Philadelphia, the art was subject to the guidelines and approval of the Philadelphia Redevelopment Authority Fine Arts Program. This project had an added constraint in that it needed to be completed within a year to coincide with the opening of the building. To select an appropriate artist, I prepared a presentation showcasing functional and environmental artworks: fountains, gates, doorways, seating, and lighting. After looking at many artists, and visiting four of the final choices, the art committee decided on a fountain for the interior garden courtyard of the hotel. Italian artist Giuseppe Penone, who incorporates nature into his work, was chosen.

Initially, Penone was reluctant to place his art in a commercial building. Most public art projects in Italy are found in government buildings. To allay his apprehension, I suggested we walk around Philadelphia, one of America's most historic cities, together. I pointed out distinctive historic buildings as evidence. I called his attention to a landmarked two-hundred-year-old house recognizing the city's respect for its cultural heritage; he was not impressed, saying that in Turin, he lived in a six-hundred-year-old house! Thus reinforcing the relativity of history: We are a very young country, and in the absence of a commitment to a

Stephen Antonakos
Neons for Buttonwood
1990
Philadelphia, PA

tradition of enduring art and architecture and civic respect for the public realm, art's value and its very existence is not guaranteed. While I was able to convince Penone to undertake the Philadelphia project, his skepticism turned out to be well-founded.

The concept for *Bifurcated Branch and Three Landscapes* (1986) explored the relationship between humans, nature, and art. Set in a black granite pool, a circular composition of living plants, vines, and bushes in red clay pots was organized around three bronze figures and a bifurcated branch through which water slowly bubbled. Intertwined with foliage, the bronzes appeared to have emerged from tree bark. The presence of the plants and fountain in the work created a placemaking environment; a focal point for the hotel lobby, engaging audiences visually and acoustically.

The artist extensively documented the finished work and left explicit instructions for the maintenance of its sculptural and plant elements, none of which required horticultural expertise, an artistic sensibility, or special materials. Nevertheless, whether from benign neglect or blatant disregard for the artist's intentions, when the plants died, the hotel replaced them with random plant species in pots whose material, color, number, and organization were stridently different from the original. The compromises effectively destroyed the art. Devastated and fearing for his reputation as an artist, Penone insisted on removing the entire sculpture.

The irony is not lost: the interest in ancient and historic cultures evidenced by Americans traveling abroad does not always translate into respect for our own cultural heritage. Philadelphia's customary respect for artists' integrity further compounds the insult to Giuseppe Penone's work.

Gian Lorenzo Bernini
Apollo and Daphne
1622–25
Galleria Borghese, Rome, Italy

Giuseppe Penone
Bifurcated Branch and Three Landscapes
1986
Philadelphia, PA

Giuseppe Penone
Bifurcated Branch and Three Landscapes
1986
Philadelphia, PA

Giuseppe Penone
Bifurcated Branch and Three Landscapes
1986
(After destruction circa 2000)
Philadelphia, PA

195

Grand Rapids, Michigan

Grand Rapids sought its future relevance in its rich middle-America past. An affluent small city in America's heartland, "River City" had long depended on entrepreneurship and focused industry for its growth, notably with excellence in design and furniture manufacturing. Typical of cities its size, the downtown was central to shopping and civic activities; over time, as happened in many smaller cities, adjacent suburban communities housed its growing diverse populations. To regain its downtown as an active center, Grand Rapids turned to public art as a catalyst for its urban revitalization – the city was the first beneficiary of an NEA initiative giving matching grants for contemporary public art in 1969, commissioning the prominent artist Alexander Calder's innovative sculpture *La Grande Vitesse*. At first it seemed too modern for the traditional city, but it quickly became the visual symbol of the city. An image of Calder's work appears on sanitation trucks, while a replica in its airport greets visitors. An active sculpture by Mark di Suvero became another major artist's work commissioned for downtown Grand Rapids, underscoring the city's long commitment to innovative furniture design.

Fast forward to 1994, when the city with the aid of a prominent local business, the Frey Family Foundation, helped to create a model public/private partnership. At the time, the city at the time was building a new sports arena intended to bring people downtown, and hopefully continue to energize the city center.

The Frey Family Foundation convened a team of urban designers and public art professionals to conceive and realize yet another signature artwork as a new dynamic urban focus for the expected revitalization of downtown Grand Rapids. Robert McNulty and Penny Cuff, principals in Partners for Livable Communities, recommended Ronald Lee Fleming of The Townscape Institute; Fred Kent; and Cynthia Abramson of Projects for Public Spaces, Inc.; Charles Zucker, director of Planning, Lee & Liu Associates, Inc.; and my firm, Joyce Pomeroy Schwartz, Works of Art for Public Spaces, Ltd. to launch the Frey Foundation Public Art/PlaceMaking Initiative. Consensus-building was of paramount importance: In developing an overall strategy for the project, we met with diverse constituencies and learned about the needs and desires of citizens and local businesses. All agreed that creating and promoting cultural and economic activities in the heart of downtown Grand Rapids was critical to its future. The objective was to reinvent the urban center as a destination with amenities that would incentivize people to linger.

I initiated a formal artist selection process with a "Call for Artists." Over 350 submissions from nationally and internationally renowned and emerging

Alexander Calder
La Grande Vitesse
1969
Grand Rapids, MI

Joe Kinnebrew
City of Grand Rapids logo
1982

Maya Lin
Ecliptic
2001
Grand Rapids, MI

197

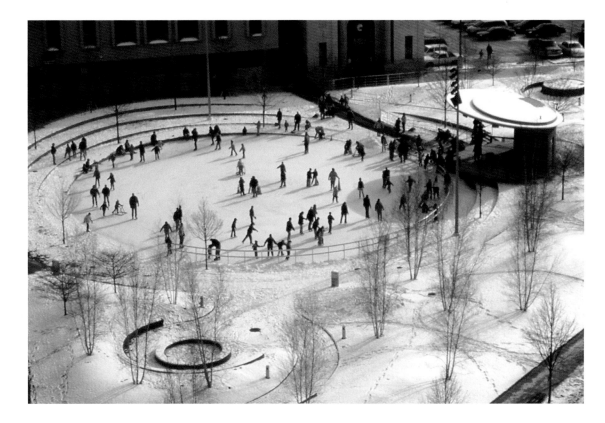

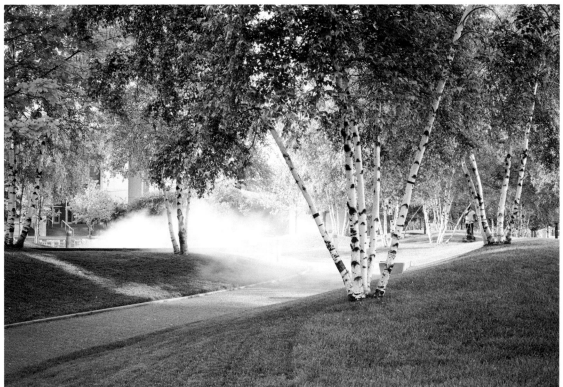

artists were received. The project confirmed the value of a creative, open, and participatory process and the wisdom of having a strong and diverse leadership committee managed by an art professional. Its stated goal – downtown redevelopment – demanded broad community representation and active civic ownership. In October 1995, The Frey Public Art/PlaceMaking Initiative formed a Community Advisory Committee (CAC), comprised of more than fifty downtown business owners, representatives of the university, parks officials, and concerned citizens. Among them was Mary Ann Keeler, a Grand Rapids native, philanthropist, leader of the previous downtown revitalization, and passionate advocate for the arts. It was she who had driven the acquisition of the Calder stabile years before.

The CAC participated in three days of intensive visual presentations – my standard introduction to public art. With the goal of opening the committee members to new ideas and inspiring them with possibilities, we showed them many examples of historic and contemporary art in public places, showcasing a diversity of imagery, materials, and forms. The client's "cultivated receptivity" meant greater appreciation of the artists' vision throughout the design process. We generated a short list of twenty-three artists. From that group, we selected six artists for review by Frey Foundation Trustees: Alice Aycock, Maya Lin, Marisol, Andrés Nagel, Tom Otterness, and Elyn Zimmerman. Maya Lin was the Art Committee's first choice; other artists were candidates for additional sites in the future, which unfortunately were not realized.

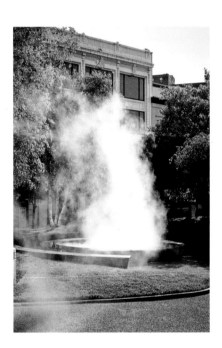

The committee visited Maya Lin in her New York studio. I explained that Grand Rapids, which had a history of commissioning important works of public art – including the Calder and an interactive sculpture by Mark Di Suvero – wanted another "signature work of art" to encourage residents and visitors to spend more time downtown where the new sports stadium, then under construction, was expected bring a greater influx of people. Lin said that she was no longer interested in making signature works of art or, for that matter, memorials. Somewhat surprised, but undaunted, I mentioned that Grand Rapids residents were primed to embrace an innovative and expansive urban design and public art strategy, and that the community had spoken lovingly of an improvised ice-skating rink created by flooding a space downtown during the winter months. Lin's interest was aroused: the idea aligned perfectly with her passion for nature and ecology and her convictions about the importance of water to environmental planning.

The selection process had not required a proposal; we had chosen Lin on the strength of her past work and confidence in her problem-solving abilities. She met with design and urban planning professionals, government officials, and all members of the CAC to discuss potential art sites, the city's history, and

Maya Lin
Ecliptic
2001
Grand Rapids, MI

199

the specific requirements of various civic stakeholders. Support for the project and its urban revitalization aspirations was overwhelming: a party to introduce Lin personally to all participants and their families was held at Frank Lloyd Wright's Meyer May house in Grand Rapids, owned and meticulously restored by Steelcase.

Lin knew that she needed a landscape architect collaborator, and I suggested three capable firms who worked well with artists. Consolidating the design team close to her New York City studio was imperative, and she selected landscape architect Nicholas Quennell of Quennell Rothschild to guide the design team's understanding of zoning ordinances and site restrictions, consult on material selection, and collaborate on landscape and site elements. They created a partnership within the larger team of local architects and planners.

A 3.5-acre sculpted landscape, *Ecliptic at Rosa Parks Circle* established a new paradigm for functional urban art, integrating civic planning, art, and architecture to create a place for people to meet, celebrate, and commemorate. Inspired by the city's location on the Grand River and the artist's ecological explorations, the design takes water as its underlying theme. The ice-skating rink and mist and water fountains capture water in its three states: solid, liquid, and vapor.

Historically, public art utilizing water, sound, and light has proven accessible and accepting to larger general audiences, some of whom are not necessarily well-versed in the arts. Water-purification and waste disposal become opportunities for art, fountains, and earthworks, heightening consciousness of the fragility of the planet and our obligation to preserve and protect it.

At the heart of the park is an elliptical space that functions as an ice-skating rink in winter and as an amphitheater for performances and other public events in warm months. Organized in concentric rings, which allude to rings of water produced by an object dropped into a pool, terraced seating surrounds the rink. Timeless but with a specific temporal reference, the rink dramatically signifies the turn of the millennium, with a fiber optic lighting array under the ice that depicts constellations of the night sky on January 1, 2000.

Lin's urban public artwork has revitalized downtown redevelopment, notably the relocation of the Grand Rapids Art Museum to an adjacent site. *Ecliptic at Rosa Parks Circle* has more than achieved its mission, attracting visitors and families from the region to experience sports and arts activities in downtown Grand Rapids and enjoy its enhanced civic amenities, cultural rebirth, and economic vitality.

Maya Lin
The Midnight Sky 01 01 00
1997
Collection of Joyce Pomeroy Schwartz

Maya Lin
Ecliptic
2001
Grand Rapids, MI

Kansas City, Missouri

In Kansas City, Missouri, I had the good fortune to work with the mayor and city officials to define percent-for-art guidelines that are still actively employed today, over twenty-five years after their publication.[103]

Public art owes its first appearance in Kansas City to local businessman and developer J. C. Nichols. Nichols had visited southern Spain in the 1920s and, inspired by the cobblestone streets, fountains, sculpture, public gathering places, and street furniture that graced even small towns, he built Country Club Plaza, the first urban shopping mall in America. The complex reflects European influences, including numerous statues, murals, and tile mosaics, and architectural reproductions. Fountains are a leitmotif of the city; in fact, Kansas City is second only to Rome in its number of fountains.

In 1981, Kansas City passed a *One Percent for Public Art Ordinance*, promoting it as "the means that will enable Kansas City to transform public improvement projects into bold statements of cultural achievement."[104] But by 1990, the city had yet to articulate procedures for implementation. Interestingly, it was a developer's proposal to place art in a public place that triggered efforts to define guidelines. Wary of ad hoc development regardless of salutary intentions, the Municipal Arts Commission and mayor Richard Berkley established a task force to study the matter.

Deborah Emont Scott, the chief curator of the Nelson-Atkins Museum of Art and a professional acquaintance of mine, was the wife of Andy Scott, the city's director of Economic Development. Familiar with my work, she recommended that I be engaged as public art adviser to the city and tasked with developing formal guidelines governing the selection of artists for works of public art. With millions of dollars allocated to art – the result of extensive development and civic projects – the mayor was anxious to develop a well-conceived program for implementation.

I began where I always have: by educating my client. To ensure broad and informed citizen participation, I felt that Kansas City residents, represented by the city's Municipal Art commission, needed to know in depth the practices of other American cities that had passed percent-for-art legislation and adopted associated guidelines. I selected five with well-proven programs – Seattle, New York City, Phoenix, Philadelphia, and Los Angeles.

My team and I surveyed the art of each selected city, studied their guidelines, and assessed their programs. Ultimately, we determined that the Seattle guidelines were most appropriate. We compiled five copiously illustrated binders, which were circulated among the Mayor, his officers, and the members of the Municipal Art Commission who became enthusiastic and took ownership

R.M. Fischer
Sky Stations
1994
Kansas City, MO

of our ongoing research. The ensuing forums about the five precedent cities' programs prompted hundreds of questions from art commission members, which suggested a usable structure for my Kansas City guidelines.

Rather than an essay on best practices, the Q&A emerged as the most accessible and comprehensive response. The guidelines cover every aspect of public art, including the composition of committees, artist selection, commissioning artists, site selection, funding, project management, community relations, the role of arts administrators and independent advisers, art installation, and allocation of funds for execution and maintenance. The reference is published online and available to everyone, ensuring that whimsy, personal preferences, and politics do not subvert decision-making about the use of public space, the selection of artists, and the management of the process.

According to plan, the city initiated a search for an internal percent-for-art administrator. But at the same time, everyone was anxious to get going, and I was as eager to demonstrate the workability of the guidelines and the benefit of exceptional public art. I was asked to undertake the first projects under the new guidelines. The first site was a historic one for Kansas City.

The stockyards, which had defined the city's identity in the late nineteenth and early twentieth centuries, were designated for the first large-scale project. Although the stockyards no longer function as they had, the American Horse and Livestock Show, a Kansas City tradition since the 1920s, is held in a new purpose-built American Royal Arena Facility on the historic site.

We conducted an artist selection process following the newly-adopted Kansas City guidelines. The artist Robert Morris was invited to create the very first sculpture in the city, celebrating the American frontier. Morris was the perfect choice: not only did he have an international reputation for outstanding conceptual art, but he was Kansas City-born and had a personal connection to the stockyards. His father had been a cattle broker in the city, and Morris's childhood memories of accompanying him to the stockyards provided him with familial inspiration. Public art is a public event and the new guidelines and its first project were celebrated with a large public event memorializing Kansas City's identity and the role of stockyards in American Western expansion. Robert Morris came home to receive honors due to him as their native son.

In *Bull Wall*, Morris chose bulls to emphasize the importance of the cattle industry to Kansas City. Its achievement lies in Morris's ability to capture with minimal detail the essence of the bulls and the excitement and confusion of the stockyards. Morris's work recalls prehistoric and Native American cliff and cave paintings and references to artist Francisco Goya's drawings of running bulls. Two parallel steel walls form a chute-like passageway. Silhouette cutouts of fifteen bulls extend the entire 120-foot length of the work. Illuminated from

Attributed to
Goya (Francisco de Goya y Lucientes)
Bullfight in a Divided Ring
Unknown Date
Metropolitan Museum of Art, New York, NY

Robert Morris
Bull Wall
1992
Kansas City, MO

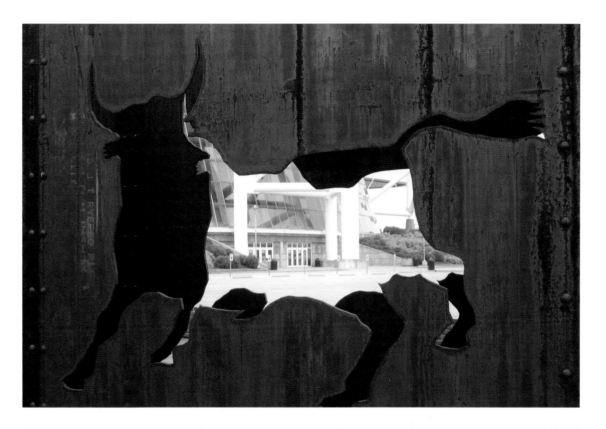

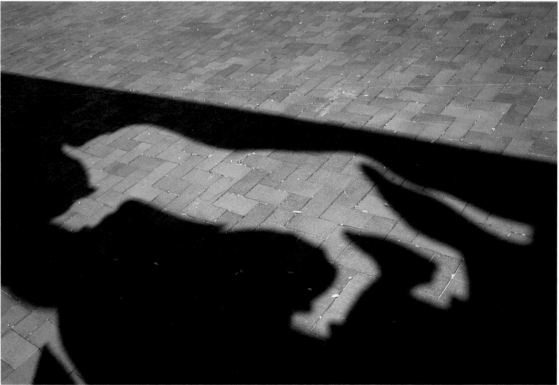

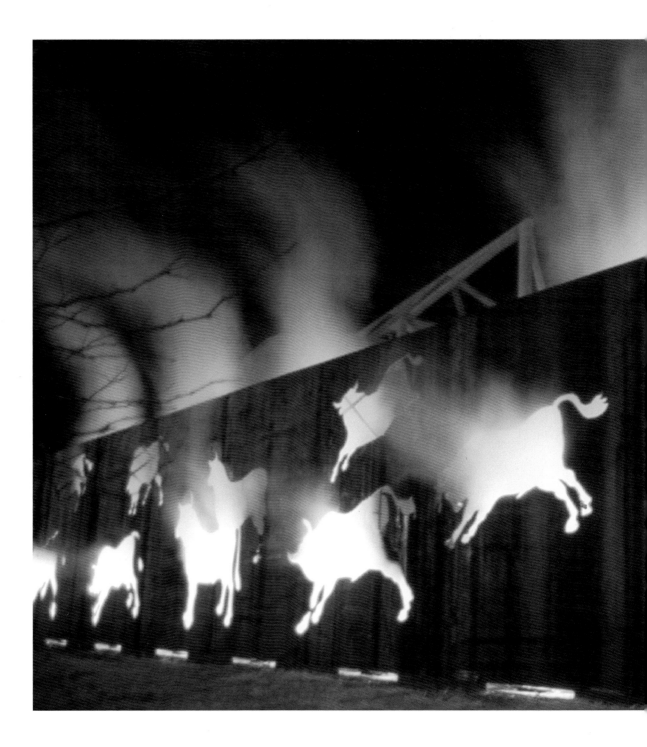

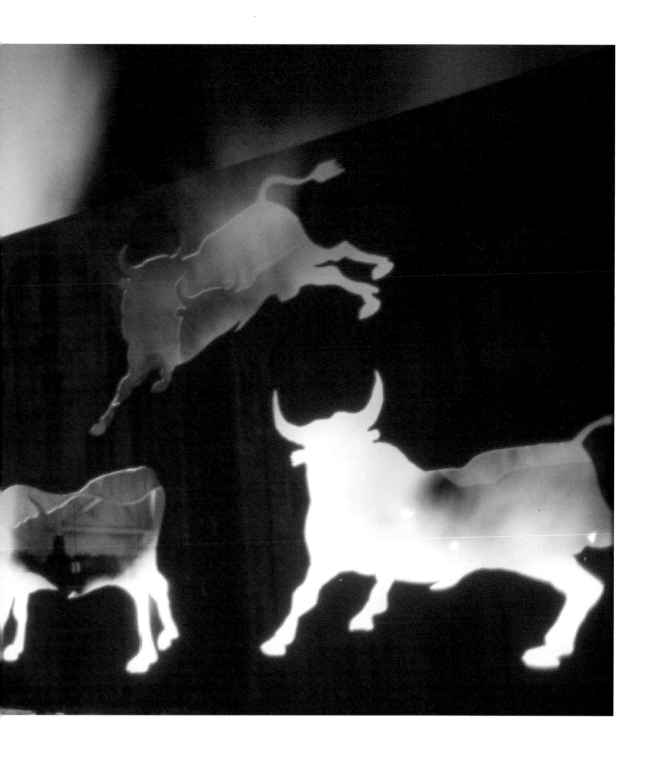

Robert Morris
Bull Wall
1992
Kansas City, MO

within, flaring steam, like clouds of dust from hundreds of stampeding feet, envelops the viewer in the total experience of the sculpture.

Dedicated in 1992, *Bull Wall* is continually changing, the solid steel panels weathering and rusting, and stands as a monument to the heritage of Kansas City and the tradition of the American Royal. When some committee members realized the steel cutouts from the sculpture were a huge leftover element of the artwork, they asked what would happen to those artifacts. Morris came up with an immediate answer. He created a second work, *Bull Mountain*, utilizing the "leftover" bull cutouts. These, he placed in the landscape amid rocks and native grasses; the art critic of the *Kansas City Star*, Alice Thorson, described the work as "an intimate experience, like going into a pen filled with animals."[105] Some Kansas Citians lobbied for a representational sculpture of a horse – a traditional, if questionably relevant, response; in a gesture of compromise, a bronze horse and foal were placed near Morris's sculpture.

I then completed two more projects for the city with regional artists, Jay Markel and Warren Rosser. As the city had a queue of prospective projects but had not yet filled the position for arts administrator, Tamara Thomas, a colleague and a well-known national public art consultant, was asked to orchestrate another public art project, ensuring the viability of our program and its guidelines. She worked with a committee, selecting the artist R.M. Fischer, whose light-oriented project, *Sky Stations*, immediately became a distinctive visual symbol of the city, and continues to identify it today in many publications noting city events.

By the mid-1990s, the civic art program was booming. Critic Peter von Ziegesar noted: "Public art in Kansas City not only changed the physical landscape, but the active cultural climate as well. For good or for ill, almost every citizen of Kansas City now has an opinion about contemporary art and is conversant with at least some of its terms."[106]

Robert Morris
Bull Mountain
1992
Kansas City, MO

Peekskill and New Rochelle, New York

Only those familiar with the cultural quality and importance of the provincial German town can understand why on two occasions a small town was chosen as the site of the Bauhaus ... They provide an ideal environment for cultural movements which require strong personal direction, and a favorable atmosphere, comparatively simple administrative machinery, comparatively few authorities (whose decisions can be quickly carried out): a community whose various elements are clearly differentiated and defined ... these are the advantages ... Both in Weimar and Dessau a fruitful working atmosphere free from distraction, and the proximity of beautiful natural surroundings were indispensable factors in the lives of those who worked at the Bauhaus.[107]
— Herbert Bayer

In the 1990s, Ralph DiBart, an imaginative and adventurous urban planner for the city of Peekskill (and son of a former mayor), proposed that artists and artmaking be the unique means for Peekskill's civic re-invention, or as he put it, "catalysts for innovative thinking."[108] His vision had a distinguished precedent in the animating ideas of the Bauhaus. North of New York City and easily accessed by rail, Peekskill is a small town on the Hudson River, with a history of shipbuilding and manufacturing. It also well known for the racist, anti-communist Peekskill Riots of 1949, sparked by a performance by prominent black opera singer and political activist Paul Robeson. DiBart envisioned a city that would welcome practicing artists, giving them affordable homes and studios in underutilized spaces, establishing an identity as an active, viable art community.

Inspired by the tradition of craft in medieval guilds and their later incarnations as Wiener Werkstätte and the Bauhaus, the master plan, *Destination Peekskill*, envisioned the town as a center of artmaking and arts experiences. Its goal was visionary: to encourage a broad arts experience in the context of a livable city, stimulating new thinking about the role of the arts in educating people.

As the city's public art adviser, I collaborated with DiBart to define the plan and the means for its implementation. Our work was exciting and far reaching, including fundraising and public information strategies, educational programs, artist selection, articulation of curatorial themes, and outreach to artists.

Sadly, the project was never fully realized due to a conflict between local interests and far-reaching ambition. The same local artists, brought by DiBart's earlier artists' housing and studio project, did not want well-known artists from outside the community to create prominent works in "their" city. Paired with

R.M. Fischer
Twilight of Dawn
1997–2017
New Rochelle, NY

the election of a less sympathetic mayor and city council, who wanted "real development" not art development, the project was doomed.

Nonetheless, Peekskill now identifies as an artists' city, aligned with DiBart's original mission. In addition to its many resident artists, art collectors Marc and Livia Straus have advanced the mission as well, having founded the Hudson Valley Center of Contemporary Art in Peekskill, whose focus is showing emerging artists and advancing community arts education.

Undaunted by the Peekskill setback, Ralph DiBart revived his vision of civic revitalization by sponsoring the arts in New Rochelle, a city about twenty miles north of New York.

DiBart, charged with urban renewal, real estate development, and new business investment as urban planner and executive director of the Downtown Business Improvement District (BID), He took positive steps to recast this small city, just thirty miles from midtown Manhattan, also as a center of art and artmaking. His ideas were enthusiastically endorsed; the city's mayor, Noam Bramson, stated: "New Rochelle has the opportunity to be at the forefront of art, technology, and information services."[109]

When DiBart enlisted me as art adviser to his new initiative, I proposed that New Rochelle was the perfect small city, close to a big city known for the arts. It could model itself on the city of Munster, Germany that had reinvented itself as a place to intimately experience "art in the city" during Documenta, the prestigious international art fair that showcases new directions in contemporary art in nearby larger city of Kassel.

New Rochelle could become a credible arts destination for many art aficionados visiting New York City during arts fairs and arts events. Locally, combining artmaking and community activities building on the weekly Saturday open-air farmers market held at the central plaza adjacent to the downtown public library could lead to a shared experience for all New Rochelle residents year-round.

With its environmental theme, New Rochelle's art program is but one example of considered engagement with the natural environment. While land art and earthworks of the 1970s and 1980s paid homage to the grandeur of the American landscape – its deserts, parks, prairies and mountains – contemporary artists like R.M. Fischer, Maya Lin, Agnes Denes, and Robert Morris among many others have directed their creative energies to the fragility of our planet and its resources.

Coincidentally, last year, my friend, artist R.M. Fischer called me about the uncertain fate of his sculpture created years ago for Sony Pictures in Los Angeles. New owners of the complex had no place for the sculpture in their plaza redesign. Light features prominently in Fischer's work, and New

Robert Lobe
Metamorphosis
2003–05
New Rochelle, NY

Rochelle's environmental art theme (earth, wind, water, and sun) immediately came to mind. Ralph DiBart was delighted, and the city agreed to acquire and reinstall the monumental light work. Fischer was ecstatic about repurposing the sculpture: he transformed the 16-foot-tall, 6.5-ton sculpture, lighting it now with solar panels, rechristening it *Twilight of the Dawn*. Not only is the sculpture now a central beacon in the library plaza, but New Rochelle has abstracted the form and adopted it as a graphic symbol of the city.

Other temporary installations for New Rochelle were planned. All the artworks, temporary and permanent, were planned to align with the curatorial theme, including Brian Tolle's *For The Gentle Wind Does Move Silently, Invisibly* and Robert Lobe's *X-Ray*.

Robert Lobe's hammered aluminum *X-Ray* marks the Memorial Highway entrance to the New Rochelle Library. Director Tom Geoffino noted the importance of art to the civic identity of the city: "(Lobe) is an artist of national note and his work 'X-Ray' speaks to our ongoing efforts to bring thoughtful public art to the attention of our residents. We're certain this initiative will also create another reason to visit our busy public library."[110]

Originally installed in Cleveland in 2004, *For The Gentle Wind Does Move Silently, Invisibly* is a series of Beaux Arts-style garden urns on pedestals. The playful work was created for a civic space defined by Daniel Burnham's 1903 plan for the city and took its cues from the symmetry of Burnham's design as well as the immediate context. Placed in series and distorted in form as though the urns are responding to Cleveland's windy lakefront, the work suggests the power of wind's sustainable energy and its positive impact on the environment.

Another program for New Rochelle was launched by the Interactive Digital Environments Alliance (IDEA) and led by Amanda Winger-Bearskin, supports creatives who are tackling the future of smart cities, sustainability, creative practice, VR/MR/AR, and technological research across multiple media, including art, immersive technologies, and information services. A competitively selected group has been awarded three- to six-months-long fellowships based at the new IDEALab live/work facility, provided by the city "to advance the development of a vibrant new Arts and Technology District."[111]

Unfortunately, in 2019 New Rochelle's art initiative was put on hold while current city fathers rethink their civic mandate for revitalizing their city through a commitment to the arts. The Brian Tolle installation never happened. Interestingly, other small cities farther away in the Hudson Valley are becoming home to many artists from New York City. Art installations and art parks become catalyst for their eventual growth as livable exciting cities attracting new artists as residents and exciting major arts development Magazzino, Dia Beacon, Art Omi, Storm King Arts Center, etc.

Robert Lobe
X-Ray
1993-96
New Rochelle, NY

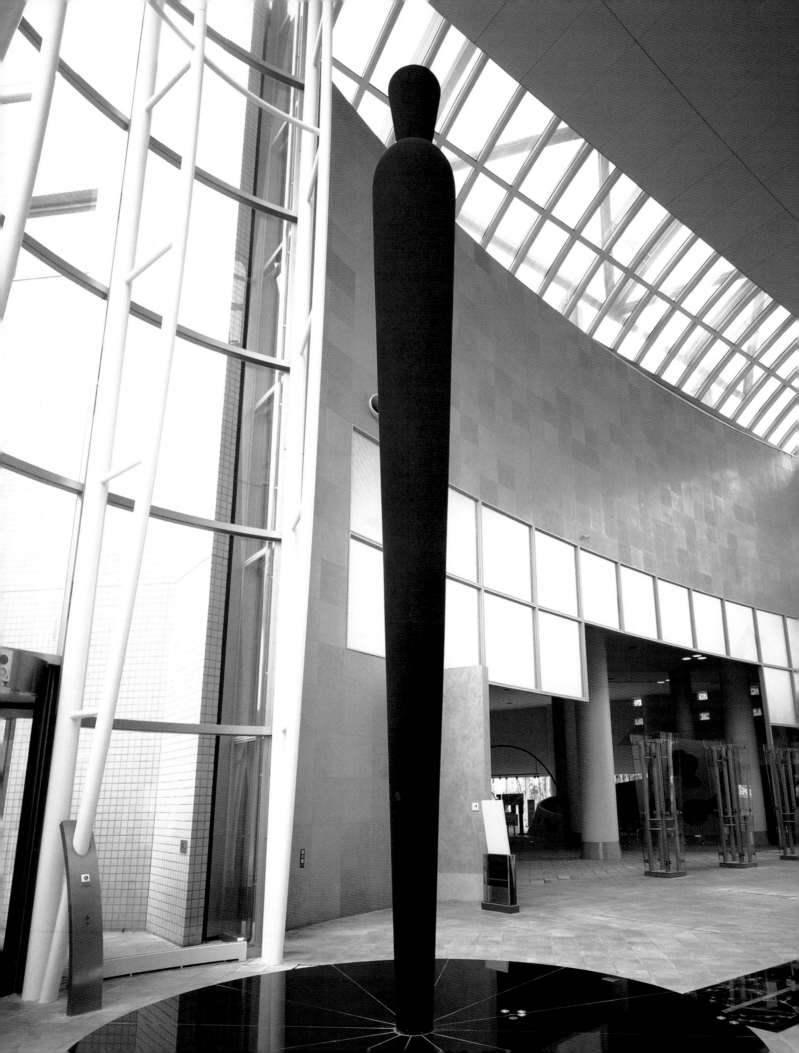

CORPORATE SPONSORSHIP

Kotobuki Chair and a Public/Private Initiative in Japan

When I was a child, my uncle had an export/import business that took him to exotic places. His stories and the dolls dressed in traditional clothing that he brought back as gifts fueled my desire to travel. Art became my ticket to fantastical places, but until I started my own business, my opportunities were limited.

In the mid-1990s, I had a most extraordinary opportunity to serve as a kind of cultural ambassador to Japan. This was an unofficial assignment, and the circumstances were serendipitous. A profile on me in a Japanese architectural journal, a coincidental family connection, a progressive client, and professionals who were eager for information on American best practices converged in a cultural exchange that transcended public art, extending into architect-artist collaborations, feminism, and transnational cooperation.

It was not that Japan lacked its own tradition of radical art. Founded in the 1950s, the Gutai group developed concurrently with the kinetic art emerging in the United States. New York may have been the center, but artists traveled widely and were well aware of developments in the art world.

Shoichiro Higuchi was a Japanese photographer, who monitored and documented trending art throughout the world. He interviewed me and published the profile in a leading Japanese architecture journal. Having read the article, Shigeyuki Fukasawa, President of Kotobuki Chair, a Tokyo-based manufacturer of much of the street furniture specified by architects of public buildings, saw an opportunity for the company's Town Art Division. He invited me to Japan and arranged for me to lecture to the prestigious Association of Artists, Craftsmen and Architects (AACA), which turned out to be the beginning of a fantastic personal and professional adventure.

Excited to learn about the country, to share my expertise and introduce new ideas, I contacted the United States Information Services (USIS) [112], a federal agency that promoted "public diplomacy": if I were to travel halfway around the world, I might as well explore any and all opportunities to lecture, meet people, and see the country. The AACA had agreed to sponsor my air travel, and the USIS offered information and assistance through American Centers in various cities throughout Japan. The Centers provided excellent translators and arranged travel on Japan's terrific high-speed rail system and accommodations in traditional ryokans.

Particularly exciting was an additional lecture organized by the American

Lita Albuquerque
Stellar Source
1996
Tochigi Prefecture Health Center, Japan

Embassy to the Tokyo-based Public Art Research Institute (PARI). PARI had been founded by Sokichi Sugimura, a manufacturer of street furniture, who had toured American cities eager to promote public art. He suggested that Joan Mondale, whose husband Walter Mondale was the Ambassador to Japan, be invited. A great advocate of public art, she accepted and in fact, introduced me!

Coincidentally, my brother, architect Lee Harris Pomeroy, who had projects in Japan, had met with Fukasawa just prior to my visit. That personal connection was important, effectively validating my identity and mission before I arrived in the country. I was welcomed most enthusiastically – virtually as family – and to this day, I maintain a close relationship with Fukasawa and his wife, my colleague Yasuyo Kudo.

The Town Art Division of Kotobuki Chair was a most enthusiastic, ambitious, and enduring client; together, we completed seven projects in only two years. Our work together tested and reinforced my conviction that art is a universal language and that because its creators are problem solvers, conceptual art transcends cultural differences.

I introduced Fukasawa, Kudo, and Town Art Division staff to the work of an extensive group of artists. Miya Yoshida was my translator for all Town Art projects, ensuring that artists' concepts were conveyed accurately to the client. In just two years, we unveiled seven projects: Jane Kaufman's *Odoru-Mizu*, a suspended mobile of Austrian crystals, geometric cut mirror forms and aluminum bars at Kotou-Ku Koukaido Concert Hall; Matt Mullican's installation art for the Miyagi Prefecture Library; works by Lita Albuquerque and Michelle Stuart for the Tochigi Kenkou To Ikiga No Mori Tochigi Prefecture Elderly Physical and Mental Health Clinics wellness center; Loren Madsen's large-scale sculpture for the outdoor plaza of the JR Kinshioyo train and bus station; Olga de Amaral's tapestry for the Judicial Scriveners' Association Building; and Manuel Neri's *Aurelia No.4* at Iwate Prefectural University. Unfortunately, a project proposal by Joyce Kozloff was not realized.

Because the Japanese government had allocated funds for these public building projects, when the proverbial economic bubble burst in Japan, the program weathered the unforeseen fluctuations in the economy. Since that time, many more works of art have been executed; moreover, the company established a curriculum to educate prospective customers and architects, artists, and craftspeople about the power of public art to reinforce communities and express cultural values.

My art projects with Kotobuki brought American artists to Japan. But it was my lecture tour that proved a thrilling and most effective platform for broad outreach. Not only did I advocate for public art per se, but I shared best practices and experiences in connection with processes and procedures

Olga de Amaral
Tapestry
1998
Judicial Scriveners' Association Building,
Tokyo, Japan

for selecting artists, defining standards, securing approvals, and building consensus. And of course, I emphasized the critical role of the independent art adviser in realizing projects.

My lectures all began with my customary introduction to the many iterations of public art, but I adjusted the structure and emphasis to align with the principal interests of three different audiences. Members of the AACA comprised my first audience. Artists aspiring to work in the United States and architects interested in working with American artists in Japan were especially curious about the role of the professional art adviser and the mechanics of successful collaborations between artists and architects.

Led by American diplomats, the American Centers sponsored a series of talks with architecture and design firms, artists, craftspeople, corporations, and regional Centers. These invitation-only gatherings, some large, some intimate, attracted mature, accomplished, knowledgeable professionals and arts-oriented individuals looking for practical information. Discussions focused on American influences on the direction of public art and on promoting American artists for commissions in Japan.

My lectures to architects and the design staffs of corporations paralleled those I gave in the United States to similar audiences. Primary topics included selecting appropriate artists, adhering to a process, defining appropriate expenditures, engaging an art consultant. This last was particularly intriguing, as art advisers were not yet recognized professionals in Japan. I endeavored to elucidate the link between an independent art adviser and the quality of the art. My audience understood that dealers, artists' agents, and gallery owners had vested interests in promoting their artists and for the most part could not be objective judges of quality and appropriateness. As these "promoters" were selecting artists for public art commissions, standards overall were inconsistent. Interestingly, or perhaps predictably, firm principals, who had businesses to run and commissions to manage, tended to be most interested in the practicalities including developing guidelines and procedures. Younger architects were eager to explore questions of aesthetics and creativity.

Particularly intriguing was trepidation about the large scale of public artworks. Skepticism stemmed from designers' acute awareness of space limitations in Japan. I appreciated the reality, but I tried to allay their concerns, emphasizing that to be effective, a public artwork needed to be scaled to the architectural or urban context. Moreover, I stressed that public artists are problem solvers, attuned to the scale and conditions of the specific place.

My experience in Japan was extraordinary – indulging my voracious appetite for travel, encouraging my passionate curiosity, to engage with a radically different culture, and in fact, reversing many preconceptions.

Manuel Neri
Aurelia No. 4
1997
Iwate Prefectural University, Japan

Pages 218–219

Jane Kaufman
Odoru-Mizu
1994
Kōtō-Ku Kokaido Concert Hall, Tokyo, Japan

Loren Madsen
Echo
1997
JR Kinshichō Station, Tokyo, Japan

Beyond the obvious, my convictions about art's universal language, its power to transcend cultures, and its humanizing force were affirmed. Those were the real lessons for me. But what of a reciprocal effect? Had my lectures, the relationships I developed, the projects I completed, the American artists I introduced had a positive and enduring impact in Japan? Had they had any impact at all?

I believe they helped to open minds and bridge cultures. Everywhere I lectured, I found people hungry for practical information about the public art process – the artist selection process, the role of the independent adviser, negotiations with regulatory agencies, building consensus and excitement within the community. Perhaps more important than the logistical and technical questions were their expressed concerns about quality and standards, sponsored by their convictions about the precious nature of shared space and public welfare.

The overarching Japanese aesthetic sensibility was incredible. Everywhere I encountered an innate appreciation for visual perfection in all things, evidence that an enduring creative sensibility over time infuses an entire citizenry. I fell in love with everything from indigo kimonos to the Japanese gardens I experienced in cities throughout the country, particularly the Ryōan-ji in Kyoto, the replica of which I had visited many times at the Brooklyn Botanic Garden. Experiences with art stay with us forever, forming who we are and what we can appreciate instinctively.

Michelle Stuart
Gardens for Seasons
1996
Tochigi Prefecture Health Center, Japan

Joyce Kozloff
Chofu
1994
Collection of Joyce Pomeroy Schwartz

Michelle Stuart
Gardens for Seasons
1996
Tochigi Prefecture Health Center, Japan

Matt Mullican
Paintings
1997
Miyagi Prefecture University Library, Japan

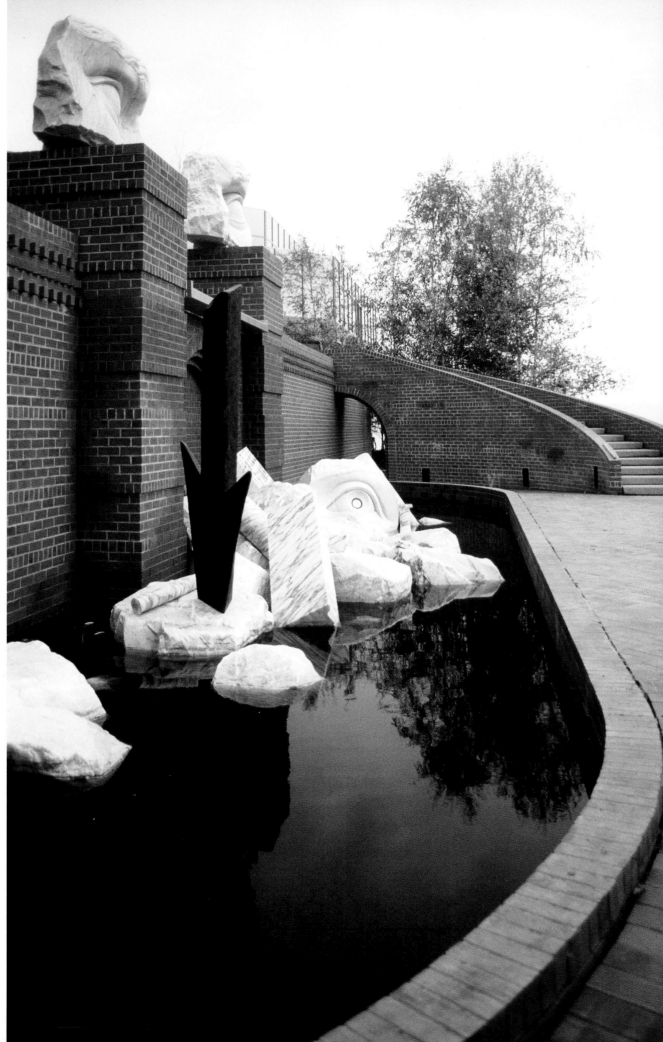

Promenade Classique, The Transpotomac Canal Center

Developed by the Dutch Savage-Fogarty Companies, the Transpotomac Canal Center in Alexandria, Virginia exemplifies a highly integrated artist/landscape architect partnership and importantly, an enlightened patron keyed in to the value of art in defining and elevating the identity of a place. Designed by CHK Architects and Planners of Silver Spring, Maryland, the $125-million, four-building complex occupies a 10-acre site along the Potomac River.

As a Dutch company with European ideals about art, the Savage-Fogarty company took their patronage role actively and seriously. In an unusual move for a development on private land, one that does not happen often with private developers, the company enlisted the Federal GSA's director of Art-in-Architecture and Historic Preservation Programs Donald Thalacker for professional guidance. He recommended me to be their art adviser, and with our guidance, Annaeus Brouwer, chairman of Savage-Fogarty, engaged a knowledgeable art committee comprised of their project's landscape architect M. Paul Friedberg, director of the Hirshhorn Museum and Sculpture Garden (Smithsonian) James Demetrion, curator of Twentieth Century Art for the National Gallery of Art (Smithsonian) Jack Cowart, associate director and chief curator of the Corcoran Gallery of Art Jane Livingston and Donald Thalacker.

Of all artists reviewed by the committee, the French artists Anne and Patrick Poirier were clear favorites: their mythologically-inspired marble and bronze sculptures resonated with the classicism of the capital's monumental architecture, and their strong interest in garden design proved fortuitous. This would be their first large-scale public commission in the United States.

Having a restricted timeframe – the artists were brought on as the buildings were nearing completion – proved advantageous in moving the art/landscape project quickly. The Poiriers had been chosen to create a single fountain or sculpture for Friedberg's landscape design; however, after surveying the site, they imagined creating a far more expansive concept. Surprisingly, the open-minded Dutch Savage-Fogarty developers consented happily to allowing Friedberg to discard his original landscape plan and collaborate with the Poiriers to create a totally new and expansive art-in-landscape concept.

Friedberg explained the extraordinary nature of Savage-Fogarty's decision: "The intriguing aspect of this project to me is the selection by the developer of a complex design solution which relates and integrates the art to its environment rather than simply commissioning an independent artwork object which is then placed within a commercial building setting. This willingness to permit a re-design of the plaza and fountain areas to absorb the art into the fabric of the project is truly exceptional. Additionally, the receptiveness of Anne

Anne and Patrick Poirier
Promenade Classique
1986
Alexandria, VA

and Patrick Poirier to what became a truly collaborative effort, I think is in large part responsible for the landmark character of the artwork … "[113]

Annaeus Brouwer underscored Savage-Fogarty's elevated aspirations as patrons: "We wanted to go beyond the placing of an artwork object within the project strictly for decoration. Our concern was with the total atmosphere of the project … From the initial planning, we were intent on having the sculpture work in harmony with the architectural design of the pedestrian plaza, the buildings, and the surrounding architecture in Alexandria and Washington, D.C."[114]

By working in tandem, the artists and landscape architect intensified their creative energies to accomplish an expansive, major public artwork for a corporate site and the community of Alexandria at breakneck speed. The fast track helped: developers, committee members, artists, and architects embraced a decision-making process that ensured completion of the project within thirteen months from the artists' initial site visit in September 1985 to installation in November 1986. Consensus was built, decisions made, and distractions eliminated.

The Poiriers had never been to Washington, D.C. A boat tour on the Potomac Rivers proved revelatory: not only were they captivated by the city's neo-classical monuments since their art is always about remembrance of the past, but upon learning that the French architect Pierre L'Enfant was responsible for the formal design of Washington, D.C. they became inspired about their art concept for the site. Anne Poirier described the couple's response to the context: "Because the proximity of the water was so wonderful, we asked if we could work with [Friedberg] to change something of the global concept, and transform a single sculpture into a promenade. We [felt] we had to introduce into this project a kind of final touch which would make a strong reference to the classical style of Washington … We tried to introduce this classical idea in the composition of the garden itself, as well as in the sculptural representations."[115]

In the interest of an integrated design process, Friedberg and I spent an intensive week at the Poiriers' studio in Paris, discussing, reviewing, and modifying the artists' initial concept while planning for integrating all aspects of the sculpture fountains into the overall landscape design. Both Friedberg and the Poiriers acknowledged that the truly outstanding collaboration was dependent on everyone's willingness to forego individual egos in the interest of art as the environment, rather than art in the environment. This conceptual alignment was tested in difficult moments as the project unfolded. For example, in a design review in the Poiriers' studio, Brouwer questioned why there were two staircases when only one was necessary. Friedberg explained the aesthetic rationale of the artist's classical symmetrical design. As an ideal patron, Brouwer quickly understood the design concept and approved the additional expense.

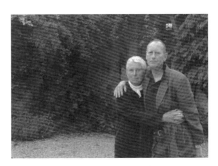

Poiriers in France

Anne and Patrick Poirier
Promenade Classique
1986
Alexandria, VA

226

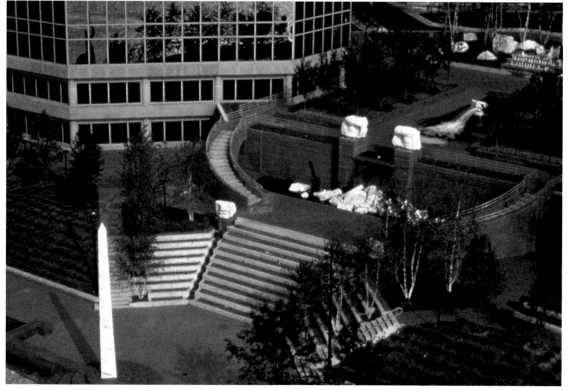

227

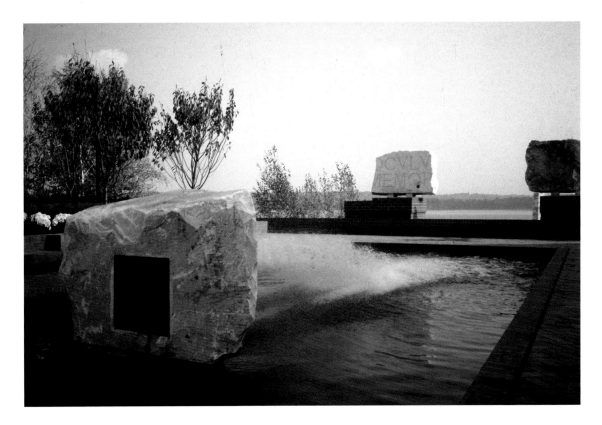

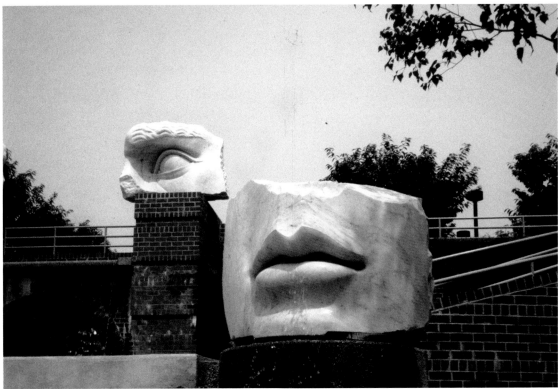

To ensure that public art is well-received by everyone, including the client, critics, the immediate community and the larger public, positive public relations must begin at the inception of a project. Although Transpotomac Canal Center was a private development, Savage-Fogarty knew the historic significance of their waterfront site and the value of creating accessible public spaces for Alexandria. Among the program elements were an amphitheater for performances and pathways for running and cycling. To promote community acceptance and heighten enthusiasm for the project, the design team presented its models and extensive drawings of the proposed project at a formal public reception and press conference in Alexandria. I have found that presenting a detailed proposal to the public prior to a work's being completed is advantageous. Informing the larger public ensures a positive reception to the work when finally installed.

Both Friedberg and the Poiriers monitored the fabrication of the marble and bronze sculptures and reviewed the engineering of all fountain elements prior to their being shipped to America from the historic ateliers and foundries of Pietrasanta, Italy. After proving to the initially recalcitrant American custom agents – the customs brokers Racine Berkow were invaluable – what appeared to be crude marble blocks were components of the artwork, six huge containers were transported by truck and unloaded at the site. Friedberg coordinated the selection and delivery of extensive plantings, including white birch trees and white-flowering rhododendrons, that were integral to the overall creation of art as place. Anne Poirier's on-site supervision throughout the installation and construction ensured that the final realization adhered to their original concepts.

Poiriers in Alexandria

A 3.5-acre ensemble of sculptural elements, fountains, brick-paved paths, cascading stairwells, and enveloping trees, *Promenade Classique* was the centerpiece of the four-building office and retail development. The Poiriers played with scale and perception, abstraction and figuration "to place the viewer in an unusual and unexpected situation."[116] Small columns were juxtaposed with large sculpture, and the different sounds of water in the many fountains lead the visitor from one part of the promenade to the next.

The artists took full and fitting advantage of the opportunity, not only to physically connect the development with the Potomac River, but to metaphorically connect Alexandria with artifacts of the capital. Their art park was organized towards the river in an axial gesture reminiscent of L'Enfant's formal, symmetrical plan for Washington – a "French Connection." A straight line connected an island studded with birch trees in the center of the building complex to an obelisk at riverside: the sequence of spaces was enticing and clear. Framed by paved walkways and double rows of cherry trees, a reflecting pool progressed to an overlook where the view is further framed by two large

Anne and Patrick Poirier
Promenade Classique
1986
Alexandria, VA

slabs of marble silhouetted against the sky. Two sweeping stairwells lead to a grotto pool and a stepped amphitheater, which embraced the 40-foot marble obelisk, a reference to the Washington Monument.

Savage-Fogarty Companies recognized the value of community involvement throughout the project and planned expansive public receptions and events to dedicate the completed work. Pride in the project was evident: the developers invited their Consul from the Netherlands Embassy and, to honor the French artists, the French Ambassador. The larger Washington D.C. art community, and the individuals and principals of the businesses and government agencies involved in the project were invited to a special dinner. But the main event was a huge gala reception at Transpotomac Canal Center for the general public. Indeed, Washington's National Airport suspended all flights to accommodate a magnificent fireworks display honoring the project's completion.

Promenade Classique is a gift of livable art to the city from the developer patrons. Its grand scale, carefully coordinated process, appreciative and enlightened corporate sponsor, and purposeful public information program led to the artwork's positive acceptance beyond the community.

An interesting footnote caps this story: unanticipated maintenance issues shone a light on critical questions about artists' prerogatives and the preservation of art. A graffiti artist had appropriated a marble sculpture as his canvas. The artists were traveling and consultation about a remedy was impossible. With good intentions, Savage-Fogarty had a sculpture restoration expert recommended by the Metropolitan Museum of Art clean the marble. Later, while the artists agreed that the graffiti was unpleasant, they had intended their work, which is always about memories of lost and ancient civilizations, to show the ravages of time and wear. Indeed, an important precedent for them was ancient Rome, where "cultured" destruction such as graffiti was common.

Anne and Patrick Poirier
Promenade Classique
1986
Alexandria, VA

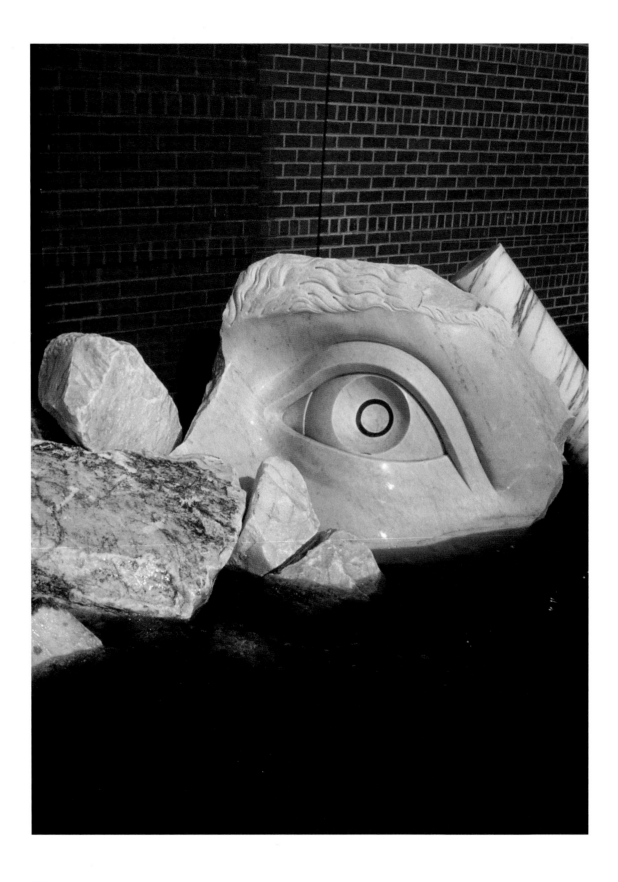

Garden of Columns, Coca-Cola USA

Vito Acconci created an oasis of art and architecture for employees of Coca-Cola USA in the company's corporate building in Atlanta. His *Garden of Columns* transforms static architectural elements into a lively interior park.

The site is a 35-foot square bordered by five black columns. The square is on the second floor of the Coca-Cola Headquarters; around the square are general stores, a cafeteria, a credit union – the square is crossed by employees on their leisure time, before and after work and during breaks. The columns are structural and continue throughout the floor.

The square is filled with columns; the edge of the square is extended into the middle. The columns that border the square are replicated by columns the same in color, texture, and diameter, but different in height. One column, 13 feet high – the height of the existent columns – is added to the edge, where a sixth column might have been, completing the square border. Eleven more columns are inserted inside the square, in and out of crossing lines that start from the bordering columns; the columns get lower as they approach the middle, each successive height decreasing about 18 inches – the column in the middle is about 18 inches high.

The top edge of each column below standard height is ragged; it's been broken off, not at full height – the columns are brought down to size, brought down to people's level.

Person-shaped cuts, torso-sized, are cut into the columns at different levels and on opposite sides, from near bottom to near-top. One cut in each column, 18 inches from the bottom, is turned into a hollow and lined with translucent fiberglass; it functions as a seat. The other person-shaped cut are filled with plants, that burst also out from the top. The columns are lit from within; a person sits inside a column, within a glow.

The seats in the columns face different directions, allowing for different seating arrangements. One seat in one column is face-to-face with a seat in another column; three or four neighboring columns have their seats turned toward each other; the seat in one column is directed away from any other seat. The columns are stopping places for people on their way across the square; the columns are a place to meet at, or a place to withdraw to and sit alone in; the columns are a place for talk, or a place for lunch.

The column in the middle, the lowest column, is filled with water at the top – fish swim in the hollow column. Although this column is seat-height, there's no place to sit in the center; people sit around the center, as equals. – *Vito Acconci*

Coca-Cola engaged me to select an artist to re-envision the central space. At his visit to the site, Acconci learned that three imposing black structural columns dominating the lobby space were universally disliked. With his characteristic irony and wit, Acconci exploited the existing architecture: rather than hide the existing columns, he multiplied them. Acconci filled the 35-foot-square space with fifteen more black columns that vary in height and function. Like trees in a forest, the columns function as a concentrated mass. People wander and explore, surprised to discover a column hollowed out as a shallow aquarium for rare Koi fish, a planter, and others that function as womb-like seats illuminated from within fulfilling the original concept of a Public Place.

While the installation was received positively, the process illustrates different perspectives on public and private space and illuminates pressures on artists to relinquish their rights if the client or public agency insists on retaining full control of its property. Acconci's concept model had been approved before he negotiated a contract. Anxious to realize the work, he reluctantly agreed to sign away his "moral right." Attorneys for Coca-Cola relied on the *Tilted Arc* litigation as precedent, claiming that the fate of the site-specific work was subject to the discretion of the company's leadership. They argued that although conceptually a "public" work, *Garden of Columns* was actually private, given its location in the interior of the Coca-Cola Headquarters building, and thus would not be subject to legislation or practices governing public art. Importantly, the company conceded one condition: the artist asked that in the contract, he be given the opportunity to address Coca-Cola directors and employees about the work if ever it were to be removed. Unfortunately, the work ended up destroyed without fulfilling the contract; when Coca-Cola began redesigning their Headquarters in 2011, Vito Acconci was not contacted or informed in any way. If he had been called, perhaps he could have come up with a more innovative solution.

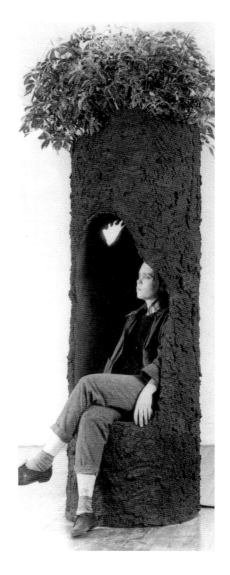

Vito Acconci
People Plant
1986

Vito Acconci
Garden of Columns
(A Town Square for Employees)
1986
Atlanta, GA

George Sugarman and Manuel Neri

In Tampa, Florida, an ordinance requiring city-owned properties to allocate at least one percent of construction costs to art had passed in 1985, and the Tampa City Council encouraged private owners to follow suit. By the late 1980s, an impressive assemblage of important art, including works by Nancy Holt, Charles Perry, James Rosenquist, Vernina Warren distinguished the city's downtown, under the leadership of Margaret Miller, director of the University of South Florida (now Director of the Institute for Research in Art). North Carolina NationsBank (now Bank of America) was excited to participate. Robert L. Kirby, president of NCNB Florida, spoke eloquently about the bank's commitment to art and architecture and its role in defining the vitality and identity of the city: "World-class art is an important component in the achievement of what urban planners call 'pride of place.' We believe this is an important contribution to Tampa's culture."[117]

I worked with the CEO of NationsBank, Hugh McColl, to commission large-scale, site-oriented sculptures for the bank's Harry Wolf-designed cylindrical buildings (Rivergate Towers) at a prominent downtown intersection. We selected two eminent contemporary artists – Manuel Neri and George Sugarman. Sugarman's site-specific aluminum sculpture, *Untitled*, was widely acclaimed, but the building changed hands, and the new owners, Capital Partners, decided to donate the artwork to the city, raising important questions about the responsibilities of ownership, about commodification, about whether relocation compromises the work's integrity, and about artists' rights. A prominent new site was found: the sculpture now sits on a traffic roundabout near the Aquarium, the costs of restoration and relocation borne by concerned individuals and businesses.[118] Although some have claimed that the site is a better one for the sculpture, nicknamed *Exploding Chicken*, the "happy ending" does not negate unsettled issues surrounding the vulnerability and protection of public art.

Manuel Neri
Española
1987
Tampa, FL

George Sugarman
Untitled
1988
Tampa, FL

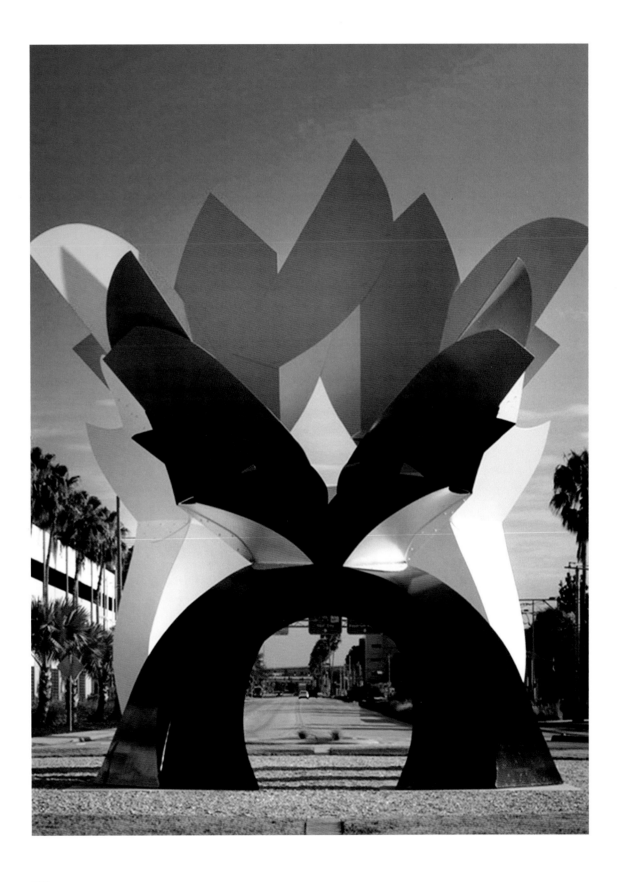

235

Charles Ross: Prismatic Light

Among the most seductive and readily accepted materials for art in public places are water and light. Charles Ross has transformed many public places throughout America and abroad with his lightworks. In sculpting light, he compels the viewer to take notice of light's physical and metaphysical qualities. The artist has said: "Art helps us experience personally and concretely what science demonstrates impersonally and abstractly."[119] In Dallas, my client Wynne-Jackson Inc. commissioned Ross to build a thirty-five-prism sculpture at the Plaza of the Americas, a retail-hotel-office complex. The ever-changing color spectrum of *Lines of Light, Rays of Color* (1986) unifies and activates the atrium of the building. Colors envelop plants, bathe walls, penetrate elevators, and punctuate walkways; passersby cannot but be stimulated by the piece, which also throws light across their bodies.

As Donald Kuspit has written, "What Ross is in effect proposing … is not simply to demonstrate, to passive witnesses, the seasonal movement of light, but to have it dynamically intervene in their lives, in however momentary a fashion … Ross shows us light 'interrupting' rather than simply illuminating ordinarily hospitable space."[120] Also in that year, Ross created *Light, Rock, Water*, his first outdoor prism sculpture, which is located in an active plaza in downtown San Diego. It incorporates a rough-cut column of pink Texas granite with a wall of prisms set in a reflecting pool. Light and water are seductive materials for public art and have proven appealing to a broad public.

Charles Ross
Lines of Light, Rays of Color
1986
Dallas, TX

Page 238-239

Charles Ross
Lines of Light, Rays of Color
1986
Dallas, TX

Charles Ross
Lines of Light, Rays of Color
1986
Dallas, TX

Charles Ross
Light, Rock, Water
1986
San Diego, CA

MEMORIALS

Irish Hunger Memorial

Brian Tolle's winning design for the *Irish Hunger Memorial* in Battery Park City, New York followed Maya Lin's paradigm. Battery Park City Authority and I began the project in the spring of 2000 with optimism – confident that an important chapter in the history of immigration, and a complete story of vulnerability, resilience, and ultimately, survival – would be told honestly, artistically, and sensitively. The winning artist was to be announced on St. Patrick's Day, March 17, 2001 with dedication scheduled exactly one year later. Six months after that announcement, the site was inaccessible, and the world was irreversibly altered.

In rereading Tolle's statement, I realize how profoundly his words resonated with me. Shortly after the artist selection process began, my husband of fifty years passed away, and I spent a reclusive summer reading qualifications statements. Professionally, the memorial was my last major project in the public realm. It is my only project that involved a formal compensated competition to select an artist, its emotionally charged subject matter having justified the process. The complexity of the multi-faceted client and interest groups tested the lessons in diplomacy I had learned through countless projects over the preceding thirty years.

Under construction at the time of the 9/11 terrorist attacks, the *Irish Hunger Memorial* was seen as an immediate opportunity to reclaim and "restore sanity" to the devastated area, notwithstanding its commemorating historical events some 150 years before. Even in its unfinished state, it served as an ad hoc memorial to those who perished, particularly the many Irish police and firefighters of New York.

In June 2000, the Battery Park City Authority had announced a competition for a major memorial on a half-acre site to commemorate An Gorta Mór, the Great Irish Hunger and Migration, which began in 1850. During the famine, over one million Irish people died, and half as many fled Ireland for new lives abroad, mostly to the United States and Australia. Memorials to the Irish Hunger exist elsewhere, but the cultural legacy of Irish immigration in our nation's largest city provided the pretext to create a new, compelling memorial.

The 1979 master plan for Battery Park City (by Alexander Cooper Associates) defined a residential and commercial precinct with a matrix of unified, yet distinct, open green spaces and waterfront access. Building designs were to adhere to strict guidelines developed and administered by the Authority and associated architects. And the Authority conceived art as an integral component of the overall precinct. But, interestingly, the original

Brian Tolle
Irish Hunger Memorial
2002
Battery Park City, New York, NY

Battery Park City urban plan had not envisioned memorials of any kind. Whether this exclusion signified the Authority's not considering memorials a distinct genre of public art or its never imagining that a memorial would be proposed for the precinct is immaterial. In fact, The Museum of Jewish Heritage: A Living Memorial to the Holocaust and the Police Memorial both opened to the public in 1997.

Historians have analyzed The Great Hunger extensively. It is generally agreed that underlying causes included not only crop failure and the unintended effects of free market capitalism but the systematic exploitation and "pauperization" of the Irish peasant population by the British government, which considered the over-populated island politically and economically threatening. At the height of the tragedy, even the liberal-leaning early Victorian journal *Punch* cynically pleaded with a nation ravaged by famine to "Let Erin forget." To their great credit and to shine a light on widespread hunger in today's world, then-New York State governor George Pataki and chairman of Battery Park City Authority Timothy Carey, insisted that none should forget the holocaust that had engulfed Ireland over a century and a half earlier.

Our competition was unusual: the structure of the body charged with project administration was more than ordinarily complex, and only artists were eligible to compete. Two committees constituted the leadership – the Battery Park City Authority Working Committee and the Irish Committee. Headed by Timothy Carey, president and CEO of BPCA, the BPCA committee included representatives of Battery Park City and professionals in art, architecture, engineering, construction, law, and horticulture. The Irish Committee – led by James Gill and including nine prominent members of New York's Irish community, including Margaret Pataki, mother of the governor – was especially invested in the work's ability to evoke an authentic and intimate relationship to Ireland and its people. We assigned responsibility for evaluating the quality and appropriateness of artists' work and winnowing the list to the Working Committee, with the Irish Committee making the final selection from that group.

I was hired as adviser to the competition, charged initially with orchestrating the selection process. But as we got into the project, everyone recognized how complicated it was, and I stayed on to manage the process. This continuity is a significant feature of my practice – one that is critical to the seamless execution of a project. At my first meeting with the nine-member Working Committee, I very directly asked about expectations and preconceptions for the memorial. I insisted that the committee think beyond the clichés of other Irish Hunger memorials: bronze sculptures depicting hungry women and children and coffin ships. I argued that optimism and memorability were critical messages and those were neither.

We all favored an interactive memorial that would resonate with visitors emotionally. Form and content needed to be one. Given the monument's dedication to a nation renowned for its literature, substantive textual narrative was to complement physical form. We engaged Dr. Maureen Murphy, an art historian and folklorist, to advise both the committee and the shortlisted artists. Murphy had developed an Irish Famine Studies Curriculum for New York City public schools, and her knowledge and participation were invaluable from the research phase of the project through completion.

Our working committee had no preconceptions about the selection process. I put forward three options: an open call for artists, from which three to five artists would be shortlisted and asked to make extensive concept proposals including drawings, renderings, and models to fully describe the intentions of their work; a solicitation limited to preselected artists; and a competition.

Uncharacteristically for me, I recommended that a design competition would best serve the subject matter, the community, and the public. The committee was well aware that emotional sensitivities and politics bear on the realization of memorials. They agreed that transparency – in the selection of an artist, the design process, and construction – was critical to the creation of a meaningful work of art. The committee limited the qualifications stage of the competition to fine artists who had clearly demonstrated in previous work the ability to create a superior work of conceptual public art. Importantly, all committee members brought a wealth of knowledge, commitment, and relevant experience that was vital to the selection process.

I enlisted the Working Committee and the Irish Committee in conceiving the project mission statement. The touchstone was the memorial's evocation of tragedy – not only the events that precipitated the disastrous famine but the forced migration of so many from a land they loved. But the mandate extended to illuminating instances and causes of hunger in today's world. The brief addressed aspirations for subject matter, site utilization, public access, and importantly, stipulated that an artist lead the team.

Criteria for the design were:
- Utilize the entire half-acre site
- Include signage and narrative to tell the stories of survivors and those who succumbed
- Describe the causes of the Hunger, including, but not limited to, the potato famine
- Provide space for reflection and contemplation
- Be accessible to the public
- Maintain view corridors to the Hudson River, Statue of Liberty, Ellis Island

and Castle Clinton in Lower Manhattan

– Inspire action to alleviate world hunger

– Identify the positive contribution of Irish immigrants to American life

– Meet the standards of quality and design of the Authority's park system

– Realize an artist-generated concept in collaboration with a landscape architect and/or architect chosen by the artist

We received close to four hundred responses to our "Call to Artists," which we had distributed to hundreds of artists, galleries, and art professionals. I spent the summer of 2000 whittling the number for presentation to the Working Committee. My maxim that public art must always be held to the same standards as art in museums guided my process. The submissions were not anonymous, but I based the initial selection solely on the *quality of work submitted*, regardless of the artist submitting it. I was looking for fresh approaches and new visions for a compelling work of art that would touch a broad public, and – most of all – would be of enduring value. The winning artist was to be announced on St. Patrick's Day 2001, with dedication of the memorial scheduled exactly one year later on March 17, 2002.

I presented qualifications of 171 artists, ordered alphabetically by name. Committee members were given the opportunity to respond openly, after which they privately and repeatedly ranked each submission on a scale of one-to-five, until a consensus emerged. Ultimately, we arrived at a shortlist of five artists for a compensated design competition with an honorarium of ten thousand dollars. As an additional incentive to participate, we planned an exhibition of the five full proposals and an accompanying catalogue. The Committee had made excellent choices: I would have been delighted with any of them.

In September, Timothy Carey contacted the shortlisted artists. Each was asked to deliver a complete proposal by December 1 for a project with a $4.7 million budget and a one-year timeframe for construction (from the groundbreaking on March 17, 2001). The artists had three months to generate their final proposals, to activate their design teams (landscape architect and architect), and to visit Ireland. Maureen Murphy developed an itinerary and plied them with an extensive reading list on feudal Ireland and famine. The proposals and the artists' individual presentations reflected a wide range of aesthetic points of view: each was a considered public art project, strongly conceptual as required. Each was broadly praised.

Saint Clair Cemin's mega-sculptural approach, which was inspired by the *Carpet Pages* of the eighth-century *Lindisfarne Gospels*, intrigued Timothy Carey; its centerpiece was a massive spoon "arched and twisted like hunger itself." Agnes Denes's took a very cerebral approach, focusing on sightlines and

narration. Kiki Smith returned from Ireland preoccupied with the image of the workhouses to which the British forcibly assigned Irish peasants. Her focus on domestic issues and forms had great historical resonance. His research into ancient Irish buildings and Hiberno-Roman relations, observations of modern-day Ireland and Kosovo, where massive displacements had recently occurred, informed Richard Fleischner's placemaking concept, which took the form of a serrated amphitheater.

But the sheer visceral energy of a young, somewhat obscure artist fully captured the committee's imagination. Brian Tolle's entry had a touch of magic and historical resonance beyond the others: he had transposed the power of place from Ireland to lower Manhattan. Unbeknownst to the artist, his concept embodied one committee member's informal remark that a sense of "the old sod" was crucial.

Without disclosing our preference, we sent the proposals on to the Irish Committee, with which the final decision rested. When the two committees convened, I had no idea of the eventual outcome. After three hours of intense discussion, they reached a clear consensus. To his great credit, chairman James Gill encouraged committee members to voice their opinions openly and fully. (An engaged and invested patron may be the key ingredient in selecting the appropriate artist. Too often competitions end in compromise.)

Tolle very nearly missed participating in the competition. My son's serendipitous encounter with the artist while serving jury duty reminded me of his work, which usually had a serious historical aspect to it. I sent him the brief, and he responded. His victory was something of a leap of faith by the committee, as he had never undertaken a permanent public commission. The final decision was an overwhelmingly positive reaction to the scope and quality of his work. He proved an experienced installation artist, whose art reflects an intense interest in the history of place and people.

Tolle's rugged Irish landscape is replete with stone walls, abandoned potato fields, and dozens of native Irish plant and grass species. It rises above a base inscribed with the history of the Irish people and the famine. Tolle conceived of the memorial as a living place that mourns those who died, celebrates the strength and endurance of the survivors, and honors the land and culture they were forced to leave.

The history of the famine and its consequences are recounted between the stones of the memorial's base, inscribed in illuminated bands of translucent resin. (The legends on them will be changed through time.) Radiating from these words is light, both grounding and elevating the memorial, as even the earth gives testimony to the dead … his passage embodies one the most fundamental myths

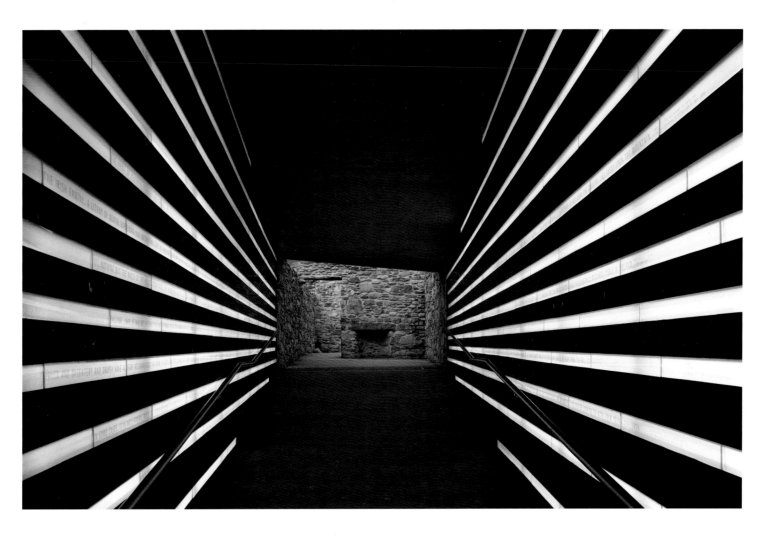

Brian Tolle
Irish Hunger Memorial
2002
Battery Park City, New York, NY

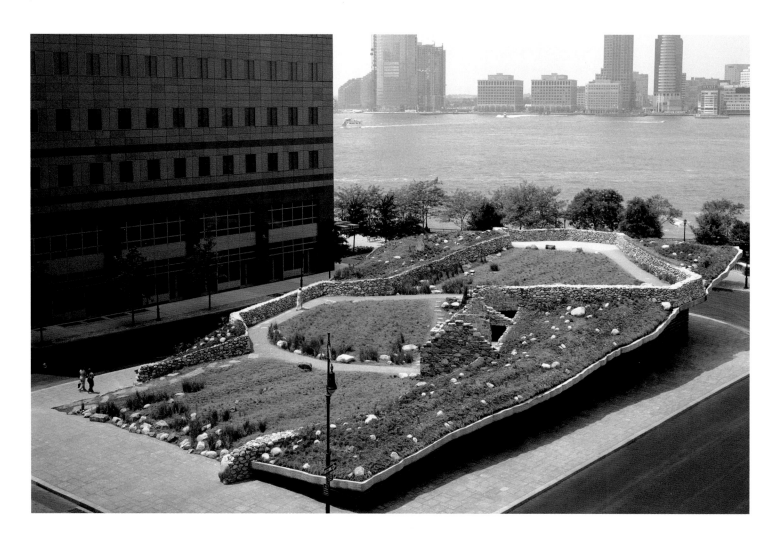

Brian Tolle
Irish Hunger Memorial
2002
Battery Park City, New York, NY

Brian Tolle
Irish Hunger Memorial
2002
Battery Park City, New York, NY

of Ireland – the myth of a land hidden within the land. The land of the Hollow Hills of the Sidhe. This is the distant past of Irish legend, the land of giants and even taller tales. As the passageway rises, it broadens. We are moving from the world of myth to the world of men … The ruins, overgrown potato furrows, and tumbled stonewalls that line this landscape signal a combined past and present. During the Irish Hunger, an entire way of life, largely unchanged for generations, was consigned to the charnel house. Because of changes in the tax law, it was primarily from quarter-acre plots like this that the Irish smallholders were evicted. By contrast, here in the midst of Manhattan, we are transported in a different way, as we contemplate this fragment of a wild landscape, of now and then: grassy resting places, a pathway that leads uphill from the ruined house, ultimately, an overlook, cantilevered over the mythic entrance to the earth below. [121]
— Brian Tolle

The site measures 96 by 170 feet, roughly one half acre. Level with the sidewalk in the east, the illuminated base rises to 25 feet in the west. One enters through a passageway in the limestone plinth. The passage widens, opening to the interior of an authentically reconstructed famine-era fieldstone cottage. Tolle's extended family, the Slacks of Attymass, County Mayo, donated the cottage, which was deconstructed, shipped, and reassembled stone by stone. Slack family members had immigrated to America during the famine, and the cottage is a moving evocation of history. Exiting the cottage, visitors meander on a winding pathway adjacent the stone walls and rugged landscape, which is thickly planted with Irish flora often found growing in fallow fields.

Tolle engaged landscape architect Gail Wittwer-Laird and architect Jüergen Riehm of 1100 Architect as his design team. 1100 Architect had worked extensively and directly with artists in the past. A specialist in urban horticulture and design, Wittwer-Laird brought extensive experience with New York City public parks and memorials. She visited Ireland to select grasses and wildflowers, which were grown in greenhouses in the United States.

Wittwer-Laird's design is a perfect conceptual complement to Tolle's idea. The landscape of the *Irish Hunger Memorial* does not fall into traditional categories of landscape design. It is neither formal, nor an imitation of a wild landscape, it is a landscape in between. It is the rural landscape of the countryside and waysides, the domesticated yet unkempt nature of a once active farm.

This landscape allows people to contemplate firsthand the intimate connection families had with the land. The traces of once cultivated potato furrows, softened by time, combined with the wild buttercups, clovers and grasses evokes the

254

fragility and resilience of nature and our complex dependency upon it. The outbreak of the potato blight combined with the politics of land ownership of the time caused one of mankind's worst, yet still ever-present calamities, famine ... The flora for the monument was carefully chosen to evoke the landscape of Mayo in western Ireland. There are more than sixty-two species of wild plants from Ireland some of which have already naturalized in the Northeast, such as White Clover, Sheep's Fescue, The Yellow Flag Iris and Foxglove ... Some of the plants were chosen because they have symbolic value in Irish folklore ... [122]
— Gail Wittwer-Laird

Excepting the supporting concrete structure, materials for the memorial's construction were imported from Ireland: the Kilkenny fossilized limestone of the base and walls that contain and divide the elevated landscape and the cottage ruin that is the centerpiece. Taken from and named for each of Ireland's thirty-two counties, the stones scattered throughout the landscape reference the tragedy's reach.

Ground was broken on March 17, 2001, and dedication was planned a year to the day later. Were it not for the September 11 tragedy, Tolle's memorial – a block away, and in clear view of Ground Zero – undoubtedly would have been completed on schedule.

Tolle expressed his optimism simply: "From here, one can see Ellis Island, the Statue of Liberty, the future." [123] He reminds visitors that America welcomed survivors in the mid-1800s and was in turn changed and strengthened by their countless contributions to our country. A metaphor for the hopeful Irish emigres who crossed the Atlantic to begin a new life, the memorial is fragment torn from the Irish countryside that has taken root in the New World.

Brian Tolle
Irish Hunger Memorial
2002
Battery Park City, New York, NY

TEMPORARY INSTALLATIONS

Temporary installations and performances, powerful and often controversial in the moment but ultimately ephemeral, can have an enduring effect on the community; memories can energize a neighborhood. One need only remember Agnes Denes's *Wheatfield* (Public Art Fund) and the late 1970s curatorial phenomenon Art on the Beach (now Creative Time) on the site of what would become Battery Park City in Manhattan. Circumventing concerns about the permanent transformation of public space, temporary installations can catalyze critical public debate about public art in the urban environment.

As part of a program initially sponsored by the Public Art Fund and now run by The Sculpture Committee of The Fund for Park Avenue and NYC Parks' Art in the Parks Program, Manhattan's Park Avenue malls provided a highly visible and unusual venue for temporary solo outdoor exhibitions by numerous artists. Fourteen sculptures by Fernando Botero inaugurated the program in 1993. Over the intervening years, works by artists including Fernand Léger, (*La Grande Fleur Qui Marche*), Donna Dennis (*Tourist Cabins on Park Avenue*), Alice Aycock (*Cyclone Twist*), and many others have brought important sculpture to midtown Manhattan.

Among the earliest of temporary instillations in Midtown was Louise Nevelson's *Atmosphere and Environment XII*, displayed in what is now Doris Freedman plaza for six weeks in 1971. To celebrate her fifty years in New York City, Nevelson decided to give her beloved city *Night Presence IV*. While Nevelson searched for a permanent home for the sculpture, the urban-scaled Cor-Ten steel sculpture was placed at Park Avenue and 92nd Street. Emblematic of artworks becoming an integral element in the environment, there was a huge outcry when the deteriorated work was removed for conservation in 2011. By then, the Park Avenue neighborhood community had taken ownership of the Nevelson work. Local residents and art lovers helped with funding the restoration of the sculpture, which was matched by New York City. Following a complete repair by the Citywide Monuments Conservation Program, an initiative of the Parks Department division of Arts & Antiquities, and much missed by New Yorkers, it was reinstalled with great fanfare in 2014.

Louise Nevelson
Night Presence IV
1972
Park Avenue, New York, NY

Madison Square Park has also become known for its temporary installations. It has featured artists such as Jene Highstein, Martin Puryear, Dennis Oppenhiem, Maya Lin and others.

Although LaSalle Partners (now Jones Lang LaSalle), the developers of a building at NationsBank Plaza in Charlotte, North Carolina, favored commissioning a work of public art, their construction budget lacked an allocation for a singular artwork. I suggested a more modest alternative: annual exhibitions mounted in the public areas of the building's shopping mall and garden. LaSalle agreed to a rotating series as an affordable way to activate and enrich the building's lobby, gardens, and connecting spaces, creating a magnet for employees, visitors, and shoppers. In all, I curated nine annual exhibitions – "Celebrating Art and Architecture" – in these varied public spaces.

Creating one exhibition every year, each with its own theme, eminent artists, and public programming added an exciting dimension to my work in public places. I borrowed works from leading artists and galleries and produced an accompanying catalogue for each of the exhibitions. Not only was I defining content and telling a thematic story, but the shows were demonstrable proof that time is often a critical ingredient in a community's acceptance of unfamiliar contemporary art. We found that in "living with" the artworks over the course of a entire year, workers and visitors had the opportunity to reassess their initial responses, ultimately taking ownership of the art.

Fernand Léger
La Fleur Qui Marche
1952
Park Avenue, New York, NY

Donna Dennis
Tourist Cabins on Park Avenue
2007
Park Avenue, New York, NY

Alice Aycock
Cyclone Twist
2013
Park Avenue, New York, NY

POSTSCRIPT: ART AND PROPAGANDA

Art is a nation's most precious heritage. For it is in our works of art that we reveal to ourselves and to others, the inner vision which guides us as a nation. And where there is no vision, the people perish.[124]
— President Lyndon Baines Johnson

The monument or statue may mark the site of an ongoing cultural struggle between memory and denial; its construction may make possible both a pretense of memory and a de facto oblivion.[125]
— William Gass

We find ourselves today at a difficult moment. Democratic ideals are under attack, and so too is the promise of public space and by extension, the art created for it. In the wake of recent political events and challenges to the First Amendment, we must confront this issue. We have come full circle to ask again: what is public art, what is not public art, and perhaps most importantly, how are we to tell the difference?

When I first began to collect my thoughts for this book, I could not have predicted the current state of public discourse. No one, from champions of the humanizing values of public art to those who have never given it a thought, can have missed the debates raging in the media, town halls, and state houses about the meaning and appropriateness of certain statuary in the public realm. These debates are reflections of our time – of the many current controversies concerning issues of freedom of speech and the pernicious disconnect between fact and fiction among political leaders.

The equestrian statue of Robert E. Lee in Charlottesville, Virginia was the spark that ignited the immediate conversation of whether likenesses of Confederate heroes should inhabit our public spaces. There are, however, many other memorials to individuals whose indifference, disregard, or contempt for basic human rights have tainted the civic contributions for which they are honored. Pressure has mounted for public officials to look beyond aesthetics to ethics, and to reframe the debate in consideration of historical context, intention, and meaning.

It is remarkable that politicians, academics, and average citizens of all political leanings are engaging with these issues at all – as wonderful as it is astonishing. The challenges are complex and far-reaching. Our country often struggles with interpretations of the United States Constitution, as it does with representing, romanticizing, revising, and sanitizing history. The debate is rife with accusations of elevating malefactors and reinforcing or legitimizing

Henry Shrady and Leo Lentelli
Robert E. Lee Monument
1924
(View of 2021 Removal)
Richmond, VA

abhorrent deeds. Articles in mainstream media abound, addressing the fate of these seemingly inert objects. But therein lies the problem: inert though they may be, they are not mute. To paraphrase Alois Riegl, the physical object is subject to changing perceptions and cultural shifts, but the memory sustains the work's meaning.

These "portrait" statues figure into our collective consciousness as historical markers, commemorating significant events or memorializing individuals. With few exceptions, debates have skirted the artistry of the pieces. In fact, does the artistry matter, or is it incidental and in some cases, accidental? Should we consider these statues art at all?

I have spent a lifetime advocating for public art and facilitating its making. I have helped government agencies, public institutions, municipalities, individuals, and corporate patrons define their aspirations for artworks that owe their existence to percent-for-art programs; I have orchestrated the process of selecting appropriate artists for specific clients and specific commissions. I have explained clients to artists and artists to clients and have managed countless successful projects that enhance public spaces and create identity. And I have advocated for relocation when the value of an artwork is questioned by its new corporate owner, when owners determine that commerce is somehow impeded by the art, or when other circumstances threaten the art's viability. I have helped to find new places for these works. If these statues are art, surely I should be a strong supporter of their preservation in their current locations, or, barring that, their conservancy in new locations. Yet *are* they art?

In contemplating this question, I am reminded of two statements by Marcel Duchamp, which are particularly resonant today: "Art may be bad, good or indifferent, but, whatever adjective is used, we must call it art, and bad art is still art in the same way that a bad emotion is still an emotion." [126] and "I don't believe in art. I believe in artists." [127] The former assumes that the object (or performance or event) in question is art, but acknowledges that only after identifying it as such can one judge its quality. One reading of the latter would seem to cast the physical manifestation aside as unimportant. A nuanced reading, however, does not deny the art but defines it in terms of the maker. As Duchamp's *Fountain* (1917) and Picasso's *Bull's Head* (1942) demonstrate, intentionality is the key to defining art qua art. Duchamp asks us to trust the maker and the maker's concept rather than the object as such. If the intention is to make art, the object is art, even if it is bad art. This distinction bears on our current discussion: were these objects *intended* as art? Or are they instead merely propaganda?

Art defies confinement, legible across generations and hemispheres, but propaganda situates an object in a specific place and time and depends both on a narrative and the receptivity of the audience. In our evaluation of these

statues, are we assessing its technical, material, formal qualities exclusively, or are we also considering subject matter and appropriateness? Do their historical narratives eclipse or obviate the need for critical evaluation as art? For the most part, we have steered clear of art historical terms in discussing these statues (or for that matter nefarious objects like confederate flags or swastikas, or benign renditions of *Balto* or *Alice in Wonderland* in Central Park). If we had subjected them to a critique of their artfulness, we would consider the sculptor or painter or graphic designer who made them, technical virtuosity, and artistic invention. Instead we talk about who placed them, for whom and for what purpose they were intended, when they were made, intentions communicated, the story they tell. This debate places ideas of the public – public space, intentionality, symbolism, history, and morality – front and center.

The puzzle is about the intentions sponsoring creative efforts, not the artist's scope or universe. This distinction may chart a way out of the dilemma regarding what to call the problematic statues. If these memorials or monuments, regardless of their form, were intended as art, we must preserve them as such. If the forms were merely convenient, understandable, and accessible devices for promoting an idea – if they are propaganda, and not art, the rules of art do not apply.

And yet, I cannot suggest disassociating form and content, which together imbue meaning. I have made the case that *Burghers of Calais* is the quintessential example of a work of public art, whose power derives from Rodin's creative genius *and* the story it tells. If we hold these statues to a different standard, where do we draw the line? Are all commemorative monuments a subset of public art that is subject to distinct standards of critical analysis? And ultimately, what are the criteria according to which we define public art? Are all sculptures, paintings, performances in public places public art? Is physical location the critical and defining characteristic of public art, or is its definition more nuanced?

What then is the answer for the debate engulfing Robert the E. Lee statue? Should the statue of a general, who raised arms against the Union to defend the Confederacy's advocacy of and dependence on slavery – an institution that is deplored universally as evil and reprehensible – remain in the public space it occupies? If so, on what grounds? And conversely, is wholesale removal the solution? Is today's volatile socio-political climate a more valid reference for determining the fates of these statues than the prevailing mores when they were erected?

The monuments were made and placed at least three decades after the end of the Civil War. While slavery had been legally abolished, Jim Crow laws were enacted after Reconstruction and continued until the 1960s. Intentions

for the monuments were truly propagandistic: reminding of, if not celebrating, a moment in history and heroizing a champion of secession and slavery at a time when the denigration and humiliation of a population continued in both direct and subversive ways. Does the removal of these works from the public realm – whether they are destroyed or relocated to a museum – constitute revisionist history? Is it not critical to confront the burdens of the past, however ugly?

Alternatively, if these monuments remain in the public space or on college buildings, which honor individuals of questionable morals, and if said spaces retain their names because their namesakes are historical figures, should we endeavor to contextualize them? If they remain, do they signify tacit acceptance of morally indefensible positions or of the oxymoronic righteousness of moral depravity? They are not just statues or just buildings: they are memory.

The ideal way forward is unclear. Consigning Jim Crow-era statues of Confederate heroes or other objectionable works to museums (decontextualizing them) and explaining them in narratives that accompany their exhibition may be a way to defuse their power and shine a light on their propagandistic messages. We cannot forget that these statues perniciously reinforced and legitimized nostalgic longing for a way of life built on slavery and subjugation.

Crafting narratives that explain their history and allowing the statues to remain in public places is another option, although its efficacy depends on the power and truthfulness of those words. And I am not convinced that words alone can compete with the physical form. Ethan J. Kytle and Blain Roberts advanced a hybrid alternative in their Opinion piece in *The New York Times* [128]: they suggested that the figures be relocated to museums but that their empty pedestals remain. The "presence in the absence" may be the most powerful and provocative solution.

Those who argue that the statues of Lee and others should remain in our public spaces because they accept the ideas represented by these individuals are truly vile; others, who cloak the indefensible in discussions of history, claiming that they serve our memory and removal would constitute revisionism or expurgation, are certainly sinister. I cannot concern myself with these people, for their motives are thinly veiled attacks on democracy and the idea of public discourse, notwithstanding their espousal of freedom of speech.

Happily, much contemporary public art has risen in direct opposition to the intentions of these monuments, notably Kehinde Wiley's *Rumors of War* (2019), commissioned by and erected in front of The Virginia Museum of Fine Art in Richmond. Many great artists are confronting the inequality of representation in American history and public art. Of significance are Kara Walker's *A Subtlety* (2014), Fred Wilson's *Mind Forged Manacles/Manacle Forged Minds* (2022) and

Kehinde Wiley
Rumors of War
2019
Virginia Museum of Fine Arts, Richmond, VA

Page 264–265

Charles Gaines
Moving Chains
2022
Governors Island, New York, NY

Charles Gaines' *Moving Chains* (2022) from his series *The American Manifest*, all of which were direct responses to America's colonialist history of subjugation. When installed at Governors Island in New York City overlooking the Statue of Liberty, *Moving Chains* paid homage not only to the history of Black Americans, but to the indigenous Lenape people from whom the land was stolen.

It is my greatest hope that these debates do not simply scratch the surface, sidestepping important questions about the place of art in creating shared narratives and the power of art to remind us of who we are and what we believe. Whether the debate is about art or politics or history, there can be no truly public art without acknowledging the politics of public space and the history of "cultural democracy."

NOTES

1. William H. Gass, "Monumentality/Mentality," *Oppositions: A Journal for Ideas and Criticism in Architecture* 25 (Fall 1982): 127-144.

2. Rosalyn Deutsche, *Evictions: Art and Spatial Politics* (Cambridge, MA: The MIT Press, 1996), xiii.

3. Lawrence Weschler, *Seeing is Forgetting the Name of the Thing One Sees: A Life of Contemporary Artist Robert Irwin* (Berkeley, CA: University of California Press, 1982), 203.

4. Daniel J. Boorstin, "A Personal Note to the Reader," in *The Creators: The History of Heroes of the Imagination* (New York: Vintage Books, 1992).

5. Louise Nevelson, *Recent Wood Sculptures* (New York: Pace Gallery, 1969), exhibition catalogue.

6. Recollections of the author.

7. David von Schlegell, in discussion with the author, previously published in *Artists and Architects: Challenges in Collaboration*, by Joyce Pomeroy Schwartz (Cleveland: Cleveland Center for Contemporary Art, 1985), 10.

8. David von Schlegell, in discussion with the author.

9. Kristin Andrea Jones, email message to author, 2018.

10. Megan O'Grady, "Women Land Artists Get Their Day in the Museum," *New York Times Style Magazine*, November 21, 2018.

11. Hannah Arendt, *The Human Condition* (Chicago: University of Chicago, 1998), 52–55.

12. John Wiley & Sons published the Encyclopedia in 1989.

13. John Beardsley, "Personal Sensibilities in Public Places," *Artforum*, June 1981, 43–45.

14. Christopher Thacker, *The History of Gardens* (Berkeley, CA: University of California Press, 1979).

15. Thacker, *The History of Gardens*.

16. Gass, "Monumentality/Mentality," 127-144.

17. David Brooks, "A Philosophical Assault on Trumpism," *New York Times*, October 3, 2017, 29.

18. Harry Hopkins, quoted in "1934: The Art of the New Deal," by Jerry Adler, *Smithsonian Magazine*, June 2009, https://www.smithsonianmag.com/arts-culture/1934-the-art-of-the-new-deal-132242698/.

19. Irving Sandler, quoted in "Public Art and the Government: A Progress Report," by Brian O'Doherty, *Art in America*, May–June 1974.

20. Gass, "Monumentality/Mentality," 127-144.

21. Blake Gopnik, "A Jet Age Medici Gets Her Due," *New York Times*, September 16, 2016, 100.

22. Robert Smithson, "Frederick Law Olmsted and the Dialectical Landscape," *Artforum*, February 1973, 62-68.

23. Patrick Clancy, "The City As An Artwork," in *Arts of the Environment*, ed. György Kepes (New York: George Braziller, 1972), 217.

24. Richard Koshalek, foreword to *The Place of Art in the World of Architecture*, by Donald W. Thalacker (New York: Chelsea House Publishers, 1980), vi. Koshalek was Director of the Hudson River Museum, Director of the National Endowment for the Arts, Director of the Museum of Contemporary Art in Los Angeles, and Director of the Hirshhorn Museum, DC.

25. Professor Sam Hunter, preface to *The Place of Art in the World of Architecture*, Thalacker, ix.

26. William Donald Schaefer, Mayor of Baltimore from 1971–1987 and later Governor of the Maryland, quoted in *Percent for Art New Legislation Can Integrate Art and Architecture*, by Dennis Green (Denver: Western States Arts Foundation, 1976).

27. O'Doherty, "Public Art and the Government: A Progress Report."

28. Robert H. Montgomery Jr. and Patricia C. Jones, "Art as Industry," *New York Times*, September 10, 1988, 27.

29. Robert Smithson, "Cultural Confinement," *Artforum*, October 1972.

30. Robert Smithson, "Some Void Thoughts on Museums," *Arts Magazine*, February 1967.

31. H. Peter Stern and David Collens, *Sculpture at Storm King* (New York: Cross River Press Ltd., 1980).

32. Alan Balfour, *Rockefeller Center: Architecture as Theater* (New York: McGraw Hill Inc., 1978).

33. Michael Decourcy Hinds, "Equitable Seeks Park Ave. Rents on Seventh Ave.," *New York Times*, February 9, 1986, 1.

34. Robert Morris, "Note on Sculpture, Part IV: Beyond Objects," *Artforum*, April 1969.

35. Robert Buck, Director of the Brooklyn Museum, quoted in "'Tilted Arc' Removal Draws Mixed Reaction," by Douglas C. McGill, *New York Times*, June 6, 1985, 21.

36. Joan Mondale, quoted in "Public Art and the Legal System," by Harriet F Senie, *Public Art Review*, September 1, 1994, 15.

37. Robert Irwin, quoted in "How Public Art Becomes a Political Hot Potato," by Milton Esterow, *ARTnews*, January 1986.

38. Arthur Danto, "On Public Art and the Public Interest," *The Nation*, August 1990, 208.

39. Robert Descharnes and Jean Francois Chabrun, *Auguste Rodin* (New York: Viking Press, 1967), 107–115.

40. Descharnes and Chabrun, *Auguste Rodin*.

41. Mervyn Rothstein, "Jack Lang, Creatively Engagé, Plots France's Cultural Future," *New York Times*, July 26, 1988, 17.

42. Rothstein, "Jack Lang, Creatively Engagé, Plots France's Cultural Future," 17.

43. Agnes Denes, interview by Maika Pollack, "Agnes Denes," *Interview Magazine*, May 18, 2015.

44. Christo, interview by Marcus Fairs, ""We face identical problems to people building a skyscraper," says Christo," *Dezeen*, June 27, 2018.

45. Richard Daley, Mayor of Chicago from 1989–2011, quoted in "Chicago's Picasso Sculpture," by Alan G. Artner, *Chicago Tribune*, December 19, 2007.

46. Roberta Smith, "George Sugarman, a Sculptor of Colorful Works, Dies at 87," *New York Times*, August 31, 1991, 19.

47. John Henry Merryman and Albert Edward Elsen, *Law, Ethics and the Visual Arts* (The Hague: Kluwer International, 2002), 308-309.

48. Barbara Hoffman, epilogue to *Public Art and Public Controversy: The Tilted Arc on Trial*, eds. Sherril Jordan, Lisa Parr, Robert Porter, and Gwen Storey (New York: American Council for the Arts Books, 1987).

49. Michael Several, "The New World," Public Art in LA, September 1997, http://www.publicartinla.com/CivicCenter/new_world.html.

50. Jonathan Borofsky, "Molecule Man," Jonathan Borofsky, accessed September 12, 2022, https://www.borofsky.com/index.php?album=moleculemanberlin.

51. Joyce Kozloff, "The Kudzu Effect (or: The Rise of a New Academy)," *Public Art Review*, September 1, 1996, 41.

52. M. Paul Friedberg, quoted in "Promenade Classique," by Georgia Sargeant, *International Sculpture* (January/February 1987), 25.

53. "VERBATIM: Stephen Antonakos: Notes on Public Art," *The Brooklyn Rail*, April 2018, 67.

54. James Wines, *De-Architecture* (New York: Rizzoli International Publishers, Inc., 1987).

55. Calvin Tomkins, Robert Campbell, and Jeffrey Cruikshank, *Artists and Architects Collaborate: Designing the Wiesner Building* (Cambridge, MA: MIT Committee for the Visual Arts, 1985).

56. Jackie Ferrara, in discussion with the author, previously published in *Artists and Architects: Challenges in Collaboration*, Schwartz, 8.

57. Jean-Christophe Ammann, "A Plea for New Art in Public Spaces," *Parkett*, 1984, 7.

58. Ammann, "A Plea for New Art in Public Spaces."

59. Joan Marter, "Collaborations: Artists and Architects on Public Sites," *Art Journal* 48, No. 4 (Winter 1989): 315.

60. Arlington County publication for the dedication ceremony, 1984. Arlington County files.

61. Tomkins, Campbell, Cruikshank, *Artists and Architects Collaborate: Designing the Wiesner Building*.

62. "Intruder," Anchorage Museum, accessed September 12, 2022, https://www.anchoragemuseum.org/exhibitions/permanent-exhibitions/public-art/intruder/.

63. Ursula K. Le Guin, quoted in "A Category-Defying Genius" by John Wray, *New York Times,* January 27, 2018, 4.

64. Patricia Fuller, quoted in *Going Public: A field guide to developments in art in public places*, by Jeffrey Cruickshank and Pam Korza (Amherst, MA: Arts Extension Service, 1988), 58.

65. Such was the case with Diego Rivera's *Man at the Crossroads*, Rockefeller Center, New York.

66. William Shawn, former editor of *The New Yorker*, quoted in *Here But Not Here. My Life with William Shawn and The New Yorker*, by Lillian Ross (Berkeley, CA: Counterpoint Press, 1998), 151–152.

67. Michael Kimmelman, "Tears for Symbol of a Nation's Enduring Identity," *New York Times*, April 16, 2019, 1.

68. Joan Mondale, quoted by Donald Moore in *Art in Architecture, Hearing Before the Subcommittee on Public Buildings and Grounds of the Committee on Public Works and Transportation, House of Representatives*, 96th Cong., 20 (1979) (Donald Moore, Deputy Chairman, Federal Council on the Arts and the Humanities).

69. Barnett Newman, *Revolution, Place and Symbol: Journal of the First International Congress on Religion, Architecture and the Visual Art*, ed. Rolf Lanier Hunt (New York: International Congress on Religion, Architecture, and the Visual Arts, 1969).

70. Tony Smith, quoted in "Note on Sculpture, Part II," by Robert Morris, *Artforum*, April 1966, 21.

71. Tony Smith, "Master of the Monumentalists," *Time*, October 13, 1967, 86.

72. James Wines, interview by Alyssum Skjeie, "James Wines: The Architect Who Turned Buildings into Art," *Carnegie Museum of Art: Storyboard*, July 8, 2015, https://storyboard.cmoa.org/2015/07/james-wines-the-architect-who-turned-buildings-into-art/.

73. György Kepes, "Towards Civic Art," *Leonardo* 4, No. 1 (Winter 1971): 72.

74. Kevin Lynch, "The Immature Arts of City Design," *Places* 1, No. 3 (1984): 10.

75. Lynch, "The Immature Arts of City Design," 13.

76. Lynch, "The Immature Arts of City Design," 14.

77. Acts 21:39 King James Version

78. *The Berne Convention: Hearings Before the Subcommittee on Patents, Copyrights and Trademarks of the Committee on the Judiciary United States Senate*, 100th Cong., 482–490 (1988) (George Lucas, Film Director, Producer and Screenwriter).

79. "Farewell to Penn Station," *New York Times*, October 30, 1963, 38.

80. Paul Richard, "Gorky's Found Art," *Washington Post*, October 4, 1979.

81. John Coffey, "The martyrdom of Sir Henry Vane the younger: from apocalyptic witness to heroic whig," in *Martyrs and Martyrdom in England, c. 1400–1700*, eds. Thomas S. Freeman and Thomas Mayer (Woodbridge, UK: Boydell Press, 2007), 221–239.

82. Robert D. McFadden, "Developer Scraps Bonwit Sculptures," *New York Times*, June 6, 1980, 1.

83. Ezra Pound to John Quinn, March 9, 1915, in *The Selected Letters of Ezra Pound to John Quinn: 1915–1924*, ed. Timothy Materer (Durham, NC: Duke University Press, 1991), 23.

84. Wrote Kushner: "For gallery and museum acceptance, if the art was industrial-looking, rectangular, and gray, black, or white, it was shown ... Everything else (except color field painting, which today can be viewed as Technicolor minimalism) seemed to be marginalized. This simply did not fit many of our temperaments. Gray was boring. We wanted our art to be a lasting experience that took a great deal of time to decode fully."
Joyce Kozloff and Robert Kushner, "Pattern, Decoration and Tony Robbin," *artcritical*, August 2, 2011, https://artcritical.com/2011/08/02/tony-robbin/.

85. Gass, "Monumentality/Mentality," 127-144.

86. Alois Riegl, "The Modern Cult of Monuments: Its Character and Its Origin," trans. K. W. Forster and D. Ghirardo, *Oppositions* 25, Fall (1982): 21.

87. Louis Menand, "The Reluctant Memorialist," *New Yorker*, July 8, 2002, 52.

88. Cher Krause Knight, *Public Art: Theory, Practice and Populism* (New York: John Wiley & Sons, 2011), 87.

89. Director of the Speed Art Museum, Peter Morrin, "Air in Public Places" in *Atlanta International Airport Art Collection, First Commemorative Catalog* (Atlanta, 1981).

90. At the Las Vegas airport, Jenny Holzer recreated ticker-tape signage; in subways and on buses, the art of Les Levine and Keith Haring walks a line between advertising and high art; in airports and hotels, the quickly moving images of Nam June Paik's video installations recall Marshall McLuhan's dictum, "The medium is the message."
Marshall McLuhan, *Understanding Media: The Extensions of Man* (New York: McGraw-Hill, 1964).

91. Jackie Ferrara, quoted in *Five Artists at the Airport: Sculpture as Environment*, by Elaine A. King, (Pittsburgh: Wood Street Galleries, 1992), exhibition catalogue.

92. Joan Mondale, wife of then Vice-President Walter Mondale, had encouraged the Federal Aviation Administration to invite internationally known artists to create environmental concepts for new transportation facilities. She assumed a leadership role in the selection of major artworks for Atlanta's Hartsfield International Airport, including Stephen Antonakos's kinetic abstract neon sculptures.

93. Joyce Kozloff, *The Private Eye in Public Art* (Charlotte, NC: LaSalle Partners at NationsBank Plaza, 1997), exhibition catalogue.

94. Joyce Kozloff, in discussion with the author.

95. Tasso Katselas, quoted in "Site: Pittsburgh International Airport," by Kate Hensler, *Sculpture* (July/August 1993): 18–19.

96. Alan Saret, quoted in "Site: Pittsburgh International Airport," Hensler, 18–19.

97. Michael Cooper and David Masello, "'Orpheus' Descended; Now What?," *New York Times*, November 26, 2015, 1.

98. Richard Sandomir, "Lee Harris Pomeroy Is Dead at 85; Architect Revived Subway Stations," *New York Times*, February 26, 2018, 8.

99. Lee Harris Pomeroy, in discussion with the author, previously published in *Artists and Architects: Challenges in Collaboration*, Schwartz, 10.

100. Executive Director of the Philadelphia Planning Commission, 1949–70.

101. Winifred Lutz, in discussion with the author, previously published in "The Art Garden of Winifred Lutz / Philadelphia," *Public Art Review*, March 1, 1990, 15.

102. "VERBATIM: Stephen Antonakos: Notes on Public Art," 67.

103. Joyce Pomeroy Schwartz, "New Directions: A Public Art Program for Kansas City, Missouri," A planning report submitted to the Kansas City Municipal Art Commission by the Mayor's Public Art Task Force, March 1991.

104. Mayor's Public Art Task Force (Barbara Bailey, Andy Scott, Patricia Glenn and Marc F. Wilson), introduction to "New Directions: A Public Art Program for Kansas City, Missouri," Schwartz, 1.

105. Alice Thorson, "Charging Bulls Go Unseen," *Kansas City Star*, May 22, 2014, A1–A8.

106. Peter von Ziegesar, "Report from Kansas City," *Art in America*, June 1995, 55.

107. Herbert Bayer, *Bauhaus 1919-1928* (New York: Museum of Modern Art, 1938), 99.

108. Ralph DiBart, in discussion with the author.

109. Noam Bramson, quoted in "IDEA New Rochelle Announces 2018 Inaugural IDEALab Fellowship Cohort," by Amelia Winger-Bearskin, *IDEA New Rochelle*, May 21, 2018, https://medium.com/idea-new-rochelle/thursday-march-15th-2018-1f3c520a06f.

110. Zak Failla, "Latest Art Exhibit, 'X-Ray' Downtown, Installed in New Rochelle," *New Rochelle Daily Voice*, August 23, 2016.

111. Memorandum, "Agreement with New Rochelle Business Improvement District (BID) to Operate IDEALab Live/Work Space at Train Station," April 17, 2018, Packet p. 23, https://www.newrochelleny.com/Archive/ViewFile/Item/1219.

112. Established in 1953, USIS operated until 1999 when its functions were absorbed by the State Department and the Broadcasting Board of Governors.

113. M. Paul Friedberg, quoted in "Savage/Fogarty Unveils Model of Sculpture for Transpotomac Canal Center," Savage/Fogarty Companies, Inc. press release, March 11, 1986, 2.

114. Annaeus M. Brouwer, quoted in Savage/Fogarty, "Savage/Fogarty Unveils Model of Sculpture for Transpotomac Canal Center," 2.

115. Anne Poirier, quoted in "Promenade Classique," Sargeant.

116. Anne Poirier, quoted in "Promenade Classique," Sargeant.

117. Joanne Milani, "New sculpture at NCNB Plaza open to wide interpretation," *Tampa Tribune*, November 23, 1988, 2F.

118. Sue Carlton, "With the Help of Believers, the Chicken Rises," *Tampa Bay Times*, April 3, 2013.

119. Charles Ross, quoted in "Prism Sculpture by Charles Ross to be Given to City at May 1 Ceremony," Centre City Development Corporation news release, April 4, 1986, 3.

120. Donald Kuspit, "Comments on Charles Ross and his work with Light."

121. Brian Tolle, "Irish Hunger Memorial," artist's statement.

122. Gail Wittwer-Laird, "Statement of Intent for the Irish Hunger Memorial."

123. Tolle, "Irish Hunger Memorial," artist's statement.

124. President Lyndon B. Johnson, on signing the Act (Arts and Humanities Bill) that created the NEA and the NEH, September 29, 1965.

125. Gass, "Monumentality/Mentality," 127-144.

126. Marcel Duchamp, "The Creative Act," *ARTnews*, Summer 1957.

127. Marcel Duchamp, quoted in *Off The Wall, A Portrait of Robert Rauschenberg*, by Calvin Tomkins (New York: Picador, 2005) 118.

128. Ethan J. Kytle and Blain Roberts, "The 'Silent Sam' Confederate Monument at UNC Was Toppled. What Happens Next?," New York Times, August 22, 2018, 21.

PHOTO CREDITS

Magdalena Abakanowicz

Katarsis, 1985
Bronze
33 figures, each ca. 8' 10" h. x 3' 4" w. x 1' 8" d.
Collezione Gori, Fattoria di Celle, Pistoia, Italy
© The estate of Magdalena Abakanowicz
Photo: p. 68, courtesy Collezione Gori

Vito Acconci

Pink Playground, 1983
© Vito Acconci / Artist Rights Society (ARS),
New York, courtesy of Maria Acconci
Photo: p. 29, courtesy of the Artist

Wall-Slide, 2002
Stone, tile, and fiberglass
NYCT 161st Street–Yankee Stadium Station, New
York, NY
Commissioned by Metropolitan Transportation
Authority Arts & Design.
© Vito Acconci / Artist Rights Society (ARS),
New York, courtesy of Maria Acconci
Photos: p. 179, Jacqueline Pearse, 2022

People Plant, 1986
Concrete, plants, and light
8' h. x 2' w. x 2' d.
© Vito Acconci / Artist Rights Society (ARS),
New York, courtesy of Maria Acconci
Photo: p. 233, courtesy of the Artist

*Garden of Columns (A Town Square for
Employees)*, 1986
Fiberglass, enamel, lights, plants, water, and fish
13' h. x 35' w. x 35' d.
Coca-Cola Company Headquarters, Atlanta, GA
© Vito Acconci / Artist Rights Society (ARS),
New York, courtesy of Maria Acconci
Photo: p. 233, Joyce Pomeroy Schwartz

Lita Albuquerque

Stellar Source, 1996
Tochigi Prefecture Health Center, Tokyo, Japan
©2022 Lita Albuquerque
Photo: p. 214, courtesy of Town Art Division,
Kotobuki Corporation, Tokyo, Japan, 1994–1998

Olga de Amaral

Tapestry, 1998
Judicial Scriveners' Association Building, Tokyo,
Japan
©2022 Olga de Amaral
Photo: p. 216, courtesy of Town Art Division,
Kotobuki Corporation, Tokyo, Japan, 1994–1998

Stephen Antonakos

Neons for Buttonwood, 1990
23' h. x 111' w. x 2' d.
CityView Condominiums (formerly Korman
Suites at Buttonwood), Philadelphia, PA
Commissioned by the Korman Company in
cooperation with the Redevelopment Authority
of the City of Philadelphia 1% Fine Arts Program
and the Commonwealth of Pennsylvania.
©2022 Stephen Antonakos
Photos: p. 192, courtesy of the Artist

Siah Armajani

NOAA Bridge, 1983
NOAA Western Regional Center, Seattle, WA
© Estate of Siah Armajani
Photo: p. 96, Corbin Documentary, Courtesy of
Art on File

Alice Aycock

Star Sifter, 1998/2013
Stainless steel, aluminum, motorized parts
Approx. 40' h. x 60' diam. with suspended
elements of varying heights
Terminal One, JFK International Airport, NY
© Alice Aycock
Photos: pp. 164, 166, courtesy of the Artist; p.
167, Dave Rittinger

Proposal for Star Sifter, 1998
© Alice Aycock
Image: p. 165, courtesy of the Artist

Cyclone Twist, 2013
From *Park Avenue Paper Chase*, March through
July 2014
Installed between 52nd and 57th Streets and at
66th Street on Park Avenue, New York, NY
©2022 Alice Aycock
Courtesy Galerie Thomas Schulte, Berlin
Photo: p. 257, Dave Rittinger

Romare Bearden

City of Glass, 1993
Faceted glass
NYCT Westchester Square-East Tremont Avenue
Station, New York, NY
Commissioned by Metropolitan Transportation
Authority Arts & Design.
© 2023 Romare Bearden Foundation / Licensed
by VAGA at Artists Rights Society (ARS), NY
Photos: pp. 174, 176–177, Rob Wilson, courtesy of
the MTA Arts & Design

Maquette for City of Glass, 1982
© 2023 Romare Bearden Foundation / Licensed
by VAGA at Artists Rights Society (ARS), NY
Photo: p. 175, courtesy of the Artist

Gian Lorenzo Bernini

Apollo and Daphne, 1622–25
Carrara marble
Galleria Borghese, Rome, Italy
Photo: p. 194, Architas via Wikimedia Commons

Andrea Blum

Corporate Displacement, 1992

General Mills Sculpture Garden, Minneapolis,
MN
© 2022 Andrea Blum
Photo: p. 77, courtesy of the Artist

Jonathan Borofsky

Molecule Man, 1977
Aluminum
Los Angeles, CA
© 2022 Jonathan Borofsky
Photo: p. 88, Carol M. Highsmith Photography,
courtesy of the Library of Congress, Prints &
Photographs Division

Brassaï (Gyula Halász)

Graffiti 1, 1959
59 x 118 in. (150 x 300 cm)
Woven by Yvette Cauquil-Prince, French, born
1928
Collection of Joyce Pomeroy Schwartz
© Estate Brassaï-RMN
Photo: p. 22, Jacqueline Pearse, 2022

Daniel Buren

La Cabane Éclatée aux 4 Salles, 2005
Concrete, mirrors, acrylic paints
Collezione Gori, Fattoria di Celle, Pistoia, Italy
© DB-ADAGP, Paris / Artists Rights Society
(ARS), New York 2023
Photo: p. 69, courtesy Collezione Gori

Les Deux Plateaux, 1985–1986
Marble and concrete
260 columns, dimensions variable
Palais Royal, Paris, France
© DB-ADAGP, Paris / Artists Rights Society
(ARS), New York 2023
Photo: p. 85, Joyce Pomeroy Schwartz

Alexander Calder

Pittsburgh, 1958
Sheet metal, rod, and paint
28' × 28'
Pittsburgh International Airport, PA
© 2023 Calder Foundation, New York / Artists
Rights Society (ARS), New York
Photos: p. 152, John Marino; p. 163, Beth Holrich,
2015

La Grande Vitesse, 1969
Grand Rapids, Michigan
© 2023 Calder Foundation, New York / Artists
Rights Society (ARS), New York
Photo: p. 197, Russell Sekeet, 2015

Mel Chin

Signal, 1997
Stainless steel, glass, lights, ceramic tile
NYCT Broadway–Lafayette Street Station, New
York, NY
Commissioned by Metropolitan Transportation

Authority Arts & Design.
© 2022 Mel Chin
Photo: p. 178, Rob Wilson, courtesy of the MTA
Arts & Design

Christo and Jeanne-Claude

The Gates, 2005
7,503 gates draped with saffron panels, covering
23 miles
Central Park, New York, NY
© 2023 Artists Rights Society (ARS), New York /
ADAGP, Paris
Photo: p. 84, David T. Schwartz

José de Creeft

Alice in Wonderland, 1959
Sculpture: bronze; Base: Chelmsford granite
and stone
Approx. 11' h. x 16' diam.; Base: 1' h. x 39' diam.
Central Park, New York, NY © 2023 Estate of
José de Creeft / Licensed by VAGA at Artists
Rights Society (ARS), NY
Photo: p. 45, Jacqueline Pearse, 2021

Agnes Denes

*Tree Mountain - Proposal for a Forest - 1,5 x 1,5
miles - 11 000 Trees*, 1983
*Tree Mountain - A Living Time Capsule - 11,000
Trees, 11,000 People, 400 Years*, 1992-96
Ylöjärvi, Finland
© Agnes Denes
Photo: p. 48, courtesy of the Artist

Wheatfield - A Confrontation, 1982
Battery Park landfill, New York, NY
© Agnes Denes
Photo: p. 49, Agnes Denes

*Model for Probability Pyramid – Study for Crystal
Pyramid*, 1976-2019
22' 6" h. x 22' 6" w. x 17' d.
Printed by Voodoo Manufacturing
© Agnes Denes
Photo: p. 81, Joyce Pomeroy Schwartz

Donna Dennis

Tourist Cabins on Park Avenue, 2007
Vinyl on wood, metal, wallpaper, incandescent
light
Two cabin units, each 6'6" h. x 4'6" w. x 6' d.
Installed between 52nd and 53rd Street on Park
Avenue, New York, NY
©2022 Donna Dennis
Photo: p. 257, courtesy of the Artist

Donatello

Equestrian Statue of Gattamelata, 1445–53
Bronze
Padua, Italy
Photo: p. 34, Chris Light, 2015 via Wikimedia
Commons

John Dowell

Spirit Dance, 1988–1989
CityView Condominiums (formerly Korman

Suites at Buttonwood), Philadelphia, PA
Commissioned by the Korman Company in
cooperation with the Redevelopment Authority
of the City of Philadelphia 1% Fine Arts Program
and the Commonwealth of Pennsylvania.
© 2022 John Dowell
Photos: pp. 190, 191, courtesy of the Artist

Drawings for Spirit Dance, 1988–1989
Watercolor on paper
© 2022 John Dowell
Image: p. 190, courtesy of the Artist

Jean Dubuffet

Group of Four Trees, 1972
New York, NY
© 2023 Artists Rights Society (ARS), New York /
ADAGP, Paris
Photo: p. 75, Jacqueline Pearse, 2022

La Chiffonière, 1978
Doris C. Freedman Plaza, New York, NY
© 2023 Artists Rights Society (ARS), New York /
ADAGP, Paris
Photo: p. 89, Donna Svennevik, 1979, courtesy
Public Art Fund, New York

Lauren Ewing

Subject/Object Memory, 1990
Penrose Plaza, Philadelphia, PA Commissioned
by the Korman Company in cooperation with
the Redevelopment Authority of the City of
Philadelphia 1% Fine Arts Program and the
Commonwealth of Pennsylvania.
© 2022 Lauren Ewing
Photos: pp. 184, 185, Jacqueline Pearse, 2022

Jackie Ferrara

Stone Court, 1988
8' 2" h. x 65' w. x 23' 10" d.
Limestone
General Mills Sculpture Garden, Minneapolis,
MN
© 2022 Jackie Ferrara
Photo: p. 76, courtesy of the Artist

Paths, 1992
Ceramic tile
65,000 sq. ft.
Pittsburgh International Airport, PA
© 2022 Jackie Ferrara
Photos: pp. 155, 156, courtesy of the Artist

R.M. Fischer

Sky Stations, 1994
Stainless steel and aluminum
300' h., Base: 18' x 40'
Bartle Hall Convention Center, Kansas City, MO
© 2022 R.M. Fischer
Photo: p. 202, courtesy of the Artist

Twilight of Dawn, 1997-2017
16' h.
New Rochelle, NY
© 2022 R.M. Fischer
Photo: p. 210, courtesy of the Artist

Richard Fleischner

La Jolla Project, 1984
Stuart Collection, UC San Diego, CA
© 2022 Richard Fleischner
Photo: p. 70, Philipp Scholz Rittermann, courtesy
of the Stuart Collection

Charles Gaines

Moving Chains, 2022
From *The American Manifest*, 2022-2023
Steel, sapele (African mahogany)
17' 6" h. x 19' w. x 110' 6" d.
Governors Island, New York, NY
Commissioned by Creative Time, Governors
Island Arts, and Times Square Arts
Architecture: Tolo Architecture
Construction: Torsilieri and Sons
Woodwork/Metalwork: Stronghold Industries
Sound Engineering: Arup
Engineering: AOA
© 2023 Charles Gaines
Photo: pp. 264-265, Jacqueline Pearse, 2022

Andrew Ginzel and Kristin Jones

Oculus, 1998
NYCT Chambers Street/Park Place Station, New
York, NY
Commissioned by the Metropolitan
Transportation Authority Arts & Design.
© 2022 Andrew Ginzel & Kristin Jones
Photo: p. 142, Rob Wilson, courtesy of the MTA
Arts & Design

Arshile Gorky

Activities on the Field, 1936
Newark Airport, NJ
Commissioned by the Works Progress
Administration's (WPA) Federal Art Project.
Photo: p. 137, Federal Art Project W.P.A.,
Photographic Division

Attributed to Goya (Francisco de Goya y
Lucientes)

Bullfight in a Divided Ring, Unknown Date
38 3/4" x 49 3/4"
Catharine Lorillard Wolfe Collection, Wolfe Fund,
1922
Metropolitan Museum of Art, New York NY
Image: p. 204, courtesy of the Metropolitan
Museum of Art

Jacob Hashimoto

This Infinite Gateway of Time and Circumstance,
2019
Paper, UV ink, resin, bamboo, Spectra, acrylic,
stainless steel
San Francisco International Airport Grand Hyatt
Hotel, CA
Collection of the City & County of San Francisco
Photo: p. 145, Ethan Kaplan Photography

Maren Hassinger

Monuments, 2018
Branches on armature

Studio Museum in Harlem, New York, NY
© 2022 Maren Hassinger
Photo: p. 42, courtesy of the Artist

Cloud Room, 1992
Collaborative installation
Room: 1000 sq ft. Video: 26 min.
Pittsburgh International Airport, PA
©2022 Maren Hassinger
Photos: p 159, courtesy of the Artist

Al Held

Order/Disorder/Ascension/Descension, 1977
Acrylic on canvas
each: 13' h. x 90' w.
Social Security Administration Mid-Atlantic
Program Center, Philadelphia, PA
Commissioned through the Art in Architecture
Program, U.S. General Services Administration.
© 2023 Al Held Foundation, Inc. / Licensed by
Artists Rights Society (ARS), New York
Photo: p. 58, Carol M. Highsmith Photography,
courtesy of the Library of Congress, Prints &
Photographs Division

Jene Highstein

Tem Ptah, 1985
Old City Hall, Lincoln, NE
© 2022 Jene Highstein
Photo: p. 128, Joe Schumacher, 2011

Doug Hollis

A Sound Garden, 1982–83
NOAA Western Regional Center, Seattle, WA
© 2022 Doug Hollis
Photo: p. 96, courtesy of the Artist

Sky Column, 2021
Long Bridge Park, Arlington, VA
© 2022 Doug Hollis
Photo: p. 99, courtesy of the Artist

Untitled, 1985
Willimantic, CT
© 2022 Doug Hollis
Photo: p. 128, courtesy of the Artist

Nancy Holt

Sun Tunnels (1973-76)
Concrete, steel, earth
Great Basin Desert, Utah
Collection Dia Art Foundation with support from
Holt/Smithson Foundation
© 2023 Holt/Smithson Foundation and Dia Art
Foundation / Licensed by Artists Rights Society
(ARS), NY
Photo: p. 53, ZCZ Films/James Fox, courtesy
Holt/Smithson Foundation

Dark Star Park (1979–84)
Gunited concrete, stone masonry, asphalt, steel,
water, earth, gravel, grass, plants, willow oak
Overall area: Two-thirds of an acre
Rosslyn, Arlington County, Virginia
© 2023 Holt/Smithson Foundation and Dia Art
Foundation / Licensed by Artists Rights Society
(ARS), NY

Photo: p. 98, courtesy of the Artist

End of Line/West Rock, 1985
Environmental Sculpture, stone, masonry, steel
11' h. x 28' w. x 18' d.
Southern Connecticut State University,
Newhaven, CT
Commissioned through Connecticut's Art in
Public Spaces Program.
© 2023 Holt/Smithson Foundation and Dia Art
Foundation / Licensed by Artists Rights Society
(ARS), NY
Photo: p. 127, courtesy of Southern Connecticut
State University

Astral Grating, 1983–87
Steel, incandescent light blubs
NYCT Fulton Street Station, New York [currently
not installed]
Commissioned by Metropolitan Transportation
Authority Arts & Design.
© 2023 Holt/Smithson Foundation and Dia Art
Foundation / Licensed by Artists Rights Society
(ARS), NY
Photos: pp. 172-173, Rob Wilson, courtesy of the
MTA Arts & Design

Robert Irwin

Two Running Violet V Forms, 1983
Stuart Collection, UC San Diego, CA
© 2023 Robert Irwin / Artists Rights Society
(ARS), New York
Photo: p. 32, Philipp Scholz Rittermann,
courtesy of the Stuart Collection

Jane Kaufman

Odoru-Mizu, 1994
Kotou-Ku Koukaido Concert Hall, Tokyo, Japan
© 2022 Jane Kaufman
Photos: pp. 218, 219, courtesy of Town Art
Division, Kotobuki Corporation, Tokyo, Japan,
1994-1998

André Kertész

Chez Mondrian, 1926, printed ca. 1968
Collection of Joyce Pomeroy Schwartz
© 2022 Estate of André Kertész
Image: p. 24

Joe Kinnebrew

City of Grand Rapids Logo, 1982
Image: p. 197

Joyce Kozloff

*Bay Area Victorian, Bay Area Deco, Bay Area
Funk*, 1983
Glazed tile, glass mosaic
120" h. x 612" w.
San Francisco International Airport, CA
© 2022 Joyce Kozloff
Photos: pp. 146, 148-149, 151, David T. Schwartz;
p. 147, courtesy of the Artist; p. 150, Lewis Watts,
courtesy of the Artist

Chofu, 1994
Watercolor and metallic watercolor on paper

with a graphite grid beneath
9" x 26"
Collection of Joyce Pomeroy Schwartz
© 2022 Joyce Kozloff
Image: p. 223

Robert Kushner

Agricultural Arabesques, 1986
Bronze
Entex Building, Houston, TX
© 2022 Robert Kushner
Photos: pp. 138, 139, Joyce Pomeroy Schwartz

4 Seasons Seasoned, 2004
NYCT 77th Street Station, New York, NY
Commissioned by Metropolitan Transportation
Authority Arts & Design.
© 2022 Robert Kushner
Photos: p. 179, Rob Wilson, courtesy of the MTA
Arts & Design

Fernand Léger

La Fleur Qui Marche, 1952
Ceramic, edition of 3
123" h. x 96" w. x 55" d.
Park Avenue, New York, NY
© 2023 Artists Rights Society (ARS), New York /
ADAGP, Paris
Photo: p. 257, Joyce Pomeroy Schwartz

Sol LeWitt

Five Modular Units, 1971 (Refabricated 2008)
Painted aluminum
63" h. x 63" w. x 24' 3½" d.
Storm King Art Center, NY
© 2023 The LeWitt Estate/Artists Rights Society
(ARS), New York
Photo: p. 65, Joyce Pomeroy Schwartz

Thirteen Geometric Figures, 1984
Slate on marble
9' h. x 203' l.
Wood Street Subway Station, Pittsburgh, PA
© 2023 The LeWitt Estate/Artists Rights Society
(ARS), New York
Photos: pp. 168, 169, Steven Probert

Maya Lin

Vietnam Veterans Memorial, 1982
Basalt
10' 3" h. x 493' 6" w.
Washington D.C.
Photo: p. 140, Karen Clark, 2014

*Vietnam Veterans Memorial. Competition
Drawing*, 1981
13" x 17 1/3"
Image: p. 141, courtesy of the Library of
Congress, Prints & Photographs Division

Ecliptic, 2001
Rosa Parks Circle, Grand Rapids, MI
Sponsor: Frey Foundation
Landscape Architect: Quennell Rothschild &
Partners
Lighting Design: Tillett Lighting Design
Associates

© 2022 Maya Lin
Photos: pp. 196, 198, 201, Ngoc Minh Ngo,
Balthazar Korab, courtesy of the artist's studio

The Midnight Sky 01 01 00, 1997
Print on paper (edition of 50)
23 ¾" x 24"
© 2023 Maya Lin
Image: p. 200

Donald Lipski

Spot, 2018
Steel, fiberglass
38' h.
Hassenfeld Children's Hospital, New York, NY
© Donald Lipski. NYU Langone Art Program and
Collection.
Photo: p. 113, Andrew Neary

Robert Lobe

Untitled Metamorphosis, 2003–05
Heat treated hammered aluminum
New Rochelle, NY
© 2022 Robert Lobe
Photo: p. 212, courtesy of the Artist

X-Ray, 1993–96
Heat treated hammered aluminum
156" h. x 144" w. x 40" d.
New Rochelle, NY
© 2022 Robert Lobe
Photo: p. 213, courtesy of the Artist

Winifred Lutz

*How to Retain Site Memory While Developing
the Landscape*, 1991
Stone, marble, granite, limestone, trees and
shrubs
CityView Condominiums (formerly Korman
Suites at Buttonwood), Philadelphia, PA
Commissioned by the Korman Company in
cooperation with the Redevelopment Authority
of the City of Philadelphia 1% Fine Arts Program
and the Commonwealth of Pennsylvania.
©2022 Winifred Lutz
Photos: pp. 186, 187, 188, 189, Jacqueline Pearse,
2022

Loren Madsen

Echo, 1997
JR Kinshichō Station, Tokyo, Japan
© Loren Madsen / Artists Rights Society (ARS),
New York
Photo: pp. 220–221, courtesy of Town Art
Division, Kotobuki Corporation, Tokyo, Japan,
1994–1998

Paul Manship

Prometheus, 1932
Rockefeller Center, New York, NY
© Estate of Paul Manship
Photo: p. 74, Carol M. Highsmith Photography,
courtesy of the Library of Congress, Prints &
Photographs Division

Roberto Burle Marx

Copacabana Promenade, 1970
Rio de Janeiro
Photos: p. 154 (top), Joyce Pomeroy Schwartz; p.
154 (bottom), David Heald, *Wall Street Journal*

Ray K. Metzker

Nude Composite, 1966, 1984
Collection of Joyce Pomeroy Schwartz
© 2022 Ray K. Metzker
Image: p. 25

Michelangelo

David, 1501–04
Galleria dell'Accademia, Florence
Photos: p. 110, John Brampton Philpot, courtesy
of the Department of Image Collections,
National Gallery of Art Library, Washington D.C.;
pp. 120–121, Maksim Sokolov, via Wikimedia
Commons

Mary Miss

Framing Union Square, 1998
Glass, enameled steel, and aluminum frames
NYCT 4th St-Union Square Station, New York,
NY
Commissioned by Metropolitan Transportation
Authority Arts & Design.
© Estate of Mary Miss
Photos: p. 171, courtesy of the MTA Arts & Design

Michael Morrill

Compass, 1992
Tinted glass, aluminum, tile
10' h. x 42' w. x 60' d.
Pittsburgh International Airport, PA
© 2022 Michael Morrill
Photos: p. 158, courtesy of the Artist

Robert Morris

Glass Labyrinth, 2013
Glass, steel, bronze and stone
50' x 50' x 50'
Nelson-Atkins Museum of Art, Kansas City, MO
© 2023 The Estate of Robert Morris / Artists
Rights Society (ARS), New York
Photo: p. 38, Joyce Pomeroy Schwartz

Labirinto, 1982
Concrete, trani and serpentina stone
Collezione Gori, Fattoria di Celle, Pistoia, Italy
© 2023 The Estate of Robert Morris / Artists
Rights Society (ARS), New York
Photo: p. 69, courtesy Collezione Gori

Steam Gardens and Framed Vistas, 1992
Pittsburgh International Airport, PA
© 2023 The Estate of Robert Morris / Artists
Rights Society (ARS), New York
Photos: pp. 122, 160–161, 277 courtesy of the
Artist

Bull Wall, 1992
Milled steel, steam
Kansas City, MO

© 2023 The Estate of Robert Morris / Artists
Rights Society (ARS), New York
Photos: p. 205, Joyce Pomeroy Schwartz, 2014;
pp. 206–207, courtesy of the Artist

Bull Mountain, 1992
Milled steel
Kansas City, MO
© 2023 The Estate of Robert Morris / Artists
Rights Society (ARS), New York
Photo: p. 208, Joyce Pomeroy Schwartz, 2014

Sam Moyer

Doors for Doris, 2020
Bluestone, poured concrete, assorted marble,
and steel
Presented by Public Art Fund at Doris C.
Freedman Plaza, September 16, 2020–
September 12, 2021
Courtesy Sam Moyer Studio and Sean Kelly, New
York
Photo: p. 61, Nicholas Knight, courtesy Public
Art Fund, NY

Matt Mullican

Paintings, 1997
Miyagi Prefecture University Library, Japan
© 2022 Matt Mullican
Photo: p. 222, courtesy of Town Art Division,
Kotobuki Corporation, Tokyo, Japan, 1994–1998

Manuel Neri

Aurelia No. 4, 1997
Marble
82" h. x 27" w. x 24 1/2" d.
Iwate Prefectural University, Japan
© 2022 Manuel Neri
Photo: p. 217, courtesy of Town Art Division,
Kotobuki Corporation, Tokyo, Japan, 1994–1998

Española, 1987
Tampa, FL
©2022 Manuel Neri
Ph oto: p. 234, courtesy of the Artist

Louise Nevelson

City on the High Mountain, 1983
Painted steel
20' 6" h. x 23' w. x 13' 6" d.
Storm King Art Center, NY
© 2023 Estate of Louise Nevelson/Artists Rights
Society (ARS), New York
Photo: p. 66, Joyce Pomeroy Schwartz

Bicentennial Dawn, 1976
Painted wood
15' h. x 90' w. x 30' d.
James A. Byrne US Courthouse, Philadelphia, PA
Commissioned through the Art in Architecture
Program, U.S. General Services Administration.
© 2023 Estate of Louise Nevelson/Artists Rights
Society (ARS), New York
Photos: p. 102, Carol M. Highsmith Photography,
courtesy of the Library of Congress, Prints &
Photographs Division, p. 103, Al Schell for the
Philadelphia Evening Bulletin, courtesy of Temple
University Libraries, SCRC

Louise Nevelson Plaza, 1977
New York, NY
© 2023 Estate of Louise Nevelson/Artists Rights Society (ARS), New York
Photo: p. 134, Jacqueline Pearse, 2022; p. 135, Joyce Pomeroy Schwartz

Night Presence IV, 1972
92nd Street on Park Avenue, New York, NY
© 2023 Estate of Louise Nevelson/Artists Rights Society (ARS), New York
Photo: p. 256, Jacqueline Pearse, 2022

John Newman

Torus Orbicularis major, 1988
General Mills Sculpture Garden, Minneapolis, MN
© John Newman
Photo: p. 77, Greg Ryan

Isamu Noguchi

Playscapes, 1976
Piedmont Park, Atlanta, GA
© 2023 The Isamu Noguchi Foundation and Garden Museum, New York/Artist Rights Society (ARS), New York
Photo: p. 29, Wally Gobetz, 2013

Momo Taro, 1977–78
Granite
9' h. x 34'7" w. x 21'7" d. Overall
Storm King Art Center, New York
© 2023 The Isamu Noguchi Foundation and Garden Museum, New York/Artist Rights Society (ARS), New York
Photo: p. 67, Joyce Pomeroy Schwartz

News, 1938
Rockefeller Center, New York, NY
© 2023 The Isamu Noguchi Foundation and Garden Museum, New York/Artist Rights Society (ARS), New York
Photo: p. 74, Joyce Pomeroy Schwartz

Claes Oldenburg and Coosje van Bruggen

Shuttlecocks, 1994
Aluminum, fiberglass-reinforced plastic, paint
19' 2 9/16" h. x 15' 11 7/8" diam.
Nelson-Atkins Museum of Art, Kansas City, MO
© 2022 Claes Oldenburg and Coosje van Bruggen
Photo: p. 38, Carol M. Highsmith Photography, courtesy of the Library of Congress, Prints & Photographs Division

Batcolumn, 1977
Steel and aluminum painted with polyurethane enamel
96' 8" h. x 9' 9" diam., Base: 4' h. x 10' diam.
Harold Washington Social Security Center, Chicago, IL
Commissioned through the Art in Architecture Program, U.S. General Services Administration.
© 2022 Claes Oldenburg and Coosje van Bruggen
Photo: p. 86, Carol M. Highsmith Photography, courtesy of the Library of Congress, Prints & Photographs Division

Tom Otterness

The New World, 1991
4' x 300' (frieze), 3'5" h. x 4' w. x 1'5 d. (niche), 3'8"h. x 3'11" l. x 3'2" w. (baby)
Edward R. Roybal Federal Building, Los Angeles, CA
Commissioned through the Art in Architecture Program, U.S. General Services Administration
© 2023 Tom Otterness/Artists Rights Society (ARS), New York
Photos: pp. 90, 91, Carol M. Highsmith Photography, courtesy of the Library of Congress, Prints & Photographs Division

Nam June Paik

Something Pacific, 1986
Stuart Collection, UC San Diego, CA
© Nam June Paik Estate
Photo: p. 111, Philipp Scholz Rittermann, courtesy of the Stuart Collection

Beverly Pepper

The Sentinels of Justice, 1998
Cast iron, dimensions variable
The Charles Evans Whittaker U.S. Courthouse, Kansas City, MO
Commissioned through the Art in Architecture Program, U.S. General Services Administration.
© Beverly Pepper
Photo: p. 59, Carol M. Highsmith Photography, courtesy of the Library of Congress, Prints & Photographs Division

I.M. Pei

The Louvre Pyramid, 1988
The Louvre Palace, Paris
Photo: p. 80, Benh Lieu Song, 2010, via Wikimedia Commons

Giuseppe Penone

Bifurcated Branch and Three Landscapes, 1986
Sheraton Philadelphia Society Hill Hotel, Philadelphia, PA
© 2023 Artists Rights Society (ARS), New York / ADAGP, Paris
Photos: pp. 194, 195, courtesy of the Artist

Jody Pinto

Fingerspan, 1987
Weathering steel
9' (interior 7' 3") h. x 4' 10" (interior 3' 3") w. x 59" l.
Fairmount Park, Philadelphia, PA
Commissioned by the Fairmount Park Art Association (now the Association for Public Art).
© 2022 Jody Pinto
Photo: p. 182, Wayne Cozzolino © 1994 for the Association for Public Art

Fingerspan Pedestrian Bridge (pink hands), 1987
Watercolor, crayon, graphite on paper
72" x 60"
© 2022 Jody Pinto
Image: p. 183, courtesy of Jody Pinto

Jaume Plensa

Crown Fountain, 2004
Glass, stainless steel, LED screens, light, wood, black granite, and water
Millennium Park, Chicago, IL
Commissioned by The Public Art Program, Department of Cultural Affairs, City of Chicago, 2000.
© 2023 Artists Rights Society (ARS), New York / VEGAP, Madrid
Photo: p. 87, Carol M. Highsmith Photography, courtesy of the Library of Congress, Prints & Photographs Division

Anne and Patrick Poirier

The Death of Ephialthes, 1982
Marble, bronze
Collezione Gori, Fattoria di Celle, Pistoia, Italy
© 2023 Artists Rights Society (ARS), New York / ADAGP, Paris
Photo: p. 68, courtesy Collezione Gori

La Colonne Brisée, 1984
Reinforced concrete covered with marble
33' h. x 131' l. x 16' 4" diam.
A89, Salles, France
© 2023 Artists Rights Society (ARS), New York / ADAGP, Paris
Photo: p. 180, courtesy of the artists

Promenade Classique, 1986
Transpotomac Canal Center, Alexandria, VA
A89, Salles, France
© 2023 Artists Rights Society (ARS), New York / ADAGP, Paris
Photos: pp. 224, 225, 227, 228, 231, courtesy of the Artists

Martin Puryear

North Cove Pylons, 1992–95
Granite and stainless steel
north pylon: 72' x 5.75'; south pylon: 56.75' x 7' x 7'
Battery Park City, New York, NY
© 2022 Martin Puryear
Photo: p. 94, Joyce Pomeroy Schwartz

Knoll for NOAA, 1995
NOAA Western Regional Center, Seattle, WA
© 2022 Martin Puryear
Photo: p. 97, Henry Lee, Fotoeins Fotografie

Man Ray

Untitled (Paris Street Scene with Notre Dame), ca. 1925
Gelatin silver print with pencil
The Israel Museum, Jerusalem
© Man Ray 2015 Trust / Artists Rights Society (ARS), New York / ADAGP, Paris 2023
Image: p. 124, courtesy of the Israel Museum

Auguste Rodin

The Burghers of Calais, 1889 (cast 1908)
Victoria Tower Gardens, London, UK
Photo: p. 78, Jacqueline Pearse, 2021

Monument to Balzac, 1898 (cast 1954)
Museum of Modern Art, New York
Photo: p. 83, bobistavelling via flickr, 2015

Charles Ross

Star Axis, 1971–
New Mexico
© 2023 Charles Ross / Artist Rights Society
(ARS), New York
Photos: pp. 50, 51, courtesy of the Artist

Lines of Light, Rays of Color, 1986
Dallas, TX
© 2023 Charles Ross / Artist Rights Society
(ARS), New York
Photos: pp. 236, 237, 238, 239, courtesy of the
Artist

Light, Rock, Water, 1986
San Diego, CA
© 2023 Charles Ross / Artist Rights Society
(ARS), New York
Photos: pp. 240, 241, courtesy of the Artist

Ursula von Rydingsvard

Luba, 2009-2010
Cedar, cast bronze, and graphite
17' 6" h. x 59" w. x 59" d.
Storm King Art Center, NY
© 2022 Ursula von Rydingsvard
Photo: p. 62, courtesy of the Artist

Niki de Saint Phalle

Sun God, 1983
Stuart Collection, UC San Diego, CA
© 2023 Niki Charitable Art Foundation / ARS,
NY / ADAGP, Paris
Photo: p. 73, Philipp Scholz Rittermann, courtesy
of the Stuart Collection

Lucas Samaras

Silent Struggle, 1976
Cor-ten steel
107" h. x 72" w. x 13" d.
James L. Watson Court of International Trade,
New York, NY
Commissioned through the Art in Architecture
Program, U.S. General Services Administration.
© 2022 Lucas Samaras
Photo: p. 57, Jacqueline Pearse, 2022

Alan Saret

Home and Away, 1992
Pittsburgh International Airport, PA
© 2022 Alan Saret
Photos. pp. 155, 157, Joyce Pomeroy Schwartz

David Saunders

Lizzie and Gaffer Hexam, 1980
Steel
41' x 12'
Battery Park landfill, New York, NY
Commisioned by Art On The Beach/Creative
Time Inc.
© 2022 David Saunders

Photo: p. 95, courtesy of the Artist

David von Schlegell

Untitled, 1972
Aluminum and stainless steel
20' h. x 25' 4" w. x 16' d.
Storm King Art Center, NY
© 2022 Estate of David von Schlegell
Photo: p. 27, Signal Photography, courtesy of
Storm King Art Center Archives; p. 67. courtesy
of the Artist

Two Circles, 1972
Aluminum and stainless steel
24' h. x 18' w. x 24' d.
Storm King Art Center, NY
© Estate of David von Schlegell
Photo: p. 66, courtesy of the Artist

Voyage of Ulysses, 1977
Stainless steel
Maximum: 192" h. x 342" w. x 78" d.
James A. Byrne U.S. Courthouse, Philadelphia,
PA
Commissioned through the Art in Architecture
Program, U.S. General Services Administration.
© Estate of David von Schlegell
Photo: p. 104, Carol M. Highsmith Photography,
courtesy of the Library of Congress, Prints &
Photographs Division

Judith Shea

Storage, 1999
Bronze
A : 5' 6" h. x 18" w. x 12" d.
B : 5' 2" h. x 19 1/2" w. x 26" d.
C : 4' 10" h. x 16" w. x 20 1/2" d.
D : 42 3/4" h. x 14 1/2" w. x 15" d.
E : 7' 4" h. x 15 1/4" w. x 17" d.
Nelson-Atkins Museum of Art, Kansas City, MO
© 2022 Judith Shea
Photo: p. 37, courtesy of the Artist

Henry Shrady and Leo Lentelli

Robert E. Lee Monument, 1924
Richmond, Virginia
Photo: pp. 258–259, Steve Helber

Alexis Smith

Snake Path, 1992
Stuart Collection, UC San Diego, CA
© 2022 Alexis Smith
Photo: p. 72, Philipp Scholz Rittermann, courtesy
of the Stuart Collection

Kiki Smith

Standing, 1998
Stuart Collection, UC San Diego, CA
© 2022 Kiki Smith
Photo: p. 70, Philipp Scholz Rittermann, courtesy
of the Stuart Collection

Tony Smith

She who Must Be Obeyed, 1975
Painted steel

30' h. x 24' w. x 8' d.
Frances Perkins Building, Washington D.C.
Commissioned through the Art in Architecture
Program, U.S. General Services Administration.
© 2023 Tony Smith Estate/ Artists Rights
Society (ARS), New York
Photo: p. 20, Carol M. Highsmith Photography,
courtesy of the Library of Congress, Prints &
Photographs Division

Tau, 1961–62
Steel, painted black (edition of 3)
14' h. x 21' 6" w. x 12' 4 1/4" d.
Hunter College, New York, NY
© 2023 Tony Smith Estate/ Artists Rights
Society (ARS), New York
Photo: p. 132, courtesy of Hunter College

Robert Smithson

Spiral Jetty (1970)
Mud, precipitated salt crystals, rocks, water
1,500 ft. (457.2 m) long and 15 ft. (4.6 m) wide
Great Salt Lake, Utah
Collection Dia Art Foundation
© 2023 Holt/Smithson Foundation and Dia Art
Foundation / Licensed by Artists Rights Society
(ARS), NY
Photo: p. 52, Joyce Pomeroy Schwartz

Ned Smyth

Intruder, 1985
Marble, stone, glass, gold mosaic
20' h. x 24' w.
Anchorage Art Museum, Anchorage, AK
© 2022 Ned Smyth
Photo: pp. 100–101, courtesy of the Artist

Drawing for Intruder, 1984
Ink on paper
©2022 Ned Smyth
Image: p. 101, courtesy of the Artist

Nancy Spero

Artemis, Acrobats, Divas and Dancers, 2001
Glass and ceramic mosaic
NYCT 66th Street-Lincoln Center Station, New
York, NY
Commissioned by Metropolitan Transportation
Authority Arts & Design.
© 2023 The Nancy Spero and Leon Golub
Foundation for the Arts / Licensed by VAGA at
Artists Rights Society (ARS), NY
Photos: p. 171, Jacqueline Pearse, 2021

Eric Staller

Spirogyrate, 2014
Glass, acrylic, LED lighting, motors, electronics
Twelve 66 1/4" circular floor and wall discs
San Francisco International Airport Childrens'
Play Area – Terminal 3 Boarding Area E., CA
Commissioned by the San Francisco Arts
Commission.
©2022 Eric Staller
Photo: p. 145, Bruce Damonte

Emma Stebbins

Angel of the Waters, 1873
Central Park, New York, NY
Photo: p. 44, David T. Schwartz

Michelle Stuart

Gardens for Seasons, 1996
Tochigi Prefecture Health Center, Japan
© 2022 Michelle Stuart
Photos: pp. 222, 223, courtesy of Town Art
Division, Kotobuki Corporation, Tokyo, Japan,
1994–1998

George Sugarman

Untitled, 1988
Tampa, FL
© 2023 Estate of George Sugarman/Licensed by
VAGA at Artists Rights Society (ARS), NY
Photos: pp. 234, 235, courtesy of the Artist's
studio

Mark di Suvero

Mon Père, Mon Père, 1973–75
Steel
35' h. x 40' w. x 40' 4" d.
Storm King Art Center, NY
© Mark Di Suvero, courtesy of the artist and
Spacetime C.C.
Photo: p. 65, Joyce Pomeroy Schwarz

Mother Peace, 1969-70
Painted steel
41' 8" h. x 49' 5" w. x 44' 3" d.
Storm King Art Center, NY
© Mark Di Suvero, courtesy of the artist and
Spacetime C.C.
Photo: p. 65, Joyce Pomeroy Schwarz

Joie de Vivre, 1998
Painted steel
70' h. x 30' 6" w. x 24' 6" d.
Zuccotti Park, New York, NY
© Mark Di Suvero, courtesy of the artist and
Spacetime C.C.
Photo: p. 112, Jacqueline Pearse, 2022

Lenore Tawney

Cloud VII, 1983
Linen fiber/yarn, cotton canvas, nylon cord, dye,
paint
192" h. x 60" w. x 360" d.
Western Connecticut State University, Danbury,
CT
© 2022 Lenore Tawney
Photo: p. 130, Blake Marvin Photography; p. 131,
Joyce Pomeroy Schwartz

Hank Willis Thomas

Raise Up, 2016.
Bronze
Approx. 25' l.
Installed at the National Memorial for Peace and
Justice, Montgomery, AL
© Hank Willis Thomas
Photo: p. 37, courtesy of the artist and Jack

Shainman Gallery, New York, 2018

Jean Tinguely

Schwimmwasserplastik, 1980
Solitude Park, Tinguely Museum, Basel,
Switzerland
© 2022 Museum Tinguely Basel
Photo: p. 44, Darnel Spehr

*Project sketches for "Fontaine Stravinsky: les 74
premiers éléments" with letter to Joyce*, ca. 1985
Collection of Joyce Pomeroy Schwartz
© 2023 Artists Rights Society (ARS), New York /
ADAGP, Paris
Image: p. 46

Brian Tolle

Irish Hunger Memorial, 2002
Battery Park City, New York, NY
© 2022 Brian Tolle
Photos: pp. 242, 243, 248, Jacqueline Pearse,
2022, pp. 252-253, 255, courtesy of the Artist;
pp. 249, 250, 251, Peter Mauss/Esto

George Trakas

Berth Haven, 1983
NOAA Western Regional Center, Seattle, WA
©2022 George Trakas
Photo: p. 97, Eric Magnuson

Bernar Venet

Ligne Indéterminée, 1992
Painted steel
Norfolk, VA
© 2023 Artists Rights Society (ARS), New York /
ADAGP, Paris
Photo: p. 127, courtesy of the Artist

Arc Majeur, 2019
60 x 75 x 2.25 meters
Permanent installation for autoroute E411, km
marker 99, Belgium
© 2023 Artists Rights Society (ARS), New York /
ADAGP, Paris
Photo: p. 181, Charles Paulicevich / Meta-
Morphosis

William Wegman

Stationary Figures, 2018
Glass mosaic
NYC Transit 23 St Station, New York, NY
Commissioned by Metropolitan Transportation
Authority Arts & Design
© 2022 William Wegman
Photos: p. 179, Jacqueline Pearse, 2022

Kehinde Wiley

Rumors of War, 2019
Bronze with limestone base
835 5/16" h. x 776 7/8" w. x 481 5/8" d.
© Kehinde Wiley. Presented by Times Square
Arts in partnership with the Virginia Museum of
Fine Art and Sean Kelly, New York.
Photo: p. 263, courtesy of the Artist

James Wines

BEST Notch Building, 1977
Sacramento, CA
© 2022 James Wines
Photo: p. 92, courtesy of the Artist

Antilia "Vertiscape" Tower Proposal, 2004
Watercolor
© 2022 James Wines
Image, p. 93, courtesy of the Artist

Jack Youngerman

Sculpture Grove, 1981
(Installation view with Jack Youngerman, 1981)
Doris C. Freedman Plaza, New York, NY
© 2023 Estate of Jack Youngerman/Licensed by
VAGA at Artists Rights Society (ARS), NY
Photo: p. 54, courtesy of the Public Art Fund

Rumi's Dance, 1976
Edith Green – Wendell Wyatt Federal Building,
Portland, OR
Commissioned through the Art in Architecture
Program, U.S. General Services Administration.
© 2023 Estate of Jack Youngerman/Licensed by
VAGA at Artists Rights Society (ARS), NY
Photo: p. 56, Carol M. Highsmith Photography,
courtesy of the U.S. General Services
Administration, Public Buildings Service, Fine
Arts Collection

Additional images

p. 19
Portrait of Joyce Pomeroy Schwartz
Costas Picadas, 2014

p. 26
Louise Nevelson and Arnie Glimcher
1974
Courtesy of Pace Gallery

p. 28
Tony Smith in studio
Hans Namuth, 1970
via mondo-blogo.blogspot.com

p. 29
*Isamu Noguchi working on a model for Riverside
Park Playground*
Michio Noguchi, 1963
Courtesy of The Noguchi Museum Archives,
03933

p. 30
*Randy Rosen, Clementine Brown, Lila Harnett
– Founder of ArtTable, Joyce Pomeroy Schwartz
and Carol Morgan*

*Lowery Stokes Sims, Leslie King-Hammond,
Dorothee Peiper-Riegraf, and Joyce Pomeroy
Schwartz*
Patrick McMullan Company, 2011

p. 31
*View of Rockefeller Apartments from MoMA
Garden*
Alix Schwartz, 2022

p. 133
Bamiyan Buddhas
1930
Bamyan, Afghanistan
via Wikimedia Commons

Cultural Landscape and Archaeological Remains of the Bamiyan Valley
Mario Santana, 2011
Bamyan, Afghanistan
via Wikimedia Commons

p. 136
Bonwit Teller Building Relief
1929 (destroyed 1979)
New York, NY

p. 162
Marin Hassinger and Alan Saret
Joyce Pomeroy Schwartz, 1991

p. 170
Lee Harris Pomeroy in DeKalb Subway Station
Ruby Washington for The New York Times, 2000
Courtesy of The New York Times Archives

p. 186
Columns retrieved from Preston Retreat
1989
Philadelphia, PA

p. 226
The Poiriers in France
Joyce Pomeroy Schwartz, 2008

p. 229
The Poiriers in Alexandria
Joyce Pomeroy Schwartz, 1986

Robert Morris
Steam Gardens and Framed Vistas
1992
Pittsburgh, PA